California 24/7 is the sequel to *The New York Times* bestseller *America 24/7* shot by tens of thousands of digital photographers across America over the course of a single week. We would like to thank the following sponsors, the wonderful people of California, and the talented photojournalists who made this book possible.

ANGELS CAMP
Frog jockey Billy Marr preps his own celebrated frog for a jumping contest at the Calaveras County Fair. The 6-year-old hoped to establish a rapport with his athletic amphibian by donning bug eyes for the annual event that draws 40,000 spectators.
Photo by Meri Simon

DK

LONDON, NEW YORK, MUNICH, MELBOURNE, and DELHI

Created by Rick Smolan and David Elliot Cohen

24/7 Media, LLC
PO Box 1189
Sausalito, CA 94966-1189
www.america24-7.com

First Edition, 2004
04 05 06 07 08 10 9 8 7 6 5 4 3 2 1

Published in the United States by
DK Publishing, Inc.
375 Hudson Street
New York, NY 10014

DK Publishing, Inc. offers special discounts for bulk purchases for sales promo-
tions or premiums. Specific, large-quantity needs can be met with special edi-
tions, personalized covers, excerpts of existing guides, and corporate imprints.
For more information, contact:

Special Markets Department
DK Publishing, Inc.
375 Hudson Street
New York, NY 10014
Fax: 212-689-5254

Cataloging-in-Publication data is available
from the Library of Congress
ISBN 0-7566-0044-8

Printed in the UK by Butler & Tanner Limited

First printing, October 2004

MARIN COUNTY
The bridge shines and the City by the Bay
shimmers, but attention tonight is on the
ebbing lunar eclipse.
Photo by Jody Gianni

CALIFORNIA 24/7

24 Hours. 7 Days.
Extraordinary Images of
One Week in California.

Created by Rick Smolan and David Elliot Cohen

DK Publishing

About the America 24/7 Project

A hundred years hence, historians may pose questions such as: What was America like at the beginning of the third millennium? How did life change after 9/11 and the ensuing war on terrorism? How was America affected by its corporate scandals and the high-tech boom and bust? Could Americans still express themselves freely?

To address these questions, we created *America 24/7*, the largest collaborative photography event in history. We invited Americans to tell their stories with digital pictures. We asked them to shoot a visual memoir of their lives, families, and communities.

During one week in May 2003, more than 25,000 professionals and amateurs shot more than a million pictures. These images, sent to us via the Internet, compose a panoramic yet highly intimate view of Americans in celebration and sadness; in action and contemplation; at work, home, and school. The best of these photographs, more than 6,000, are collected in 51 volumes that make up the *America 24/7* series: the landmark national volume *America 24/7*, published to critical acclaim in 2003, and the 50 state books published in 2004.

Our decision to make *America 24/7* an all-digital project was prompted by the fact that in 2003 digital camera sales overtook film camera sales. This techno-logical evolution allowed us to extend the project to a huge pool of photographers. We were thrilled by the response to our challenge and moved by the insight offered into American life. Sometimes, the amateurs outshot the pros—even the Pulitzer Prize winners.

The exuberant democracy of images visible throughout these books is a revela-tion. The message that emerges is that now, more than ever, America is a supersized idea. A dreamspace, where individuals and families from around the world are free to govern themselves, worship, read, and speak as they wish. Within its wide margins, the polyglot American nation manages to encompass an inexplicably complex yet workable whole. The pictures in this book are dedicated to that idea.

—*Rick Smolan and David Elliot Cohen*

American nightlight: More than a quarter of a billion people trace a nation with incandescence in this composite satellite photograph.
Photo by Craig Mayhew & Robert Simmon, NASA Goddard Flight Center/Visions of Tomorrow

Inventing Reality

By Diana Griego Erwin

Through the window of a coffeehouse where a small cup of java costs $1.75 these days, I watch a Latino teenager gyrate vigorously on the corner, a Walkman stereo planted firmly on his head. In his hands is a huge arrow sign advertising a pricey new subdivision down the street. Passing motorists smile or ignore him.

These are not homes this boy or his immigrant family can afford, but that's beside the point. Content to escape his father's seasonal work in the backbreaking tomato fields and pear orchards of the Sacramento Valley, the boy is part of the dream, the dream that has always been California.

Ask about the future and the golden glow of hope in his eyes is as genuine as that of the two-income family who will buy one of the $450,000 look-alike residences or that of the fifth-generation developer selling the dream by the name of "community."

The dreams of California's 34 million residents come in many shapes and sizes, few of them alike, many of them elusive, yet always, somehow, surviving.

Observers from afar have claimed for years that the far west's golden era has passed, that the future is tarnished. A meltdown of the state budget with its $15 billion deficit. Voters turning to a muscle bound, action hero, movie star governor to save them. The shattering of the state's promise to its top students that a prestigious University of California spot awaits them— for the first time ever in 2004, that was no longer the case.

While the issues and problems are real, the California state of mind is about the freedom to search out one's fortune, not the riches themselves.

SAN PEDRO
Off Point Fermin, Catalina Island lays low at sunset. The hustle and bustle of Los Angeles and the Southland seem far from this rocky stretch of beach.
Photo by Thomas P. Mcconville

The search for what's golden is defined individually. The Salinas orchard worker presses for his children to become citizens. The teenager outside the Sacramento coffeehouse can one day own a home. The Malibu millionaire might chuck it all in search of nirvana.

From Hollywood soundstages and Bay Area biotechnology firms to the aerobics room at Sun City, we are the land of constant reinvention. We choose our lives, and almost anything goes in California. Both the Frisbee and Barbie were born here.

Like many Californians, I am a native by happenstance, not by history. My parents were 17 and 18 when they eloped here exactly 50 years ago from middle America. California represented sunshine and freedom, important for a couple melting before the frowns of a small town troubled to see a Mexican-American boy crazy over a blond he'd known since middle school. California was a haven and remains so.

As these pages reveal, it is not one place or people, but many places and people, experiencing whichever California metaphor they adopt. While we live in particular places—Anaheim, Petaluma, Barstow—no one inhabits the state called California. Both physically and symbolically, it is too vast for any one individual to embrace in its entirety. That's all the more true now, at this moment, as Californians struggle between the dream and the reality.

The boy on the corner shakes, hops, and dances. He works. He plays. He dreams. The future is now. This is his California.

Native Californian Diana Griego Erwin *is a Pulitzer Prize–winning journalist who writes news columns for* The Sacramento Bee.

SAN FRANCISCO
Workers hang a billboard for the second
Charlie's Angels movie over Union Square.
The arrival of the blockbuster's ads can
mean only one thing: Summer is just around
the corner.
Photo by Dennis A. Maloney

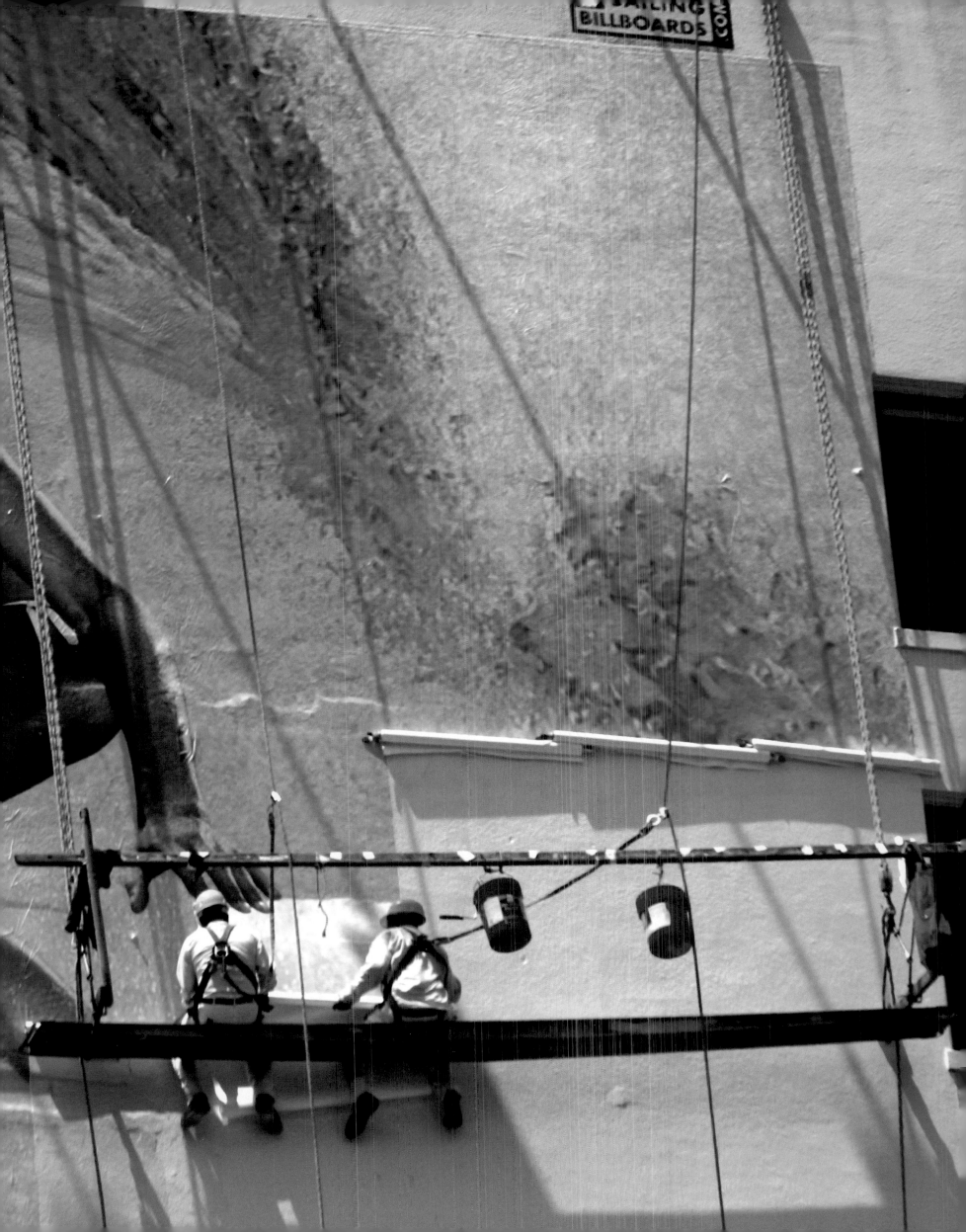

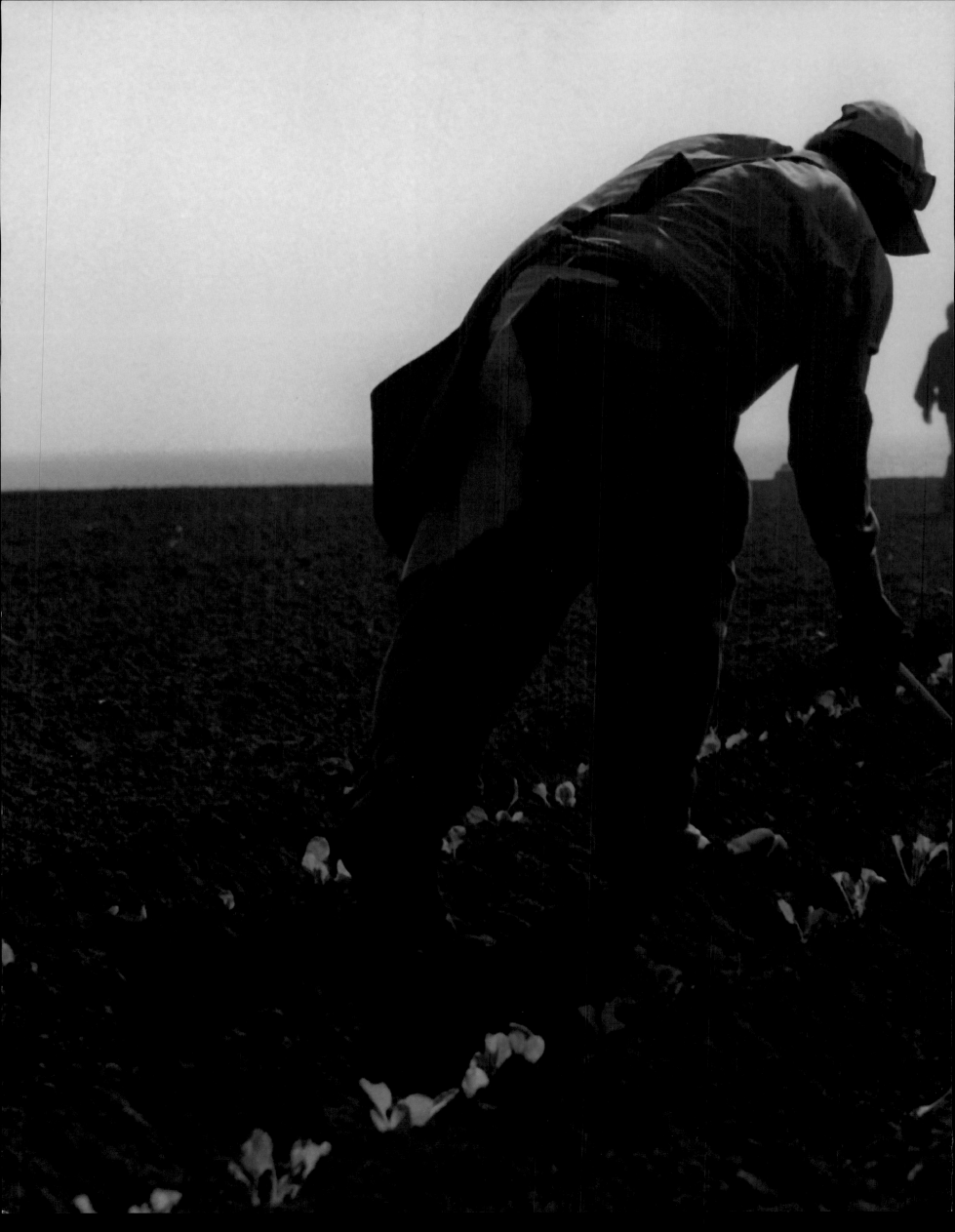

MOSS LANDING

Late afternoon, north Monterey County: Matias Soto (left) and fellow farmworkers plant seedlings. The fertile soil and range of temperatures—from moderate coastal ones here to hotter ones farther south—make agriculture the county's leading industry.
Photo by Ivan Kashinsky,
San Jose State University

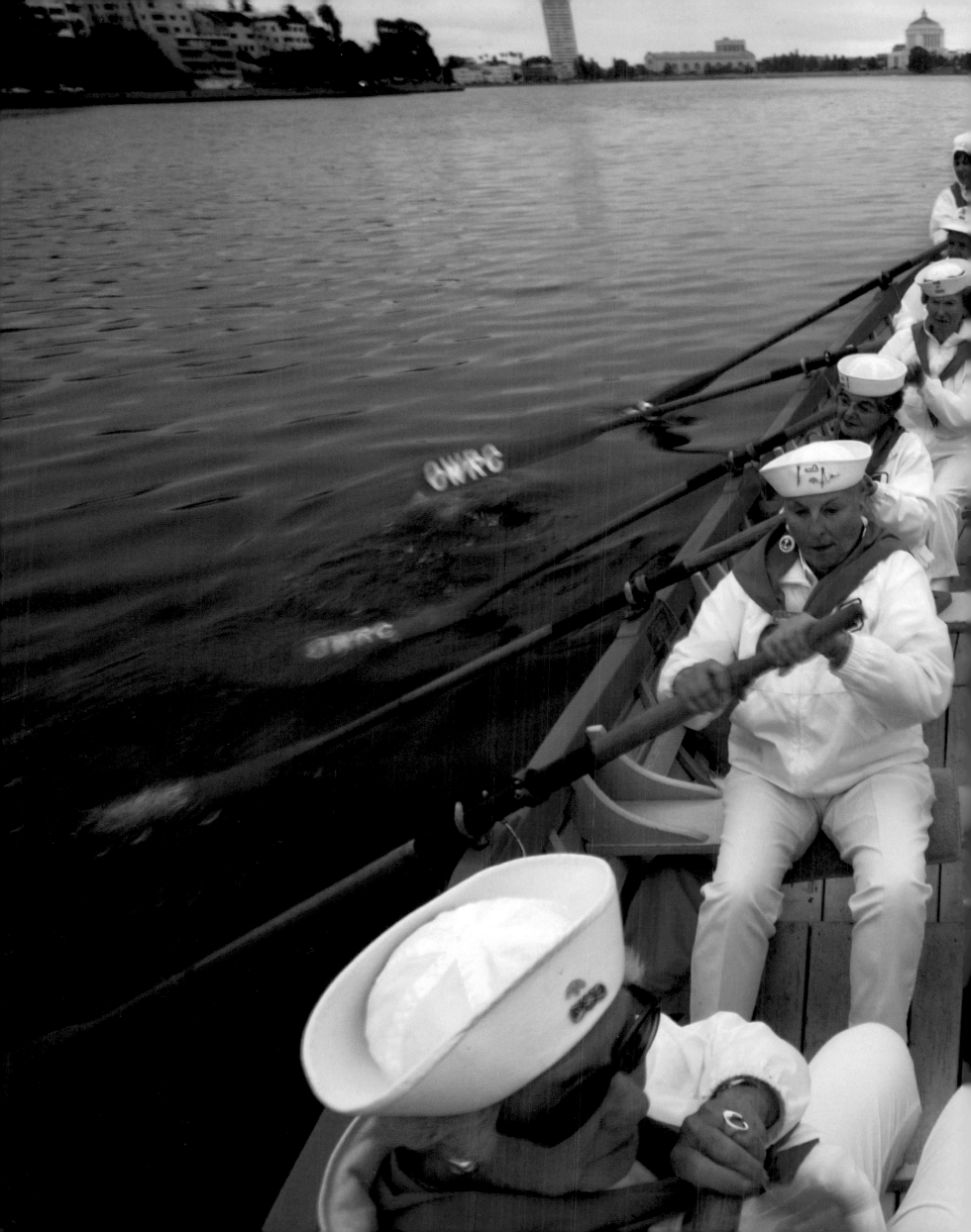

OAKLAND

The Oakland Women's Rowing Club gathers every Wednesday at 11 a.m. for an hourlong excursion on Lake Merritt near downtown Oakland. The club's 48 members, ranging in age from 53 to 96, still adhere to the dress code established by the founders in 1916.
Photo by Jean Jarvis

YOSEMITE NATIONAL PARK
A 15-mile-long glacier sculpted the contours of Yosemite Valley one million years ago, leaving behind imposing granite monoliths like El Capitan, left. The landscape inspired Ansel Adams to devote his life to capturing its beauty and John Muir to proclaim it "a paradise that makes even the loss of Eden seem insignificant."
Photo by Jim Gensheimer,
The San Jose Mercury News

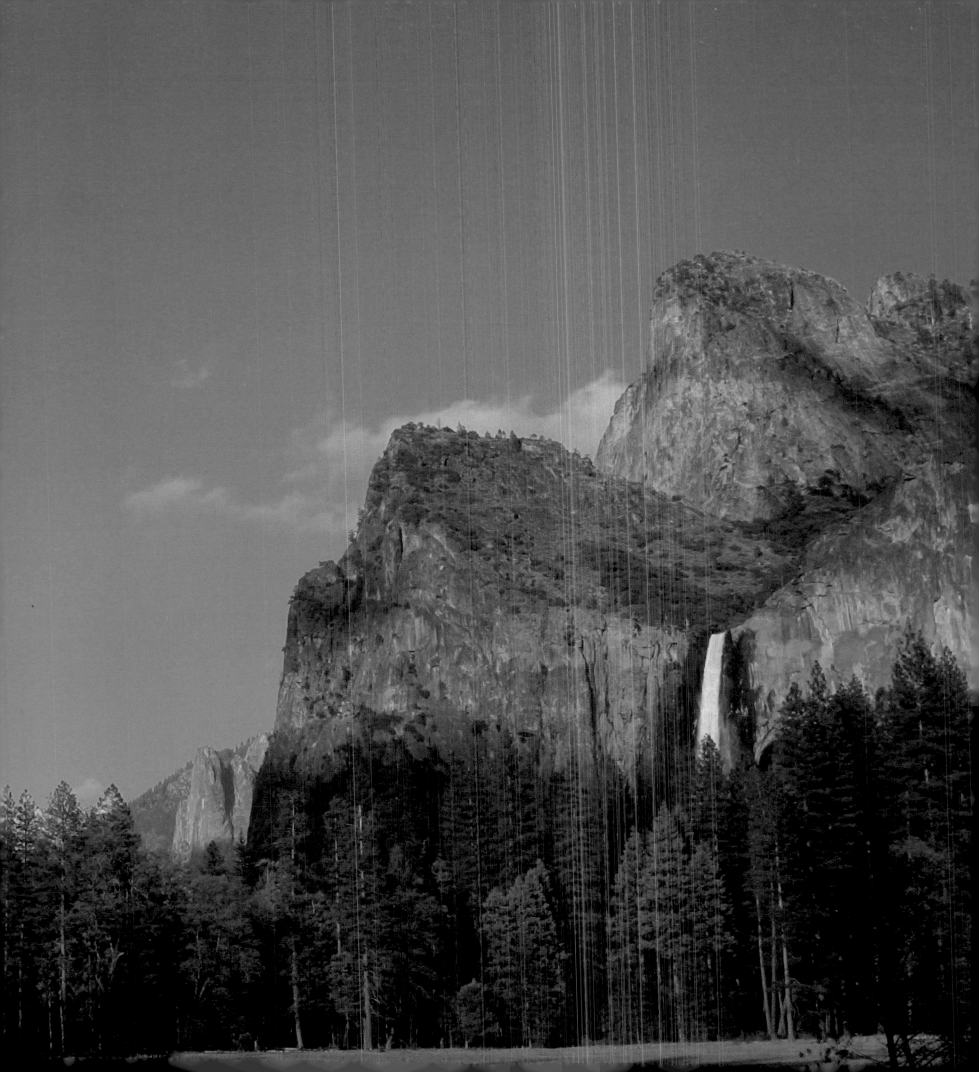

PACIFICA
Weatherworn Monterey cypress hang tough.
Enduring salty sea winds, the softwood co-
nifers on Sharp Park State Beach are denud-
ed of their small, scaley leaves.
Photo by Stephen Johnson

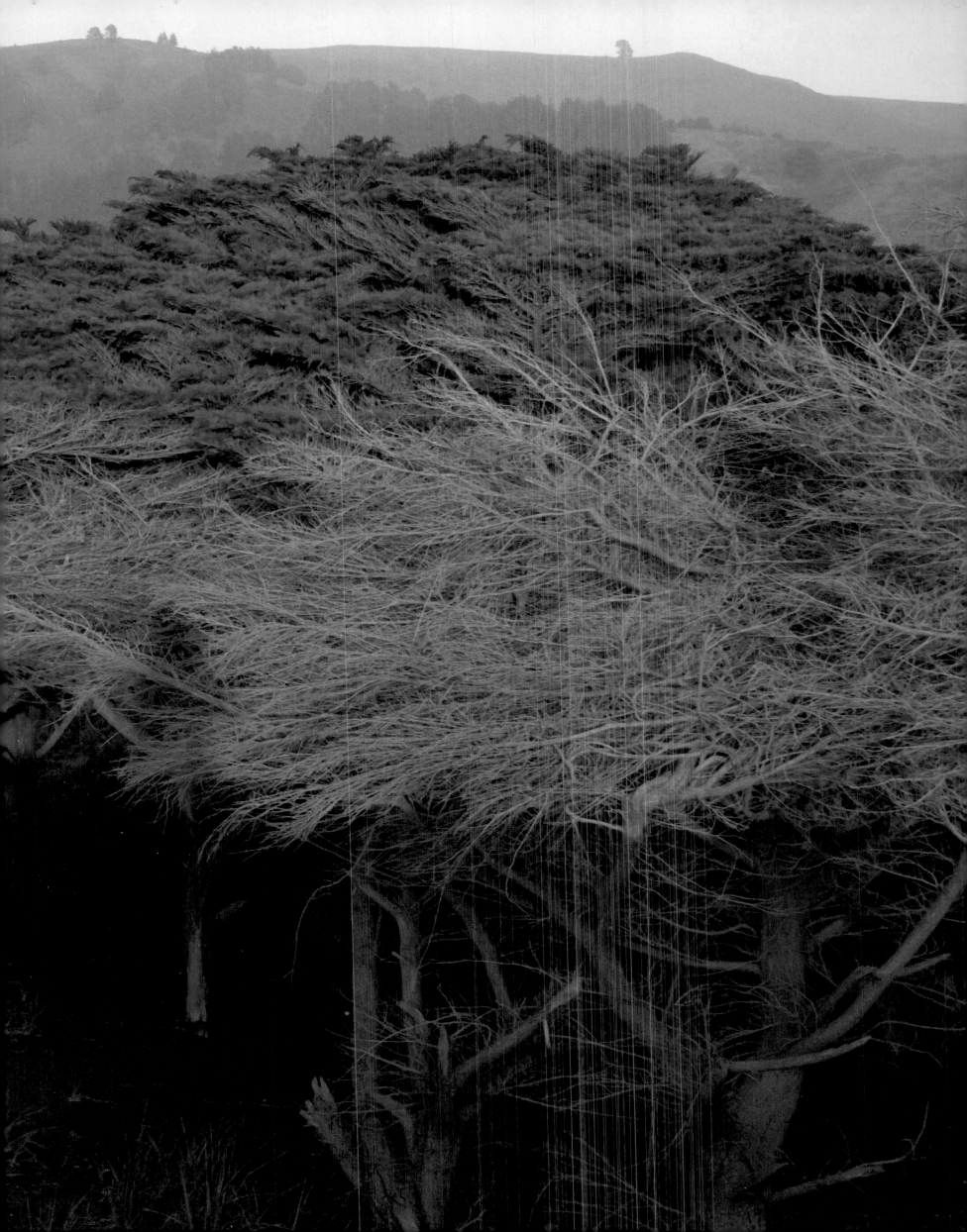

BERKELEY
A room full of toys becomes an enchanted forest, a concert hall, or a wizard's chamber for this 4-year-old ballerina. When a little girl imagines her world, it becomes as real as this room.
Photo by Rita Coury

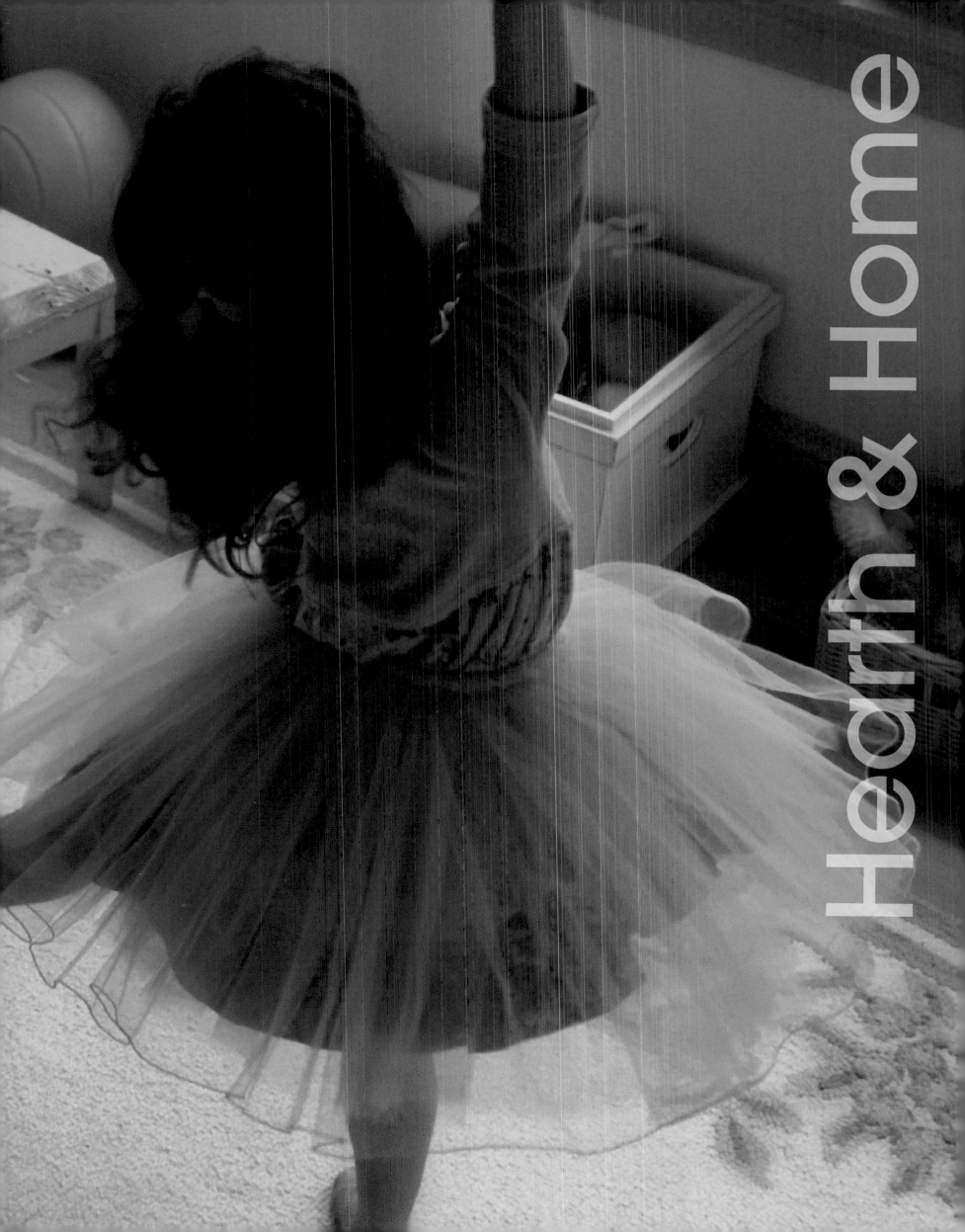

Hearth & Home

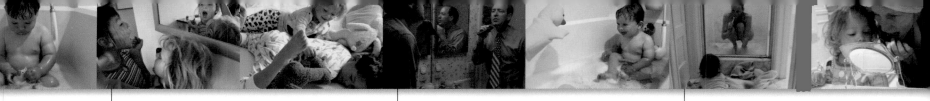

SAN DIEGO

At an indoor version of a Girl Scout campout, Rachel Dubin decorates Paige Hankins's face. The scouts built an outdoor shelter in their troop leader's backyard, made s'mores, and sang Girl Scout songs. Does face painting count toward an art badge?
Photo by Sandy Huffaker

SAN DIEGO

City councilmember Jim Madaffer, who represents two neighborhoods that hold festivals the same day, changes and shaves between events.
Photo by Peggy Peattie,
The San Diego Union-Tribune

SAUSALITO

It's 6:30 a.m. and 3-year-old bath attendant Tess Fisher is ready with two towels for her mom Holly Seeler, a marketing company executive.
Photo by Victor Fisher

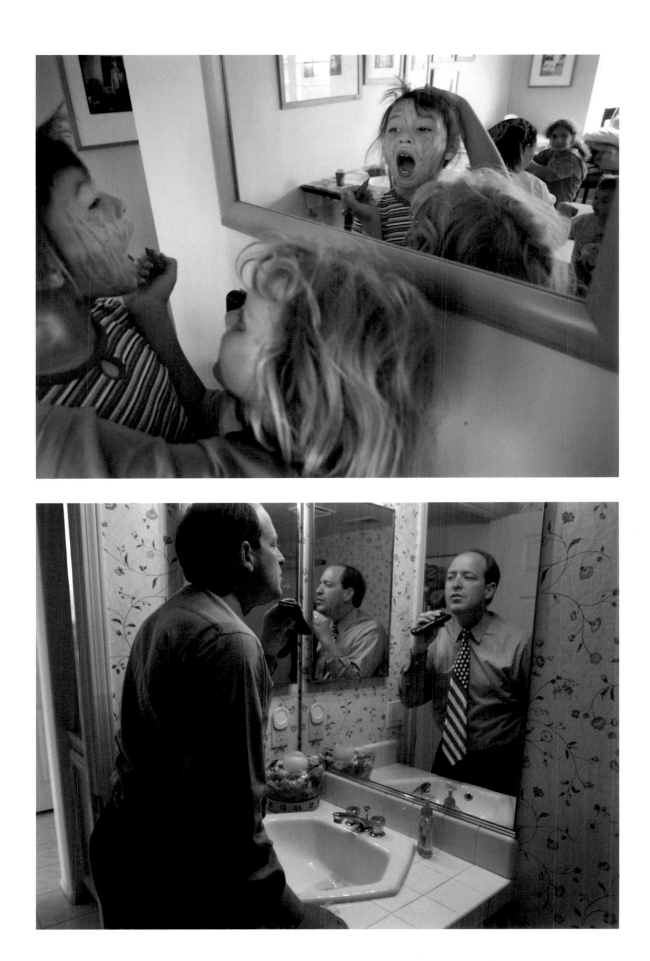

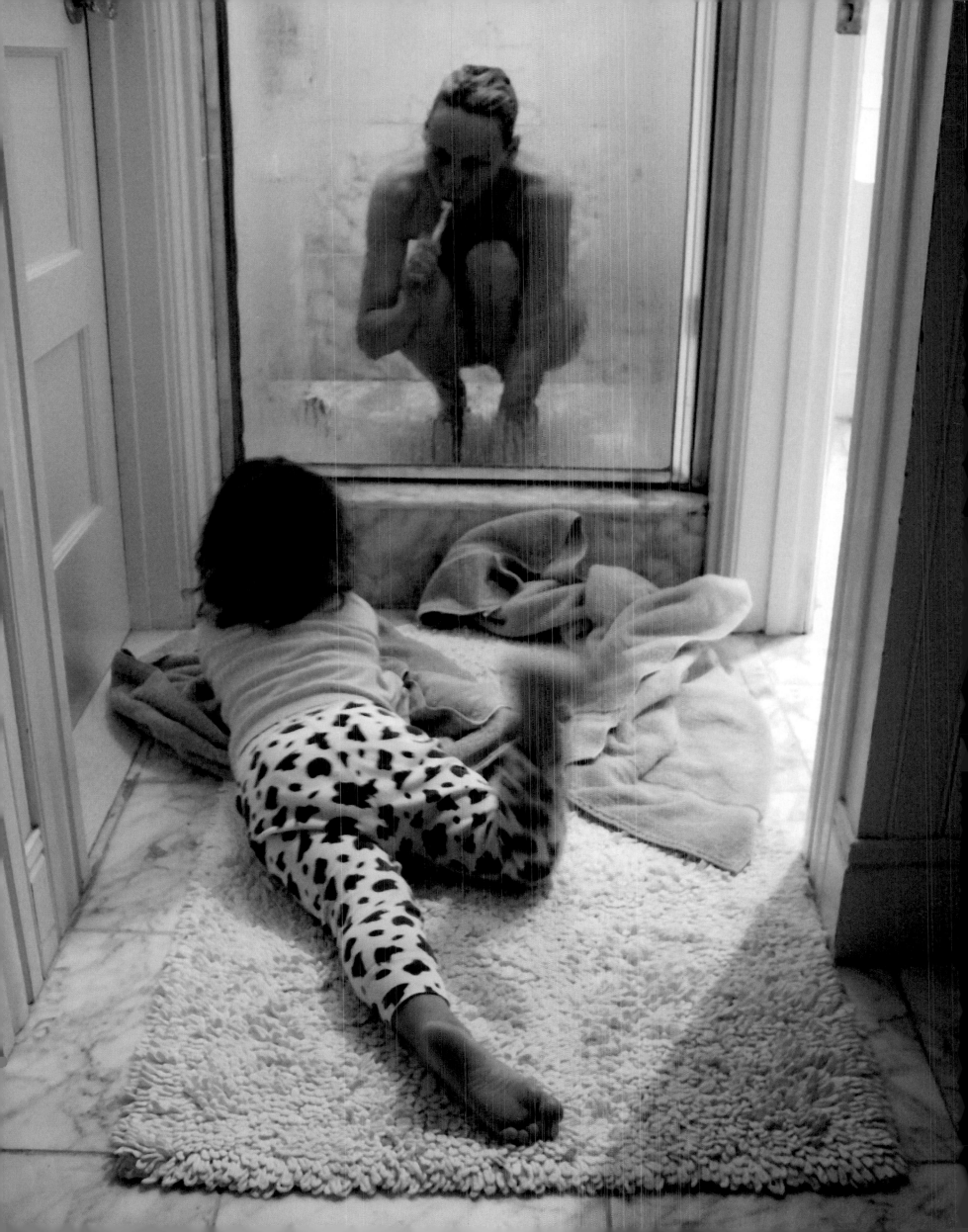

SACRAMENTO

Jaylen Bautista, 5 weeks old, will not fall off the couch on Kimani Smith's watch. At 4, Kimani takes his role as big brother seriously: His mission is to help his single mom protect Jaylen.
Photo by Gregory Stringfield

SAN FERNANDO

Constance Haas, 82, and her late husband Frank began caring for homeless youth in the 1940s. Over the years, more than 700 foster children have called her Mom. Some have come and gone while others have stayed long enough to graduate from high school. "All Child Services had to tell me was 'this child needs a home,'" said Haas. "I had no other qualifications."
Photo by David Sprague,
Daily News, Los Angeles

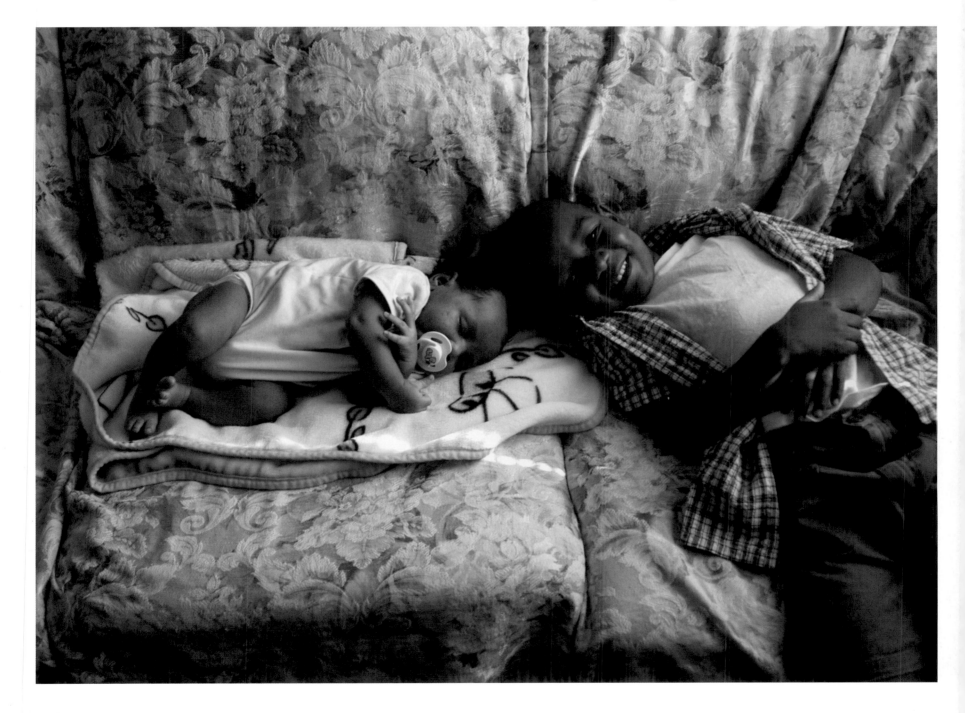

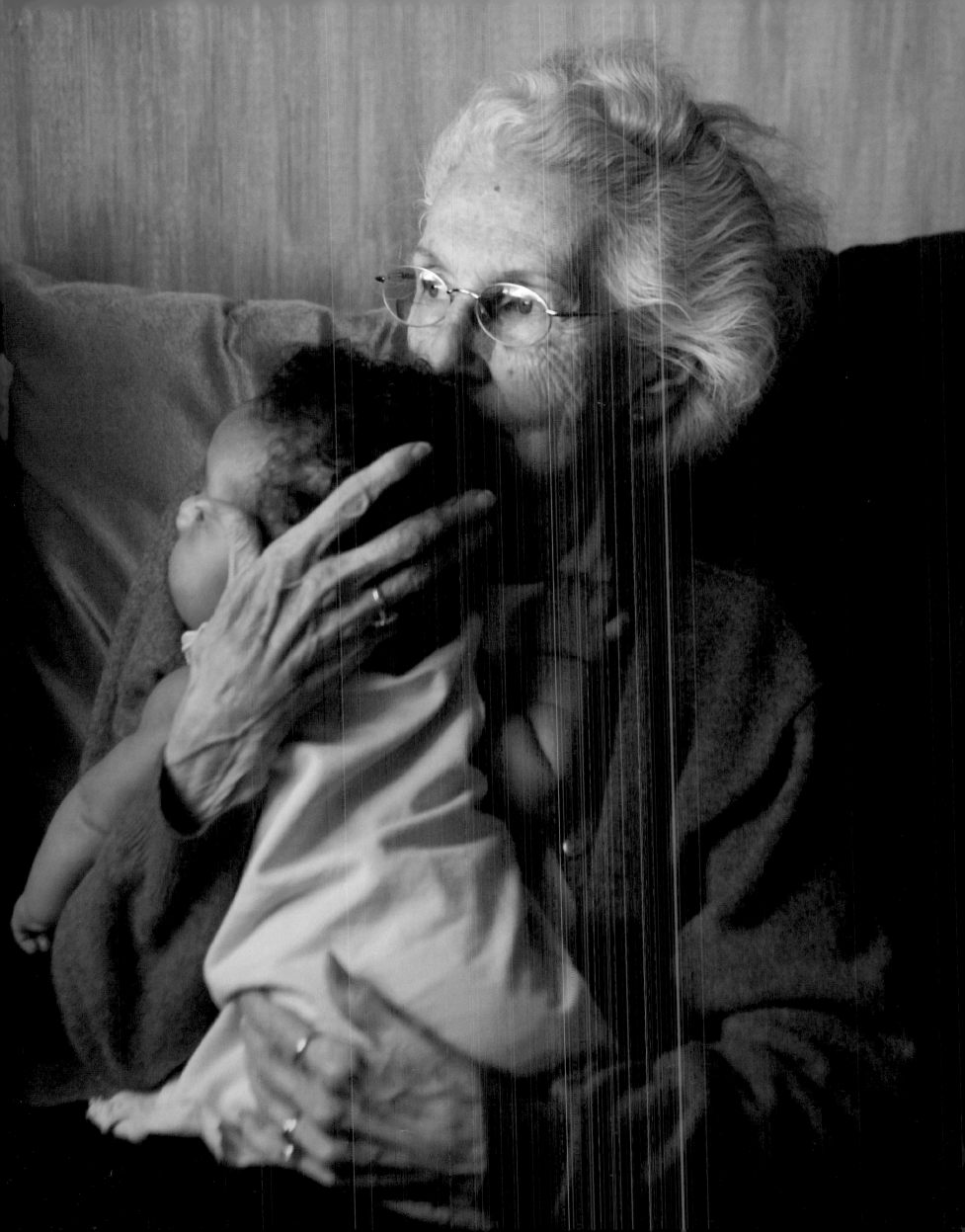

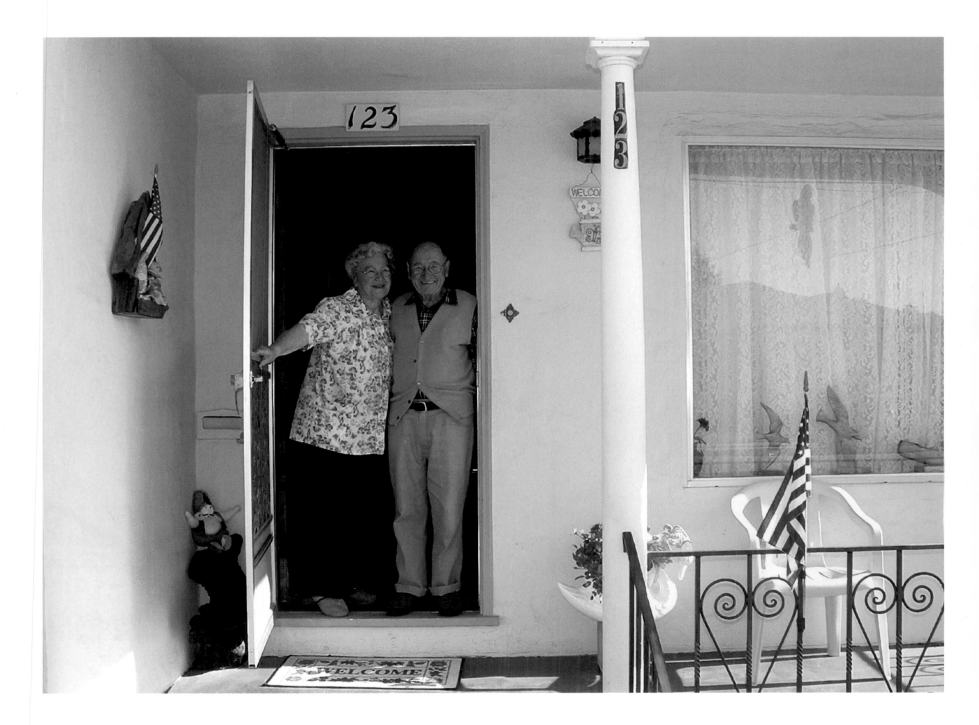

SANTA CRUZ

Erma and Tony Dalbesio have lived in their home for 56 years. "Santa Cruz had 10,000 people in it when we moved here," says Erma, who clerked at a drugstore. "Now there's over 100,000." Tony, who's retired, was a custodian at Westlake Elementary School.

Photo by Sabrina Dalbesio

TRINIDAD

Marina Garrett of Blue Lake takes her bear-foot slippers with her everywhere, even to dinner at a friend's house, 20 miles away from home.
Photo by Josh Haner

CLAREMONT

California law has allowed Giovanni Barcesi, a single gay man, to adopt Alaia, Josh, Cresean, and Tatayana. But dating is another matter: "I have pretty much knocked the partner thing out of the water—I'm middle-aged, have four kids, and I'm bald," says Barcesi, a community-outreach marketing specialist.

Photos by Jan Sonnenmair, Aurora

LOS ANGELES
What's a sippy cup doing on the floor of a yoga studio? It's the Mommy and Me class at the Center for Yoga, where moms can bring kids from 2 months to 4 years old.

SARATOGA
The world of Tinky Winky, Dipsy, Laa-Laa, and Po enthralls 16-month-old Jacob Gensheimer who cozies up to his TV for the 9:30 a.m. edition of *Teletubbies*. The British children's show is the *Sesame Street* of the new millennium: It's aired in 113 countries and generates $800 million each year in related merchandise sales.
Photo by Jim Gensheimer,
The San Jose Mercury News

MILL VALLEY

Kati Otto of San Francisco checks the fit of her wedding gown at Alençon Couture Bridal. Store co-owner Nancy Taylor assists. Otto thinks the gown, called the Savannah, will go well with her outdoor September wedding at Sonoma's Beltane Ranch.

Photos by Sisse Brimberg

MILL VALLEY

Kati Otto's $4,200 bridal gown (the price includes fittings) is a modified A-line, made from a single piece of French alençon lace. "It's streamlined and feminine and elegant without being too bridey," she says.

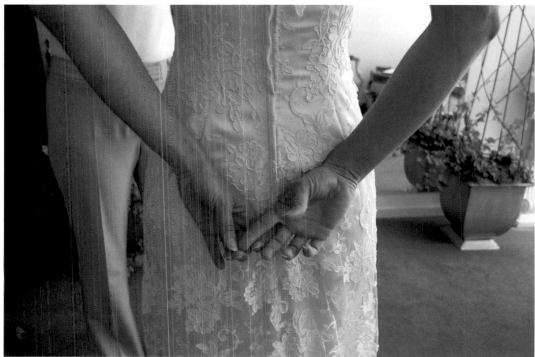

ROCKLIN

Mr. and Mrs. Don and Katie Vagt walk down the aisle and into their future together. The first thing on their new, mutual agenda: The wedding reception at the Whitney Oaks Golf Club with 60 of their friends and family.
Photo by Larry Angier

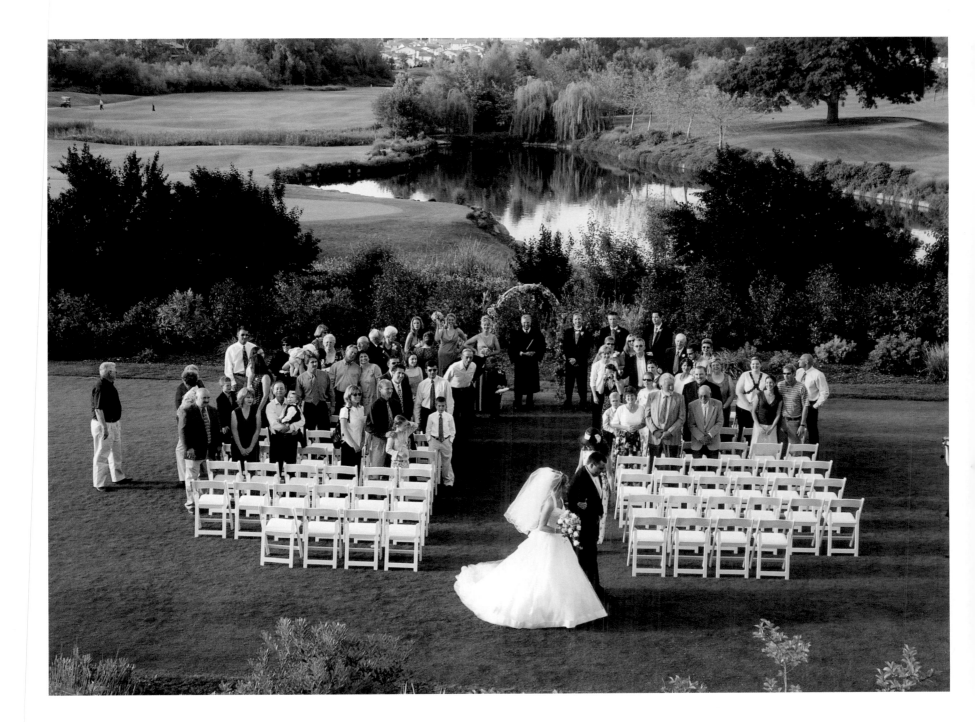

SAN DIEGO

"Passage for a kiss." Groomsmen obstruct newly-weds Elizabeth Alvarez and Lieutenant David Overcash before the traditional arch of swords until they kiss. "We loved the combination of the military pomp and the old Spanish mission," says Overcash. Mission Basilica San Diego de Alcala, built in 1769, was the first mission of 21 founded by Junipero Serra.
Photo by Nadia Borowski Scott,
The San Diego Union-Tribune

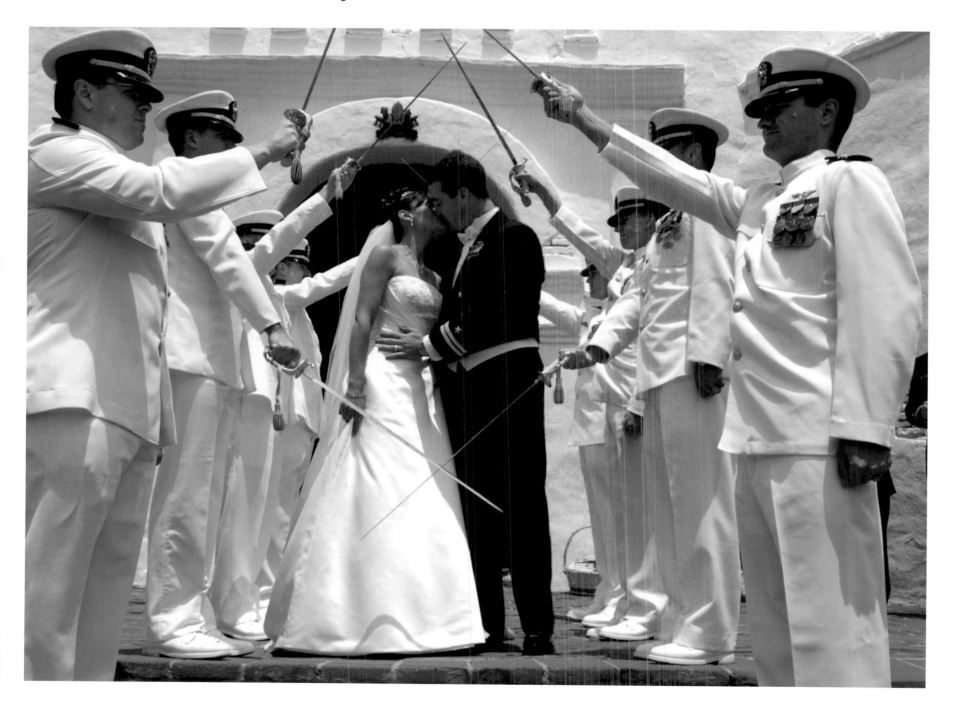

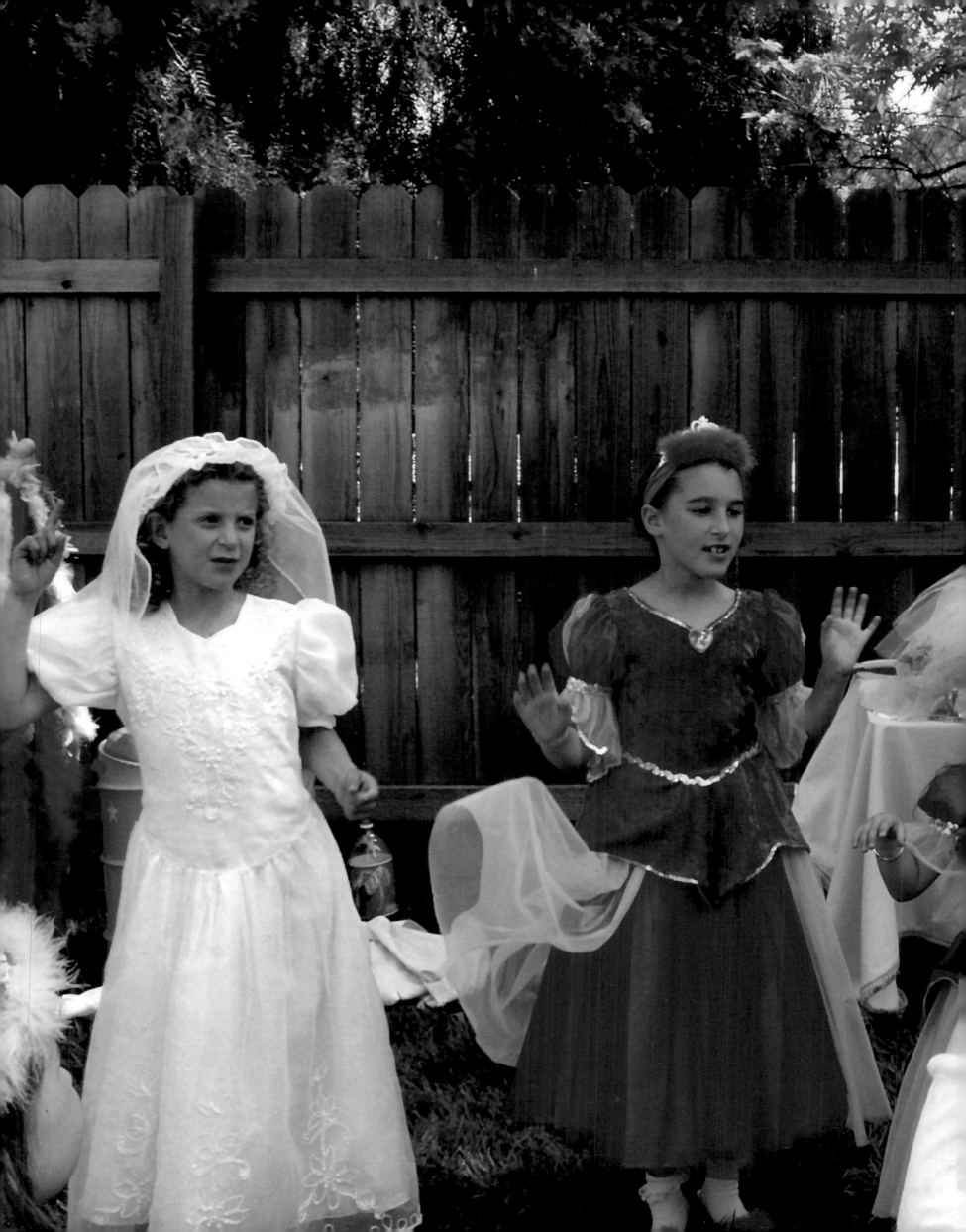

TARZANA
Miss Lori's princess parties feed the fantasies of little girls. Former Rockette Lori McMaken plays Cinderella for birthday girl Maya Golan (in the golden crown), who is turning 4. For $135, McMaken provides costumes, music, and her imagination.
Photo by Jan Sonnenmair, Aurora

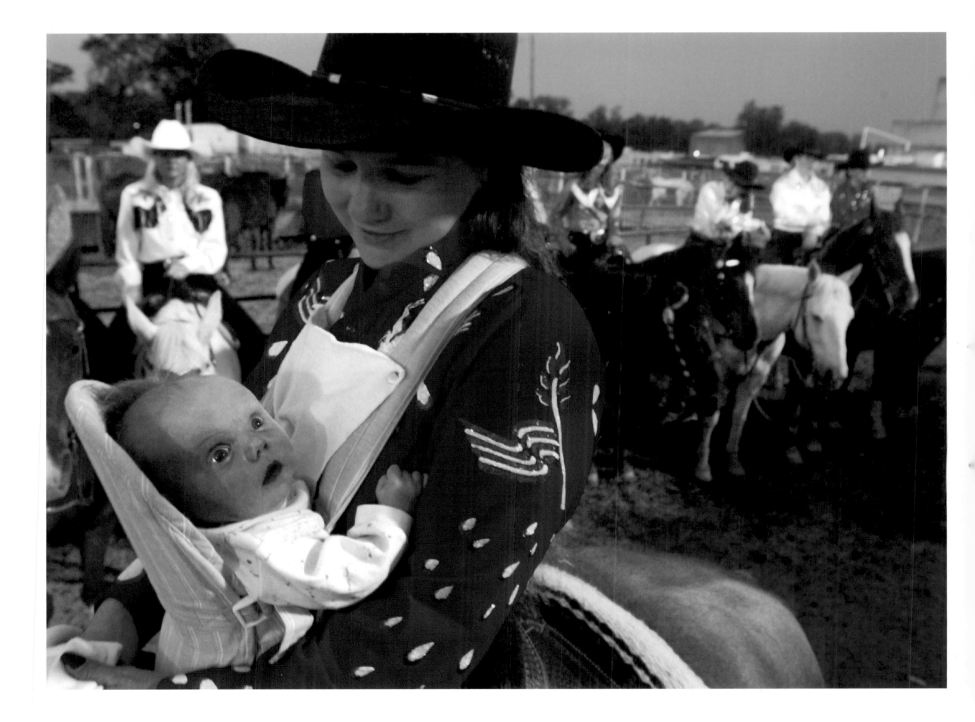

REDDING

At the Redding Rodeo 2003, 5-week-old Shelby Dunning rides tandem with mom Kimberly Gardner. Gardner is part of the sponsor flag team—50 horsewomen who carry banners while galloping around the ring. Shelby is along for the warm-up, done at a walk. "I rode horses through my eighth month with her," says Gardner. "She doesn't know any different."
Photo by Jim Merithew

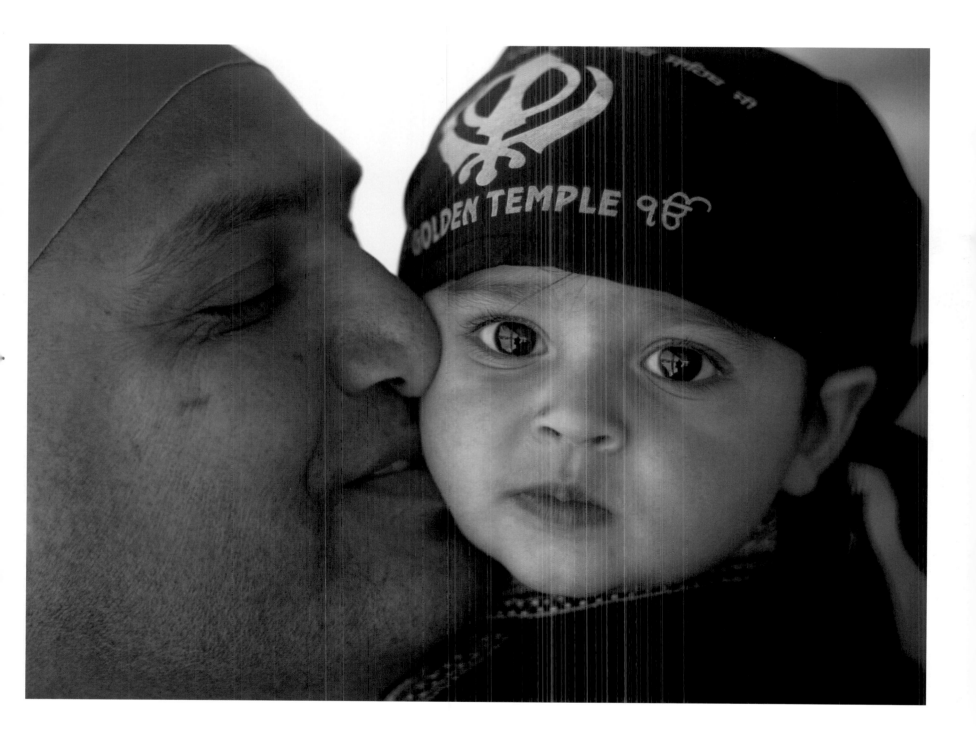

SAN JOSE

Satvinder Singh Cheema nuzzles his son before entering the San Jose Sikh Temple, or *gurdwara*. Silicon Valley's 8,000-strong Sikh community is building one of the largest *gurawaras* in America, a 94,000-square-foot complex that will cost $20 million.

Photo by Patrick Tehan

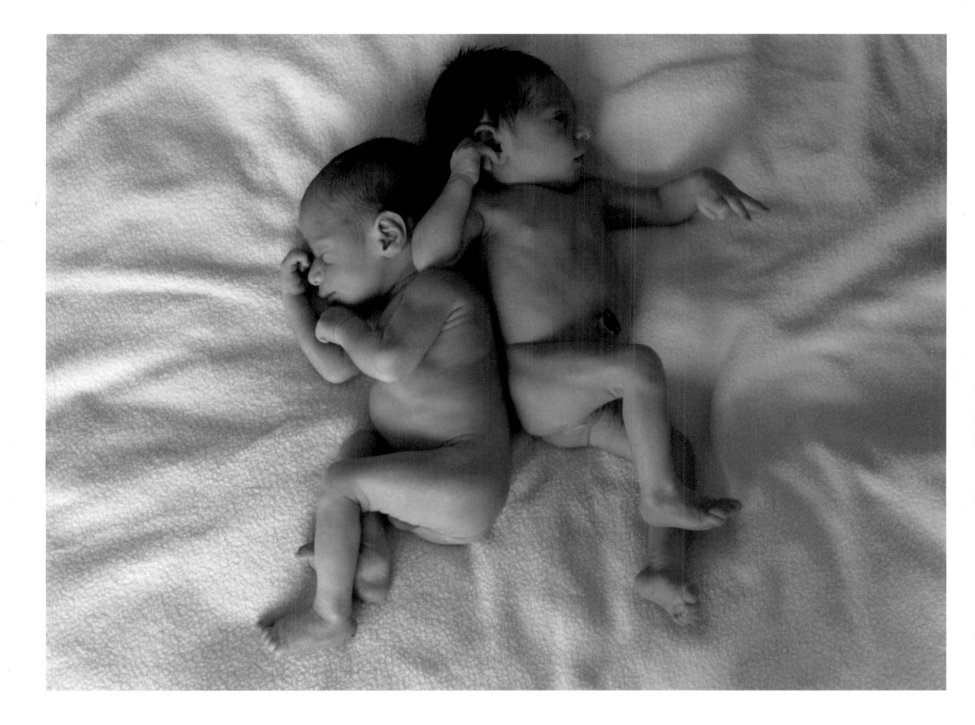

LOS ANGELES
Five days old, twins Nicholas and Sophia Cohen
remain close.
Photo by Shlomit Levy Bard

BERKELEY

On a warm day, Tyler Riverbay and his pa
Madeline Turner, both 2, decorate themselves
with "gah-toos," as Tyler calls them.
Photo by Helen Bae

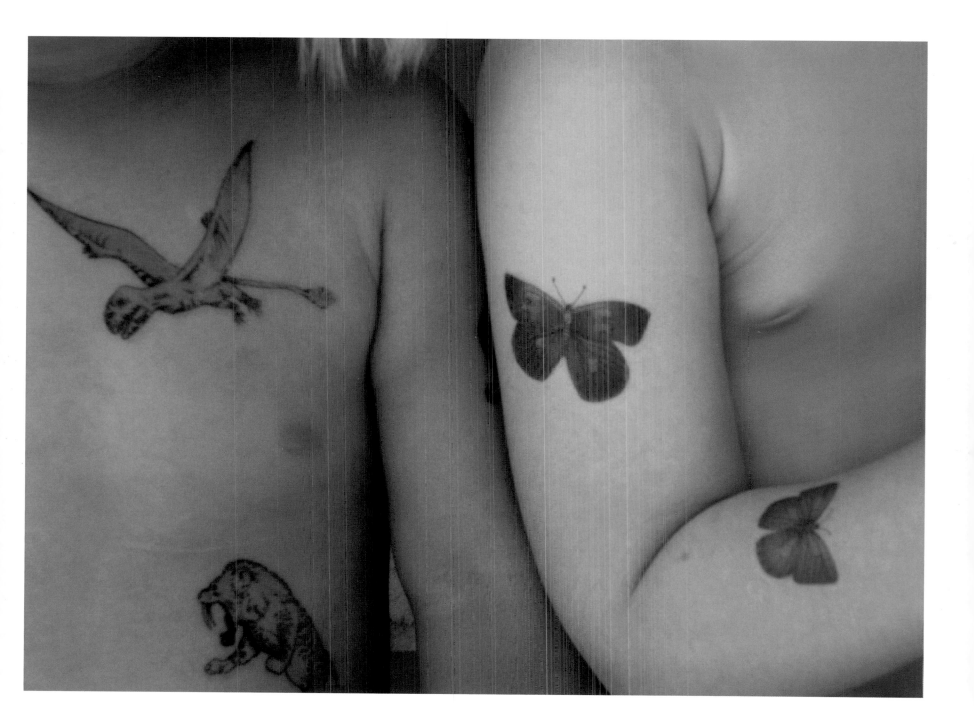

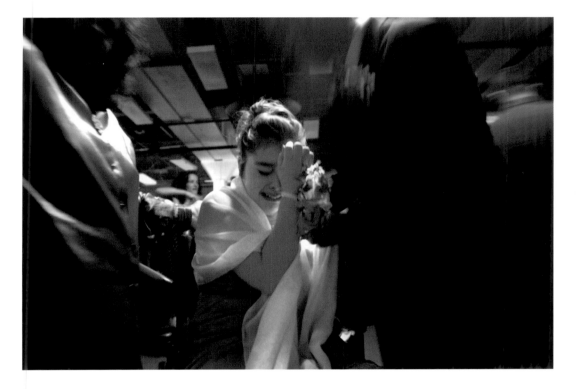

LONG BEACH

Angelina Lopez, 17, may not look happy, but in fact she's overwhelmed by the kindness of others. Hospitalized many times battling multiple sclerosis, Angie dreamed of attending her prom. Carol Walker and Dr. Warren Chin, members of her medical team, suprised her with a dress, makeover, and limousine, and accompanied Angie to the Lakewood High School prom, held on the *Queen Mary.*
Photos by Stephen Carr

LONG BEACH
Bringing good wishes, Dr. Chin delivers a present to Argie while she has her hair done by stylist Monica Ruffo.

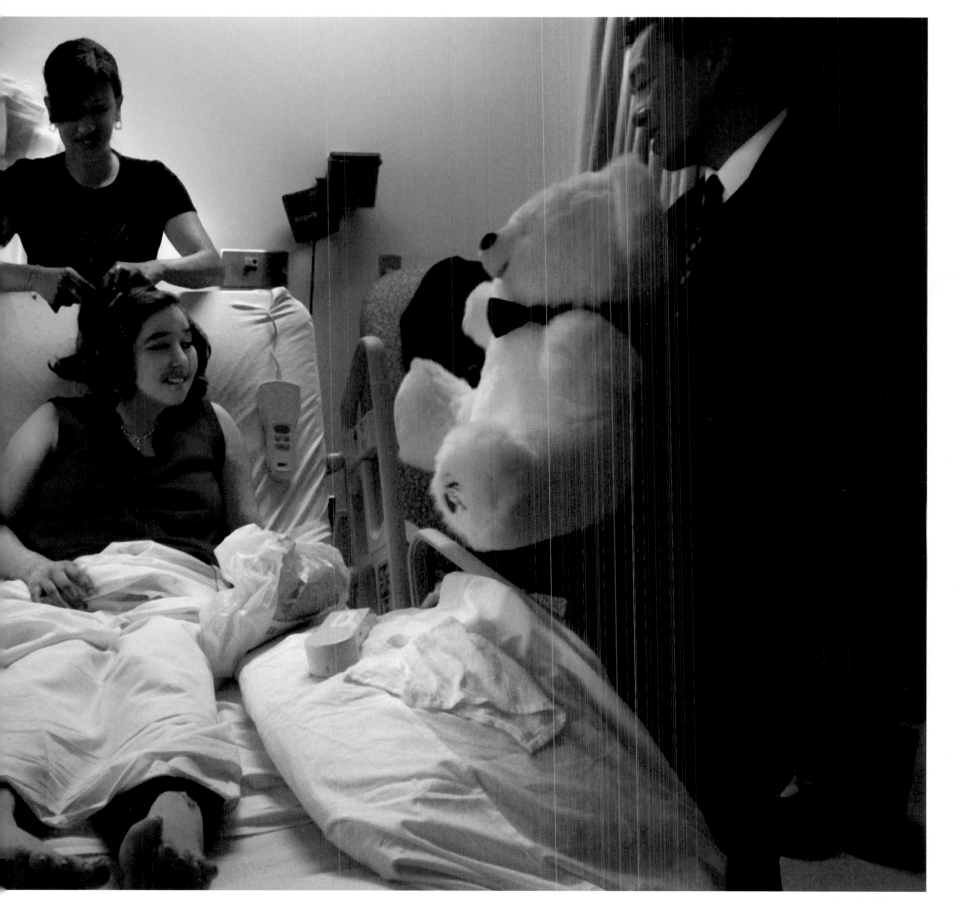

SAN FRANCISCO

Roommates for five years, Alex Holod and Nicole Kahl knew they were going their separate ways—Alex to grad school across the Bay in Berkeley, Nicole home to Sacramento—so they made a big deal of Alex's 30th birthday.
Photo by Sheila Masson

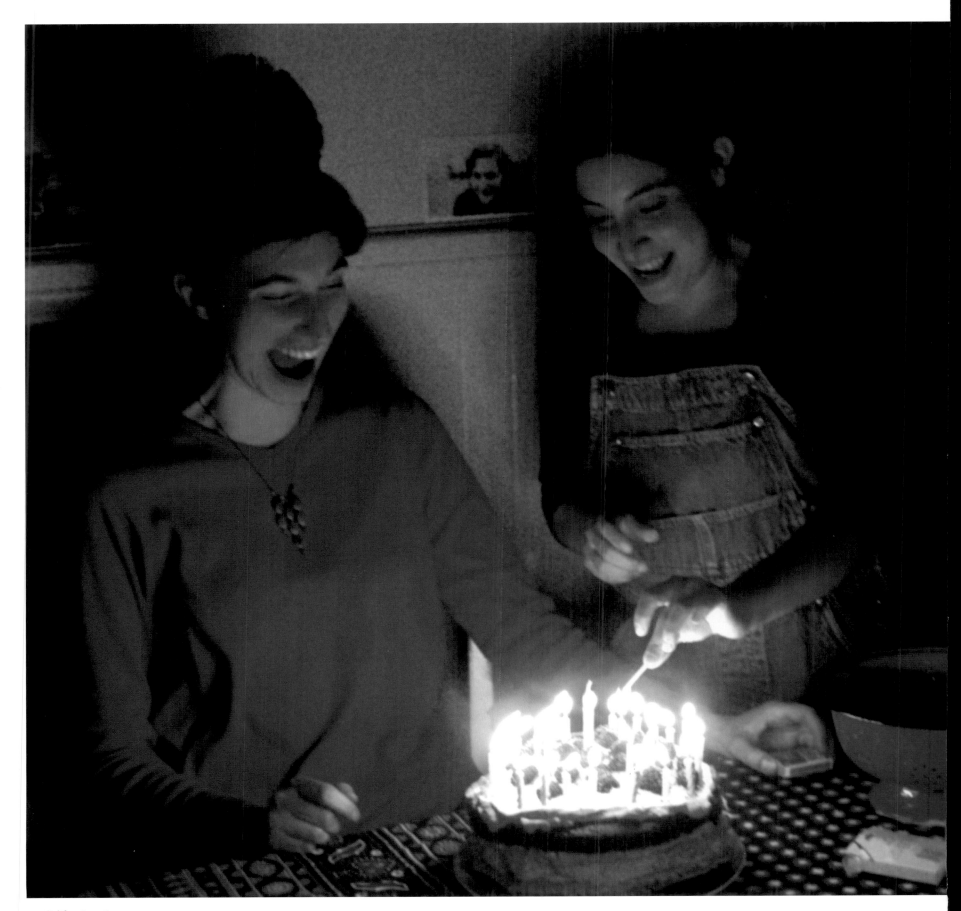

LIKELY

Chow time at the Flournoy ranch cookhouse is a 133-year-old tradition. Cattleman John Flournoy settled in the South Fork Valley in the northeast corner of the state in 1871, and his offspring have been ranching here ever since. The Flournoy brothers, their relatives, and employees debrief over a ranch-fresh lunch of roast beef, potatoes, and biscuits.

Photo by Kim Komenich

ORANGE

Baby shower bingo is one way to get through the gifts brought by 25 friends and family members for Elli Vin (left, in blue shirt), who is expecting her first child. After filling in the squares with typical presents that an expectant mom might receive, the guests mark off each gift Vin opens. The first to "bingo" gets a prize.

Photo by Tony Nguyen-Campobello

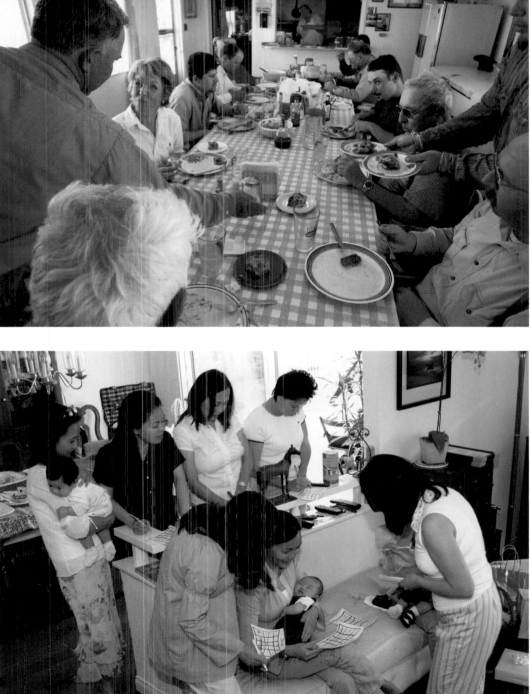

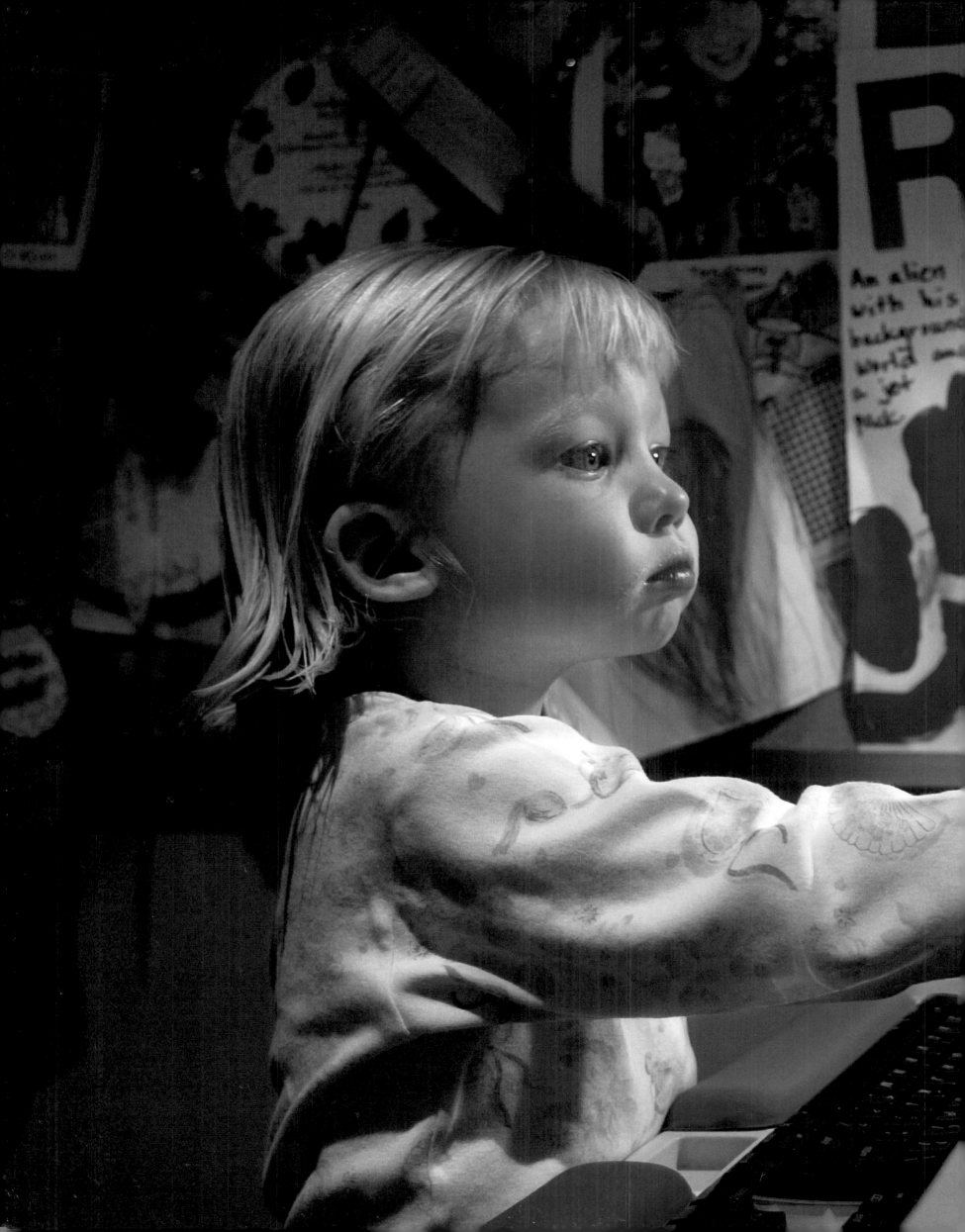

SHERMAN OAKS
Mastering the mouse, 2-year-old Shea
Sprague learns about color from her Disney
friends.
Photo by David Sprague,
Daily News, Los Angeles

The year 2003 marked a turning point in the history of photography: it was the first year that digital cameras outsold film cameras. To celebrate this unprecedented sea change, the *America 24/7* project invited amateur photographers—along with students and professionals—to shoot and, via the Internet, submit digital images. Think of it as audience participation. Their visions of community are interspersed with the professional frames throughout this book. On the following four pages, however, we present a gallery produced exclusively by amateur photographers.

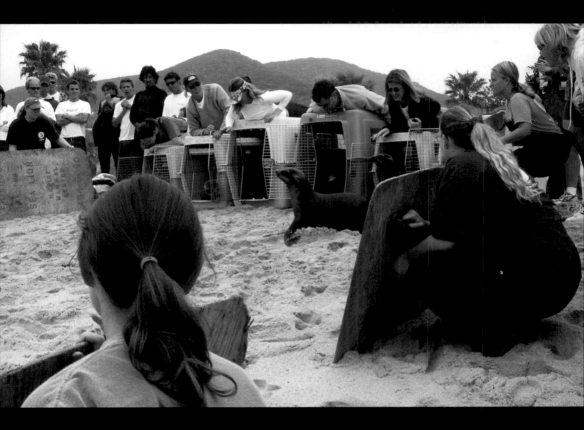

LAGUNA BEACH The Sea Lion Marine Mammal Center releases five rescued pups back to the ocean. They were brought in malnourished and found to have respiratory infections. *Photo by Ron McDevitt*

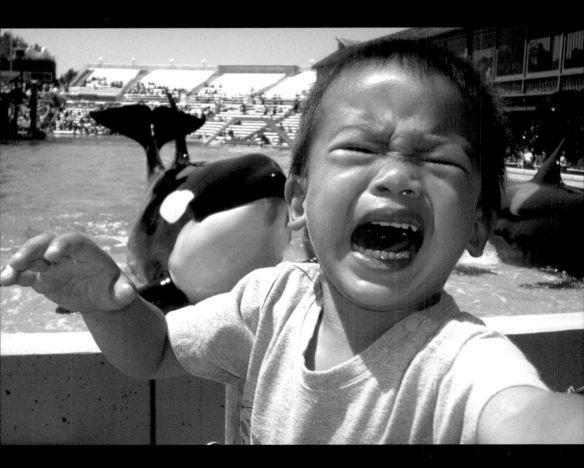

SAN DIEGO SeaWorld's Shamu, the killer whale, doesn't quite win over Dylan Michael Tabirara.
Photo by Vernon Tabirara

MILL VALLEY Charming Lytton Square is a gathering place for book readers, coffee sippers, hackysackers, chess players—and those just riding through. *Photo by David Simoni*

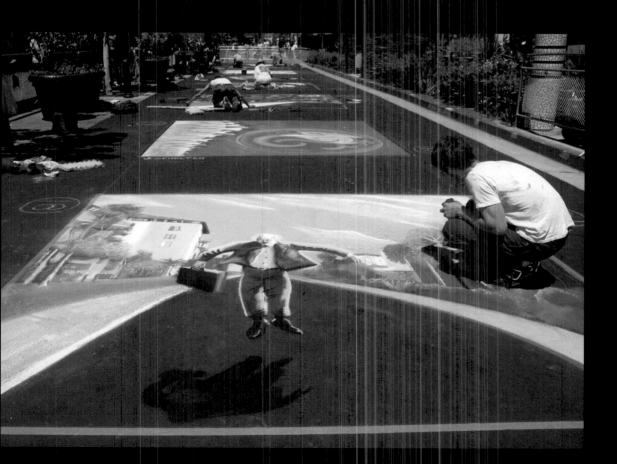

SAN JOSE Chalk artists illuminate the sidewalks of swanky Santana Row with their masterpieces.
Photo by David Hodge

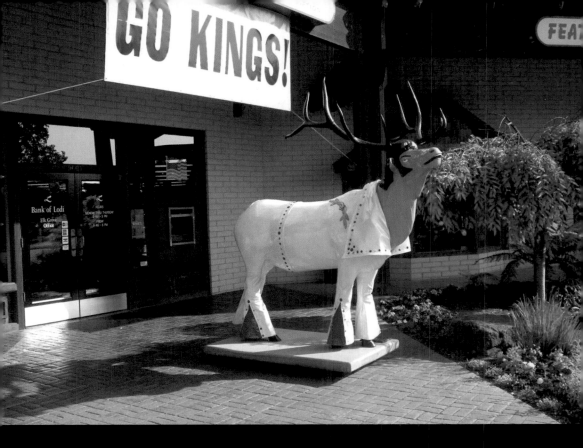

ELK GROVE This antlered homage to Elvis and the Sacramento Kings basketball team sits in front of a bank that commissioned *Elkvis* as part of Elk on Parade, a citywide fundraising art project. ***Photo by Chris Trim***

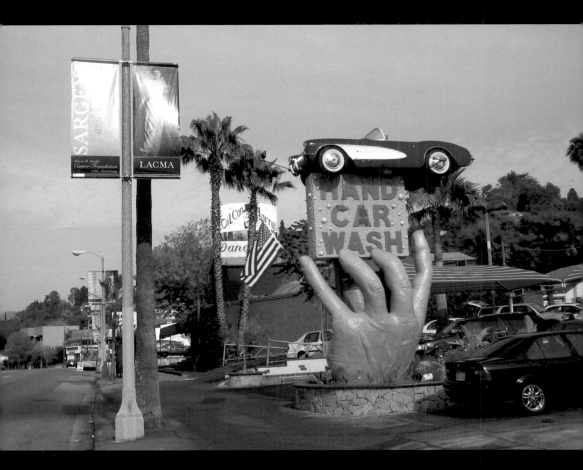

STUDIO CITY The Hand Car Wash on Ventura Blvd., owned by Ben Forat, gives free suds treatments to electric and hybrid cars. Just doing its part to reduce smog in the L.A. basin. ***Photo by Jim McCullaugh***

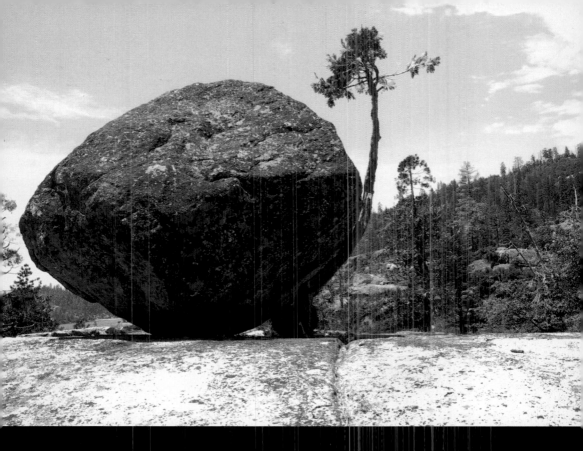

PINECREST A hefty boulder on the shore of Pinecrest Lake is not about to budge for a scrappy pine sapling.
Photo by Thorin Brentman

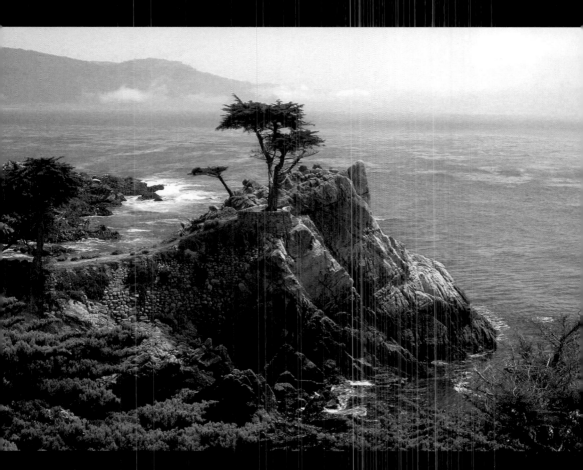

PEBBLE BEACH Along 17-Mile Drive, this solitary cypress at the edge of the continent has found enough suste-
nance in the rock to maintain its fierce hold for 250 years. *Photo by Brent Reeves*

POINT ARGUELLO OIL FIELD
Chris Harmon and Richard Filburn struggle
to attach an elevator clamp to an oil pipe
casing on Platform Hidalgo, six miles off the
central California coast. Run by Arguello, Inc.,
the platform's wells pump up sour gas (gas
with traces of toxic compounds such as hy-
drogen sulfide) and crude oil from 430 feet
below the ocean's surface.
Photo by Brian Wytcherley,
Brooks Institute Of Photography

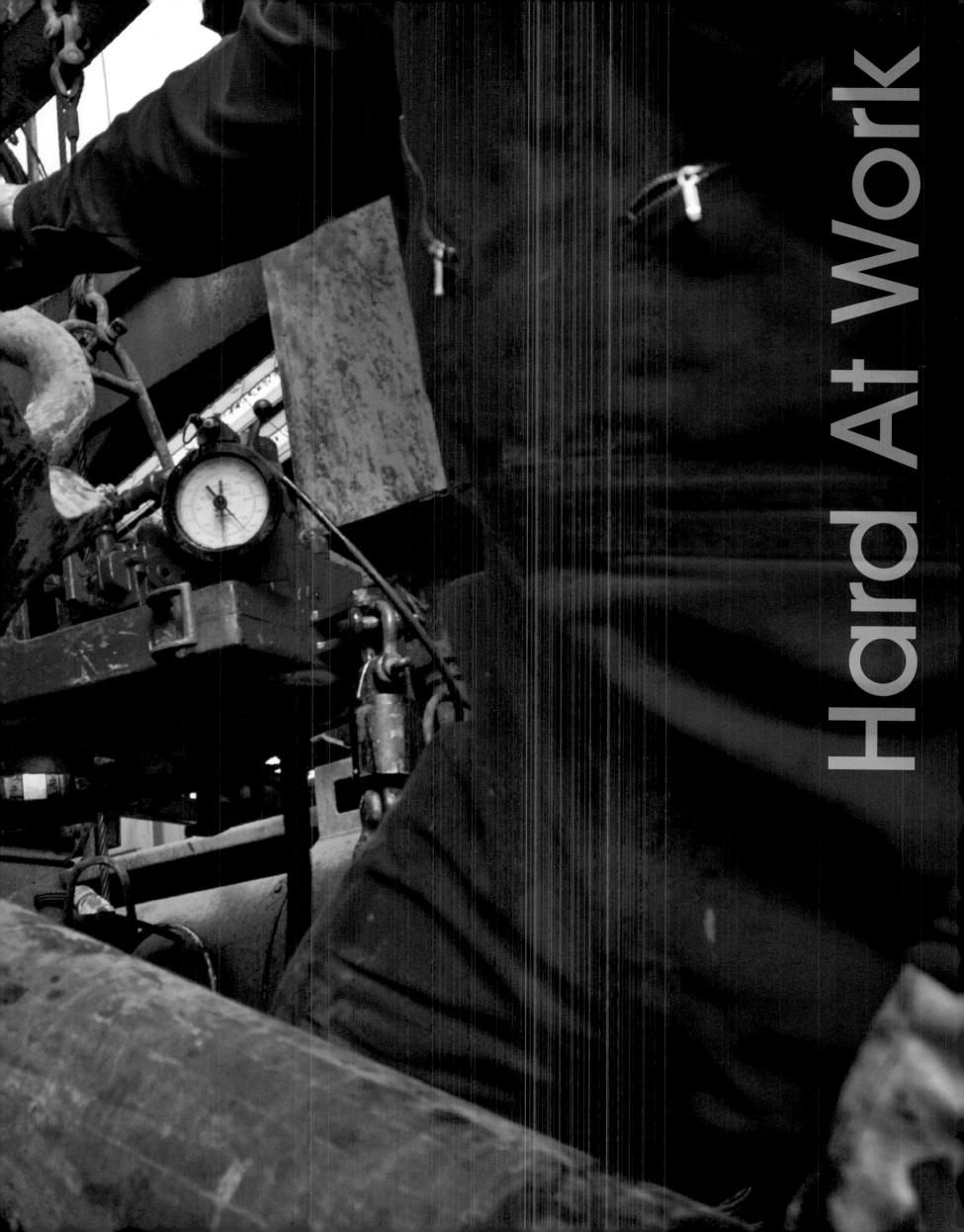

Hard At Work

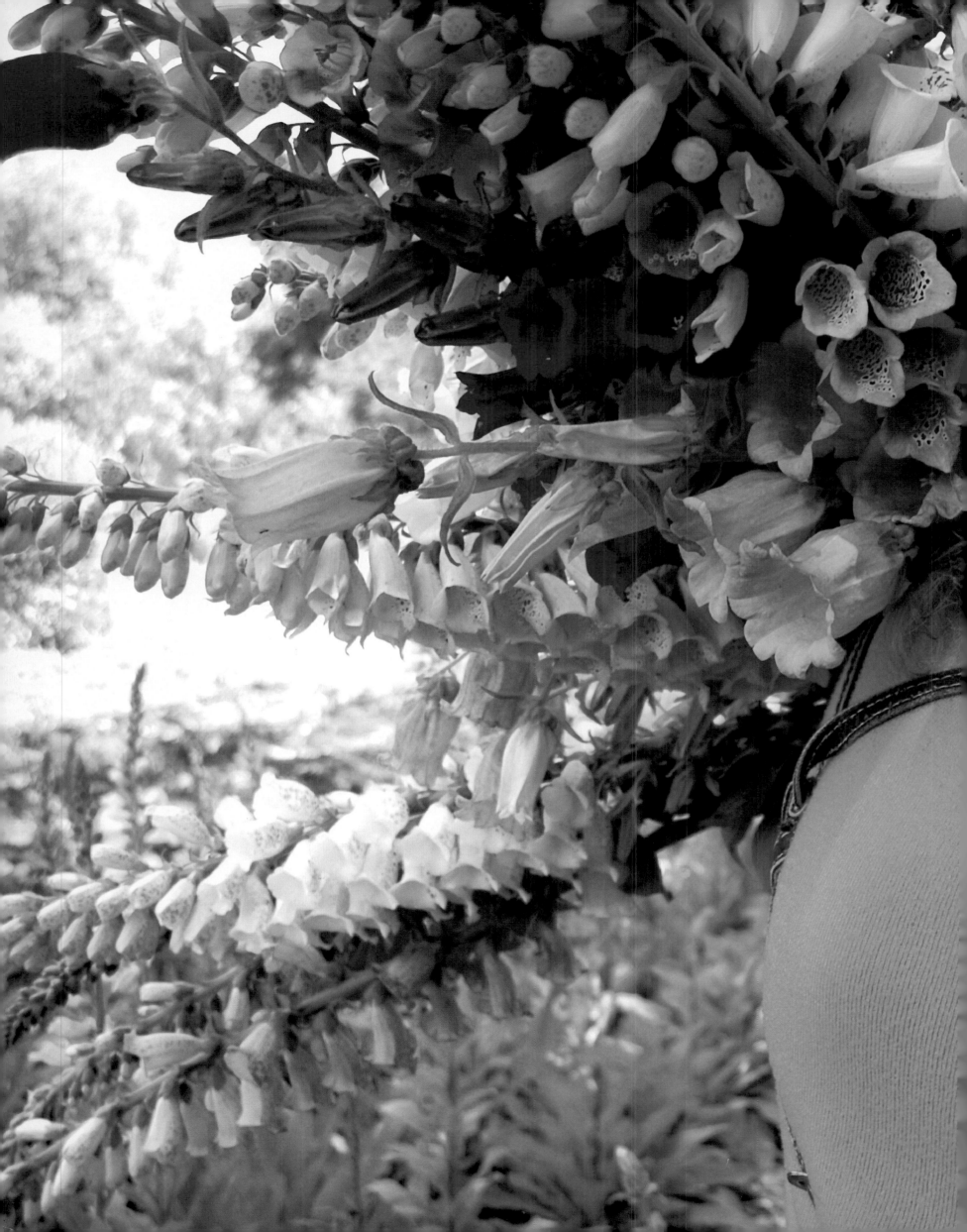

WATSONVILLE
Kathleen Seaver, 51, raises organic specialty flowers such as these foxglove-excelsior hybrids on her 5-acre Cadillac Mountain Farms. Twenty years ago, Seaver nearly died after gastrointestinal surgery. She prayed to live, promising, "no matter what," to grow flowers as thanks. Despite her husband's passing and the financial hardships of the business, she has stuck to her promise.
Photo by Sisse Brimberg

HOLLISTER

Night falls as Jesus Onesto Garrido, Israel Garcia
Resendiz, and Ricardo Aguas begin a 10-hour
shift harvesting and packing Lolla Rossa, a spe-
cialty red baby lettuce. Picking through the night
ensures that each leaf will retain as much mois-
ture as possible. By sunrise, the harvest will be
shipped by Pride of San Juan Gourmet Produce to
grocery stores nationwide.
Photo by Anna Marie Dos Remedios, The Pinnacle

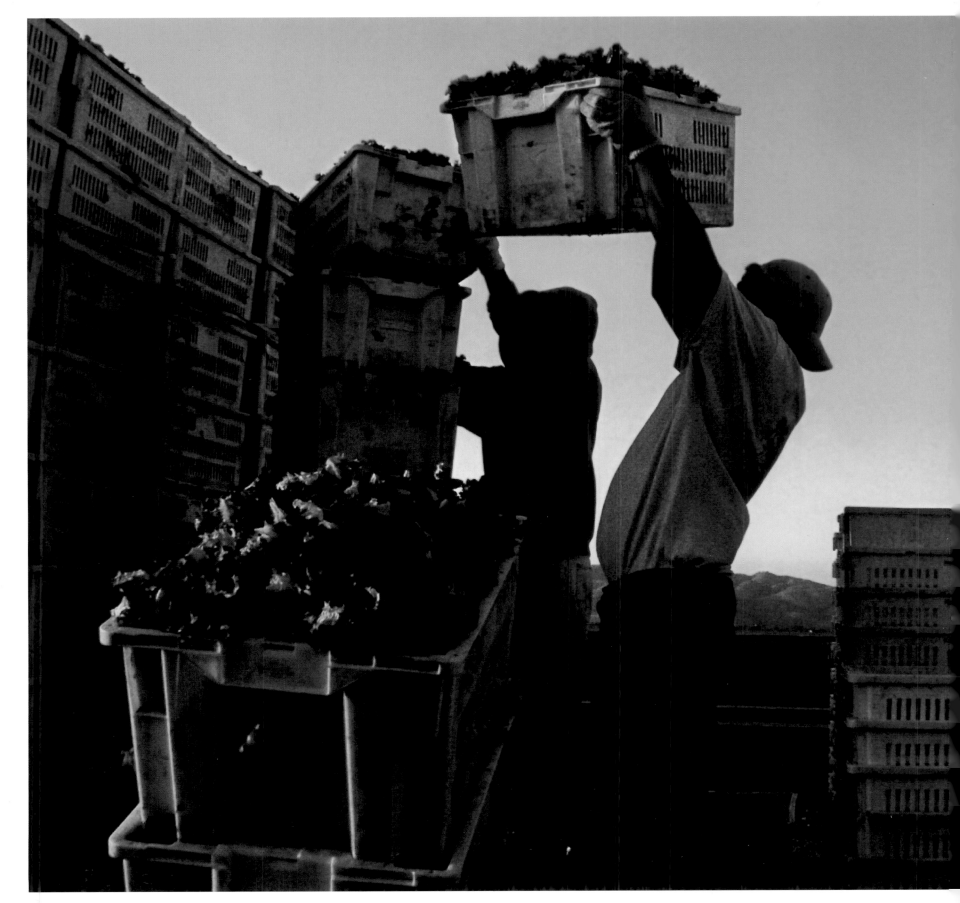

SAN JUAN BAUTISTA

Americans' taste for the convenience of bagged salad has created a boom in lettuce production in the San Juan Valley. Last year, per capita lettuce consumption hit an all-time high, a trend that has growers like T&A Farms hustling to keep up with demand. This farm grows arugula for Earthbound Farm's mixed baby greens.

Photo by Anna Marie Dos Remedios, The Pinnacle

BRAWLEY

Eddie Estrada, 19, clips onions at the 3,000-acre Lawrence Cox Ranch in the Imperial Valley. The onions are then left on the ground for several days to dry. Like many of his coworkers, Estrada works with his parents. Sometimes three generations of a family labor in the fields together.

Photo by Peggy Peattie,
The San Diego Union-Tribune

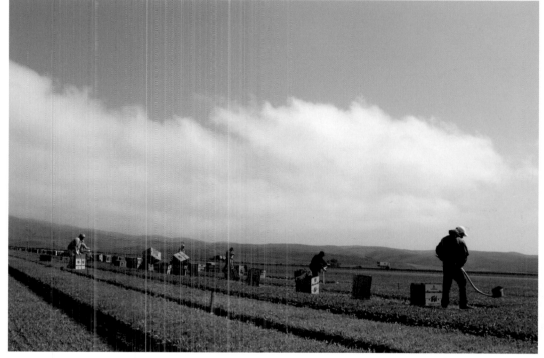

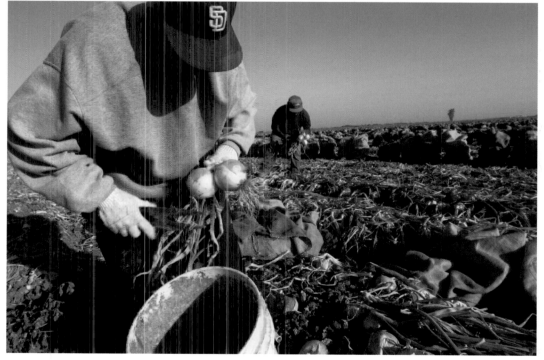

High-tech Silicon Valley is just 60 miles away from Don Douglas's horse ranch in the Panoche Valley. Hidden between the Gabilan and Diablo Mountain ranges, the valley is a rare piece of California cowboy country that has persisted in spite of explosive development in nearby communities. Douglas operates a ranch where he trains cow horses and grows Zinfandel grapes.
Photo by Anna Marie Dos Remedios, The Pinnacle

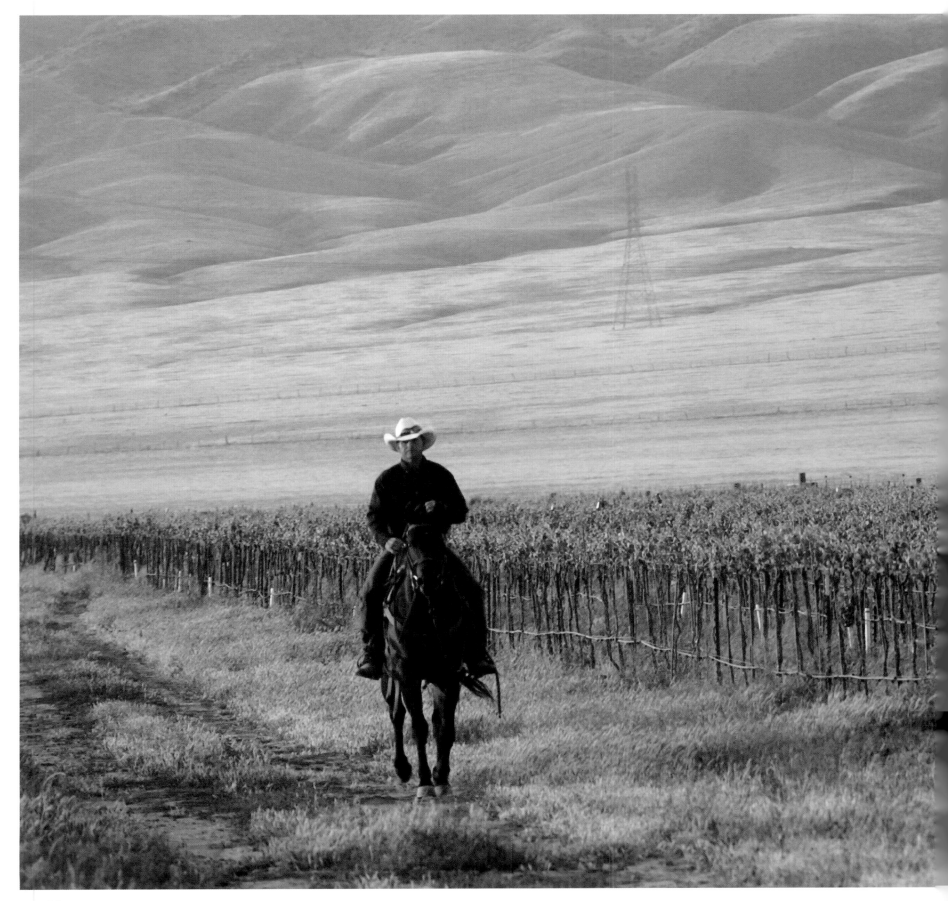

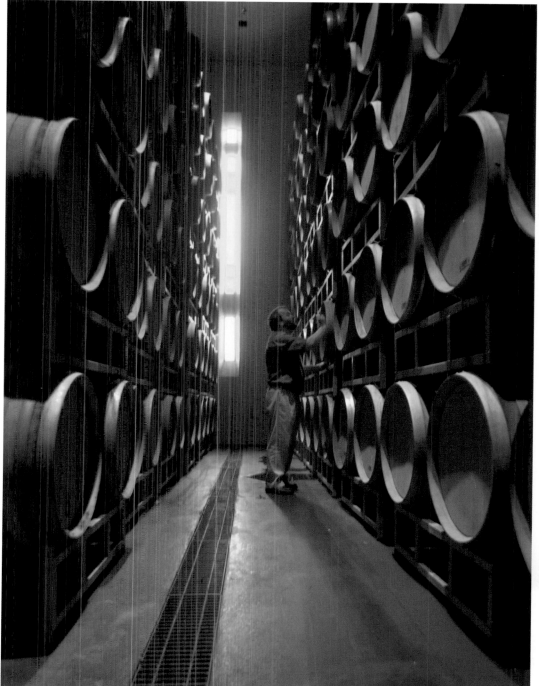

CALISTOGA

In the aging cellar of Sterling Vineyards, Jim O'Shea checks on the progress of chardonnay barrel fermentation. The Napa Valley is known as America's viticultural center. Its climate and soil rival those of the grape-growing regions in Italy and France, producing world-class merlots, cabernets, and sauvignon blancs.

Photo by Charles O'Rear

SAN JOSE
Captain Susan Jessup, Daniel Hyland, and
Matthew Pasquin are industrial firefighters
employed by United Technologies. They're
responsible for the aerospace company's
5,200-acre complex in the hills south of
San Jose.
Photo by Ed Bystrom

FIDDLETOWN

People who know Ron Scofield believe he was born 100 years too late. In 1976, he and wife Marie sold everything, including their beloved Red Mule Ranch, and traveled cross-country by covered wagon to celebrate the bicentennial. After buying back the ranch, Ron returned to building wagons and began hosting Cowboy Campfires, summertime programs of Old West entertainment.
Photo by Carolyn Fox

PETALUMA

At Della Fattoria, T m Kitzman and head baker Aaron Weber put the finish on bread loaves before slipping them into wood-fired brick ovens. The Weber family opened the bakery in 1995. They bake between 400 and 1,000 loaves each day, supplying local markets and renowned restaurants like The French Laundry in Napa Valley.
Photo by Robert Holmes

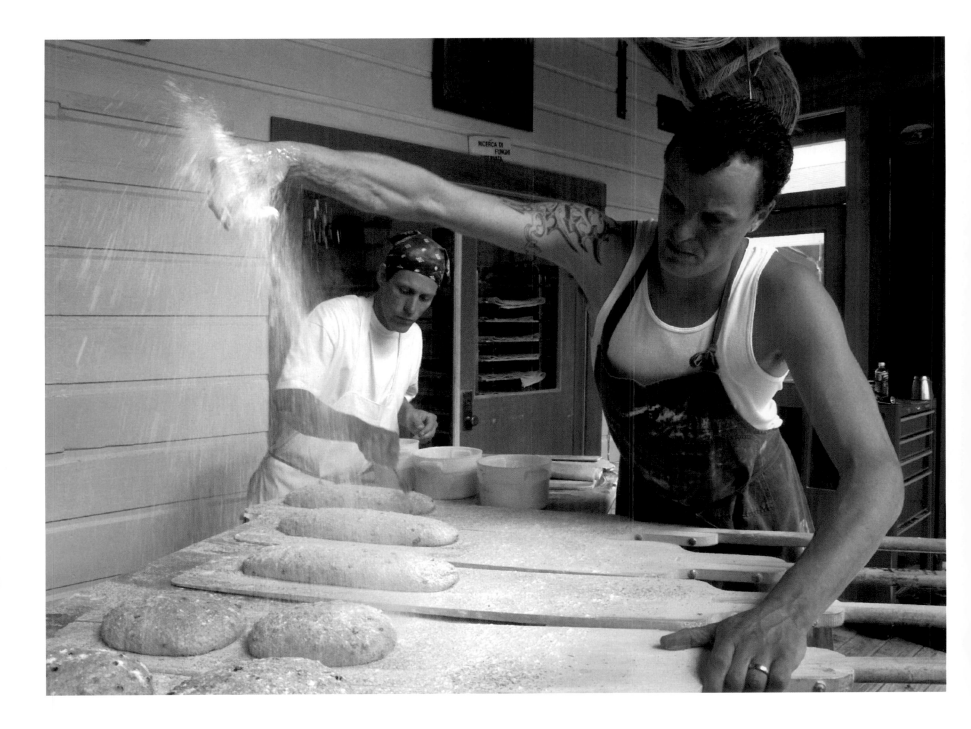

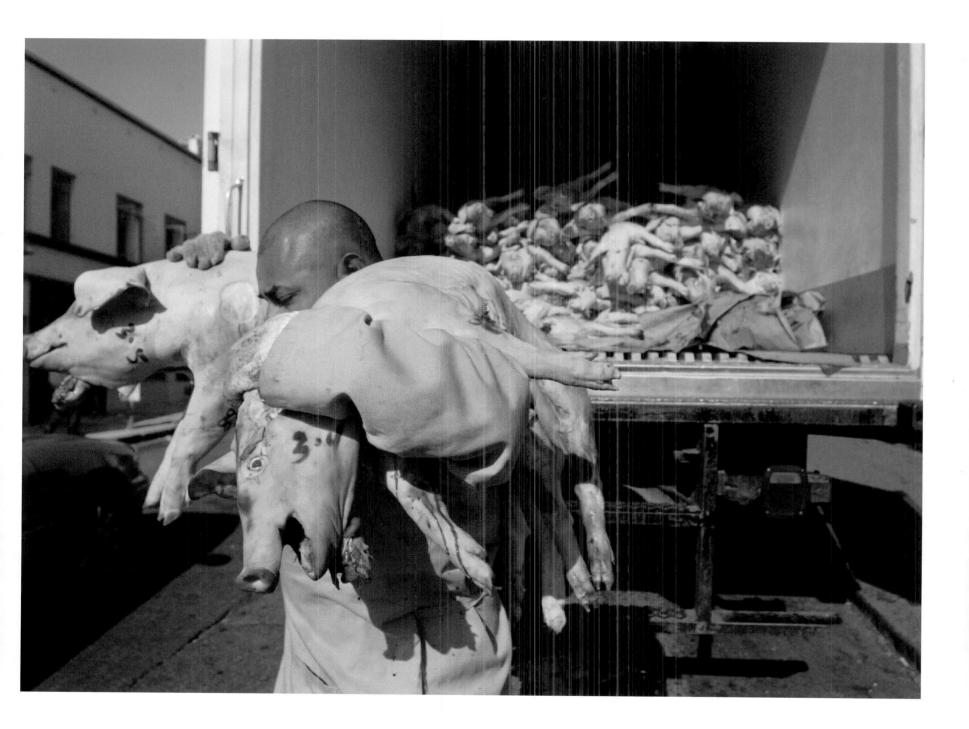

SAN FRANCISCO

A deliveryman drops off the raw material for mushu pork at butcher shops and markets along Stockton Street in Chinatown. Locals come to the area seeking out inexpensive or exotic foodstuffs, from bananas and kumquats to live chickens and turtles.

Photo by Jim Merithew

LIKELY
Calves are branded, vaccinated, neutered, and earmarked two months after they are born at the Likely Land and Livestock Company ranch. The company grazes 1,500 head of cattle on its grassy acreage in Modoc County. Rancher John Flournoy says his hay is what makes his ranch exceptional: "Cattle are convenient leather packages that market our grass to the consumer."
Photo by Kim Komenich

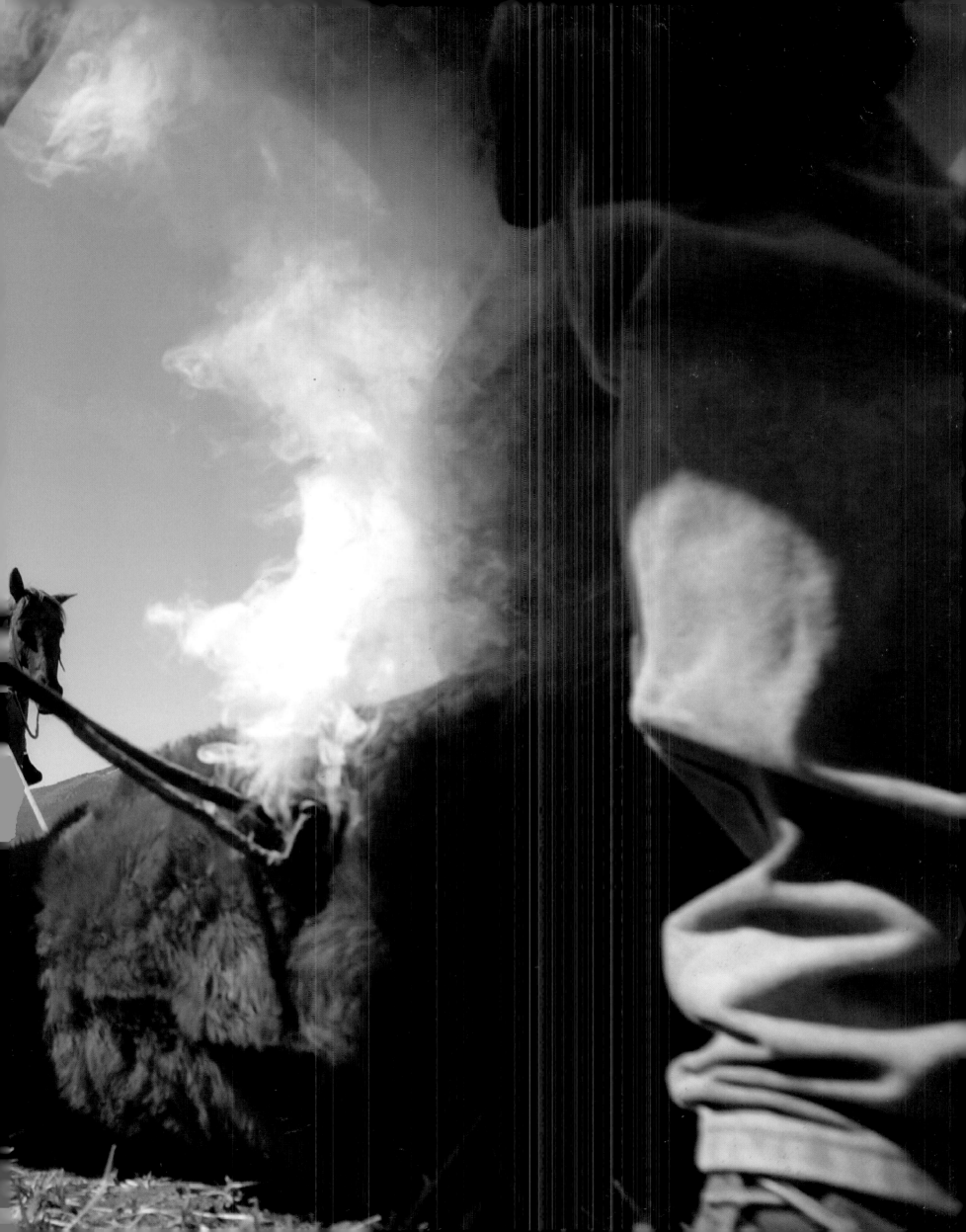

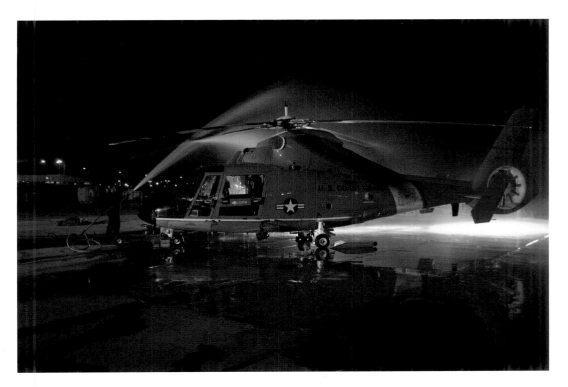

SAN FRANCISCO

At San Francisco International Airport's U.S. Coast Guard Air Station, Angie Kirkhart washes down an HH-65B Dolphin after a patrol. The crew of two pilots, a flight mechanic, and a rescue swimmer makes the rounds over San Francisco Bay and the Pacific coast for two hours at a stretch supporting Coast Guard fleets.

Photo by John B. Adrain

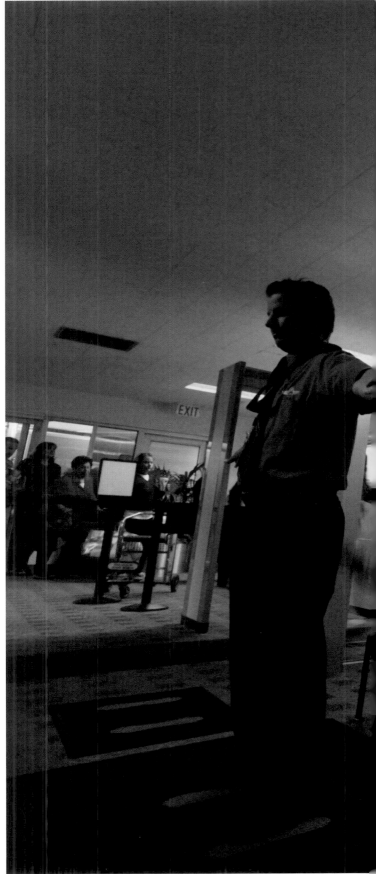

LONG BEACH

Although she is a JetBlue customer service agent, Sally Witt must go through the same security procedures as passengers. Many travelers find the checks slow and frustrating, which s why the Transportation Security Administration s stated objective is to get 95 percent of passengers through security screening in 10 minutes or less.
Photo by PF Bentley, PFPIX.com

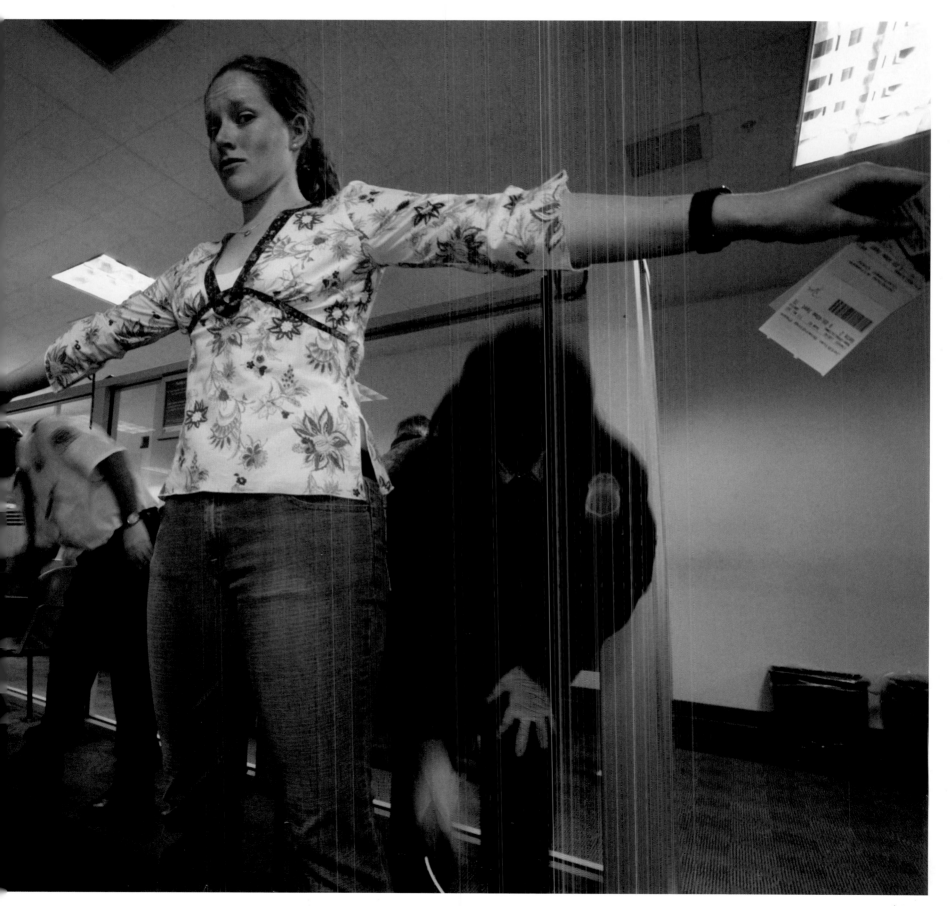

LONG BEACH

The ground crew at JetBlue in Long Beach, the airline's western hub, is nonunion, as are all JetBlue employees. The airline, begun in 2000 by entrepreneur David Neeleman, keeps costs down in other ways as well; the reservation center is in Salt Lake City, but the 700 people who answer the phones work from home.

Photos by PF Bentley, PFPIX.com

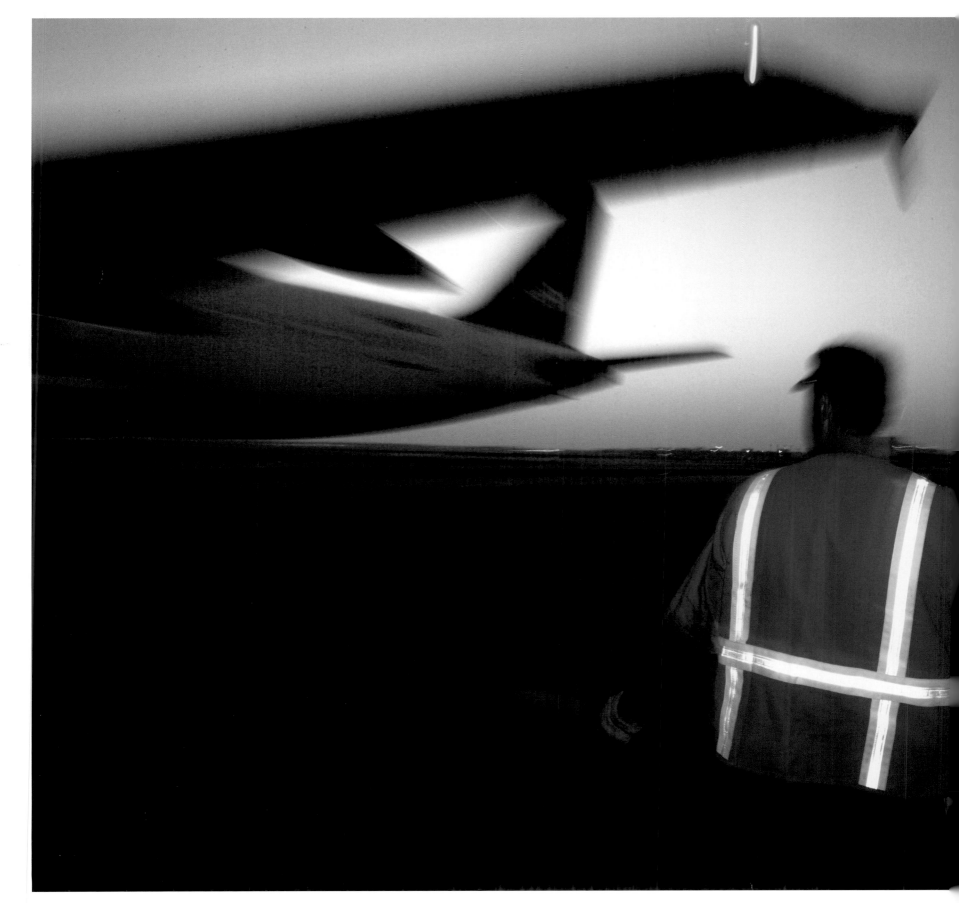

AIRBORNE, LONG BEACH TO OAKLAND

Flight attendant Gina Moore serves no meals but offers drinks and snacks. Under another budget-conscious company policy, the pilots help pick up cabin trash after a flight.

LONG BEACH

JetBlue baggage handler Glen Frank and his colleagues say they load about 8,800 pieces of luggage a day. Frank started with JetBlue in New York and even remembers founder Neeleman helping to snowplow the tarmac.

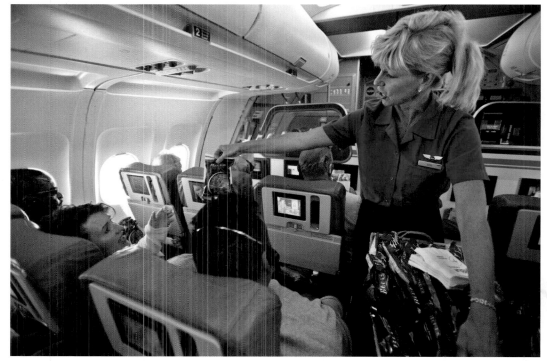

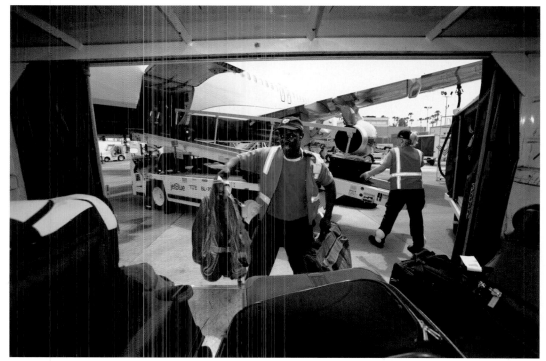

SANTA CRUZ

Chris Gonzales, who prints vinyl stickers for Bro Prints, pushes an uncut batch from the printer over to the cutting department. "I like having the resources to play around with my own ideas," says Gonzales, who also sketches stickers. The company, which started with skateboard logos, now employs nine people and runs three presses to silk-screen T-shirts and stickers.

Photo by Shmuel Thaler, Santa Cruz Sentinel

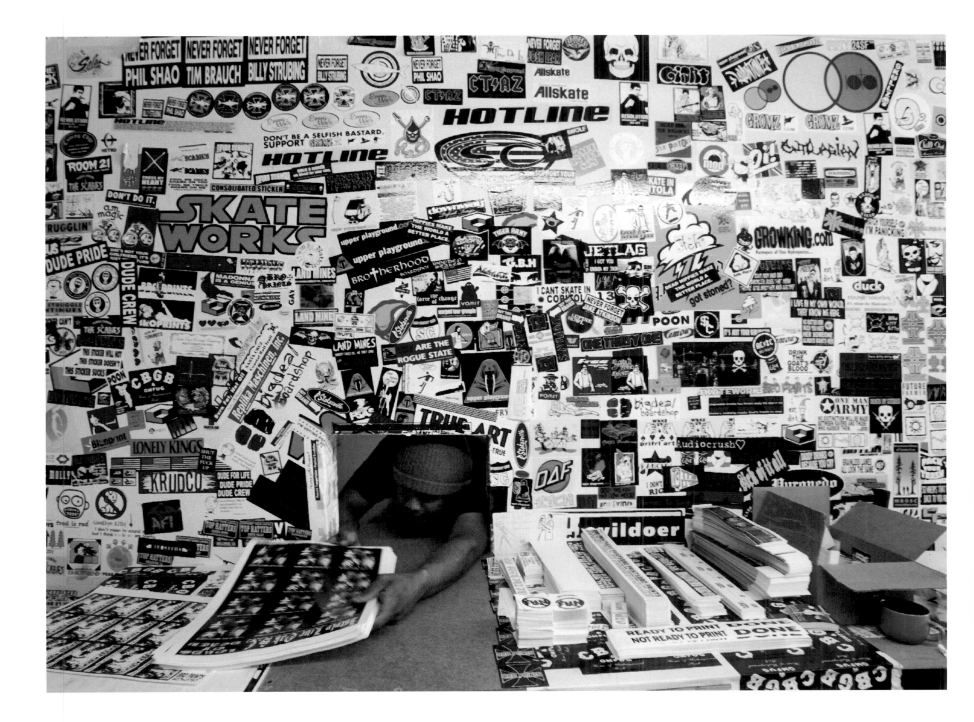

JACKSON

John Johannsen, 75, began painting in 1952 after receiving a set of paints for his birthday. He describes his art as "colorfully naïve" and says his inspiration comes from trips to Mexico where he frequented markets filled with vibrant colors. While Johannsen works mostly with acrylics on canvas, he has never met a surface that is safe from his paintbrush.

Photo by Carolyn Fox

BAKERSFIELD
Something to chew on: Jose Villatoro and Geraldo Rios empty a pot of hot caramel onto a cooling slab at Dewar's Candy and Ice Cream. The viscous mix will later be pulled into 2-inch chews, the signature candy invented by the company's founder in 1909.
Photo by Lexey Swall, Naples Daily News

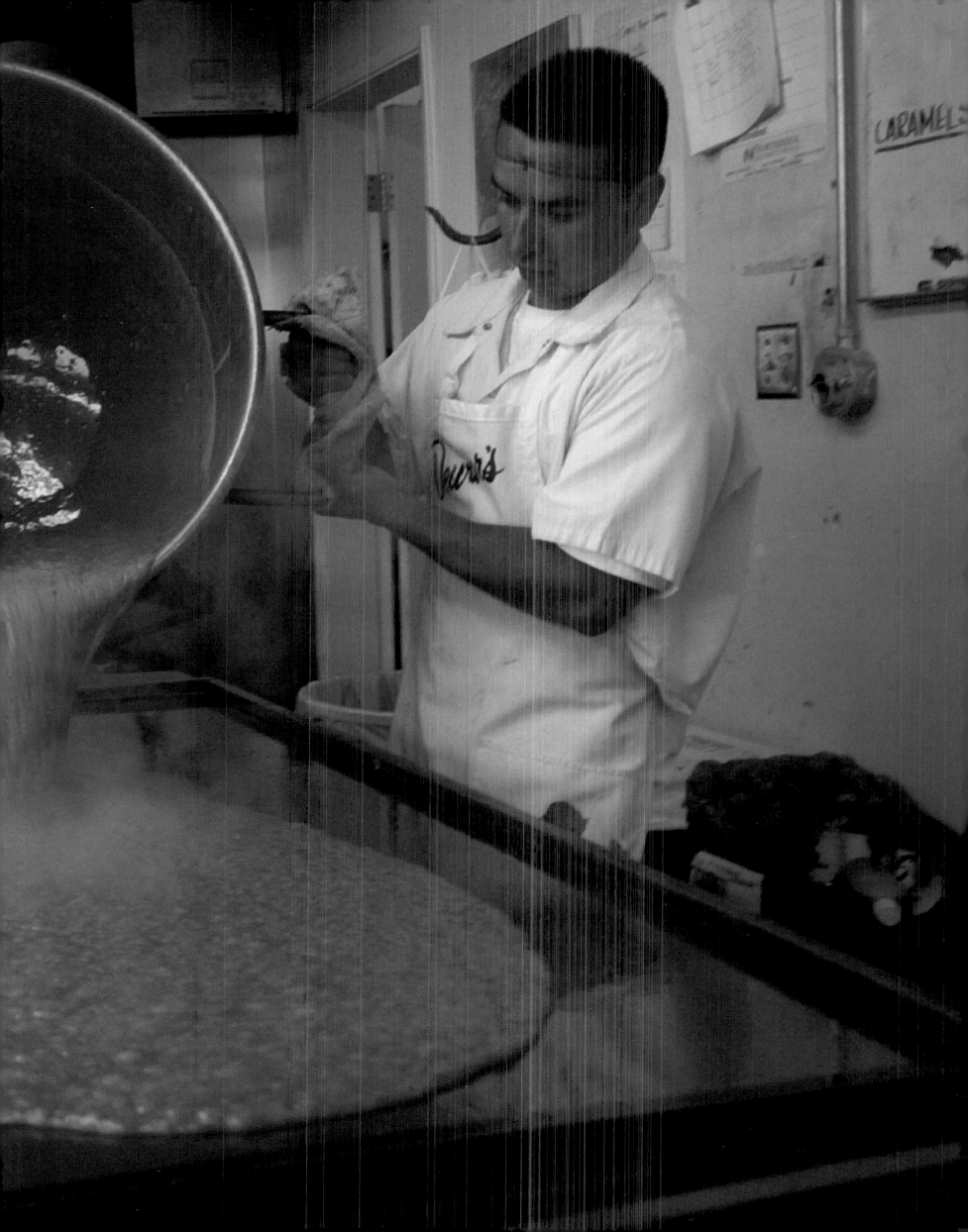

SANTA MONICA

At an ESPN commercial audition, actor and rapper Terrell "Fatso-Fasano" Ramsey (in hat) plays "let's pretend" for the camera. The commercial's premise: Three guys sit in a canoe outside a ballpark listening to a game on the radio, when a homerun ball lands next to them in the water. Ramsey and his fellow actors get one take to give it their all.

Photo by Laura Kleinhenz

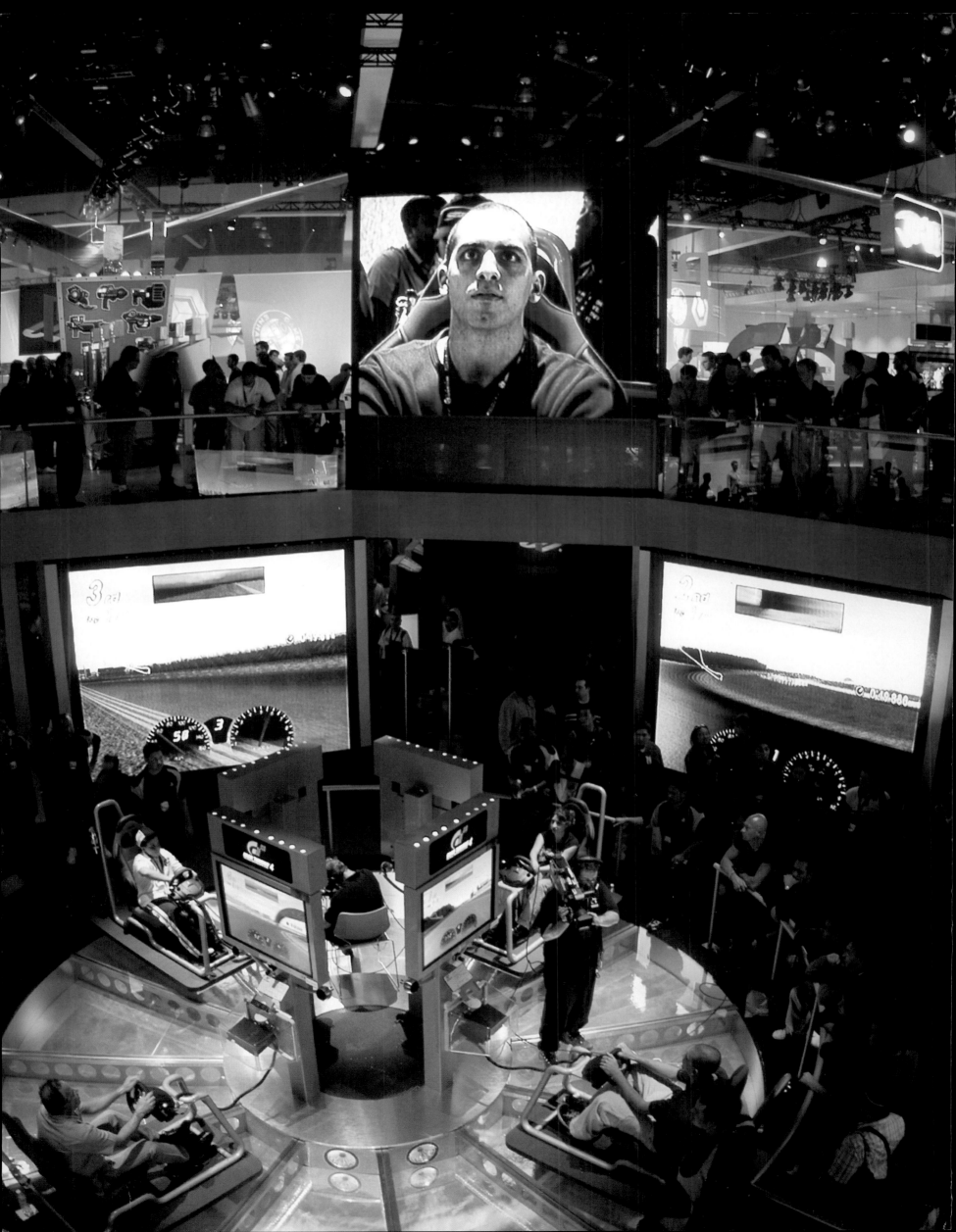

LOS ANGELES

At the Electronic Entertainment Expo held at the Los Angeles Convention Center, professionals in the interactive gaming industry give new products a spin.

Photo by Roger Ressmeyer, Visions of Tomorrow

MOUNTAIN VIEW

Comic book art, beanbag chairs, and jeans are the norm at Google's Silicon Valley headquarters. The interior design adheres to the informal office style pioneered during the dot-com boom years.

Photo by Patrick Tehan

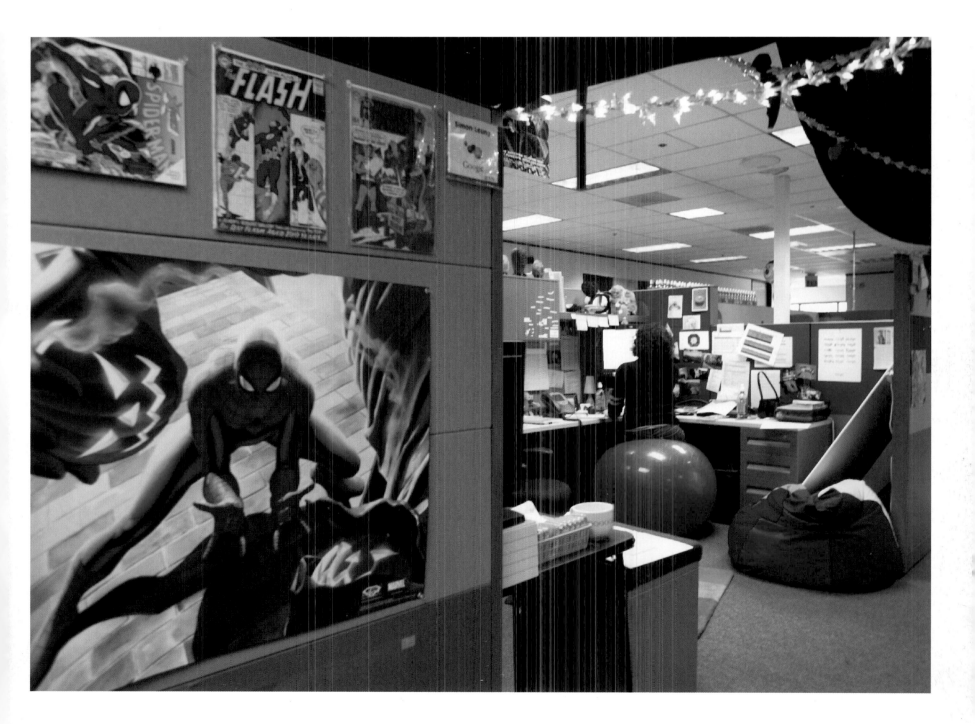

SUTTER CREEK

C'est bone: Chiropractor Terry Holland and his wife Heather, a reading specialist, have been together for 25 years. The parents of two, they are committed to community service—he's a Scout Master and both make the trip to San Francisco about once a month to volunteer at Glide Memorial Church.

Photo by Carolyn Fox

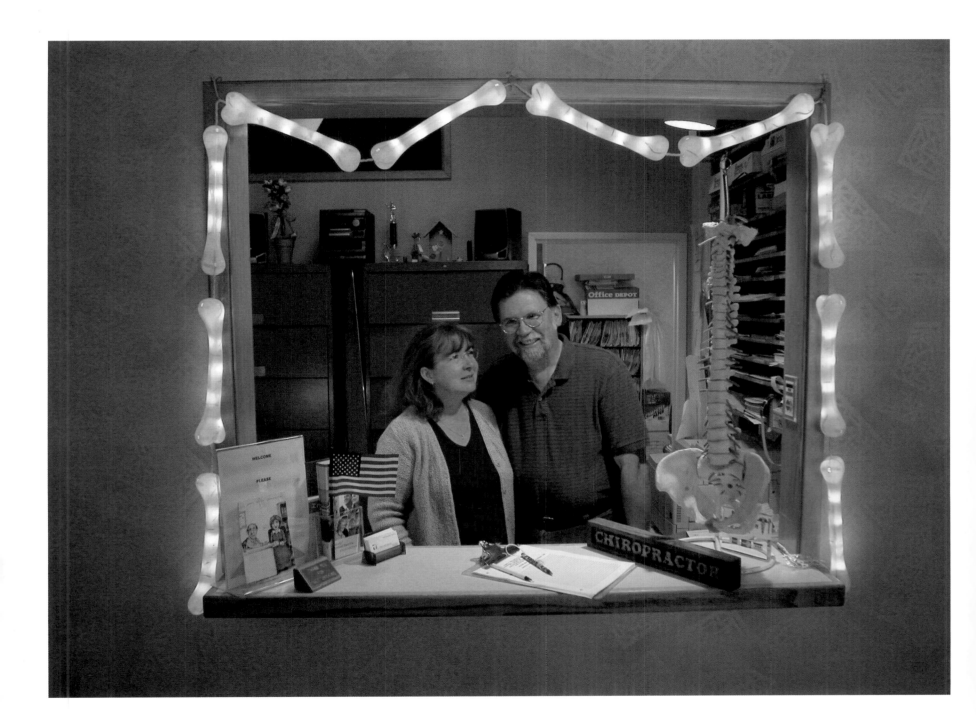

HOLLYWOOD

Guests arriving at the Standard Hotel catch an unstandard sight. From 7 p.m. to 2 a.m., vitrine sitters do yoga, nap, work their computers, whatever. The glassed-in occupants, called box girls and box guys, pretend they don't see anyone. The pay isn't great, but the exposure is hard to beat—and exposure is everything in this town.
Photo by Jeffrey Aaronson, Network Aspen

MARINE CORPS RECRUIT DEPOT
Recruits power through a "combat confidence exercise" during boot camp in San Diego. They leave the 12-week training with a thorough grounding in martial arts that allows them to fight even when exhausted. Kneeing each other is one exercise drill that instructors use to tire the soldiers out.
Photo by Nadia Borowski Scott,
The San Diego Union-Tribune

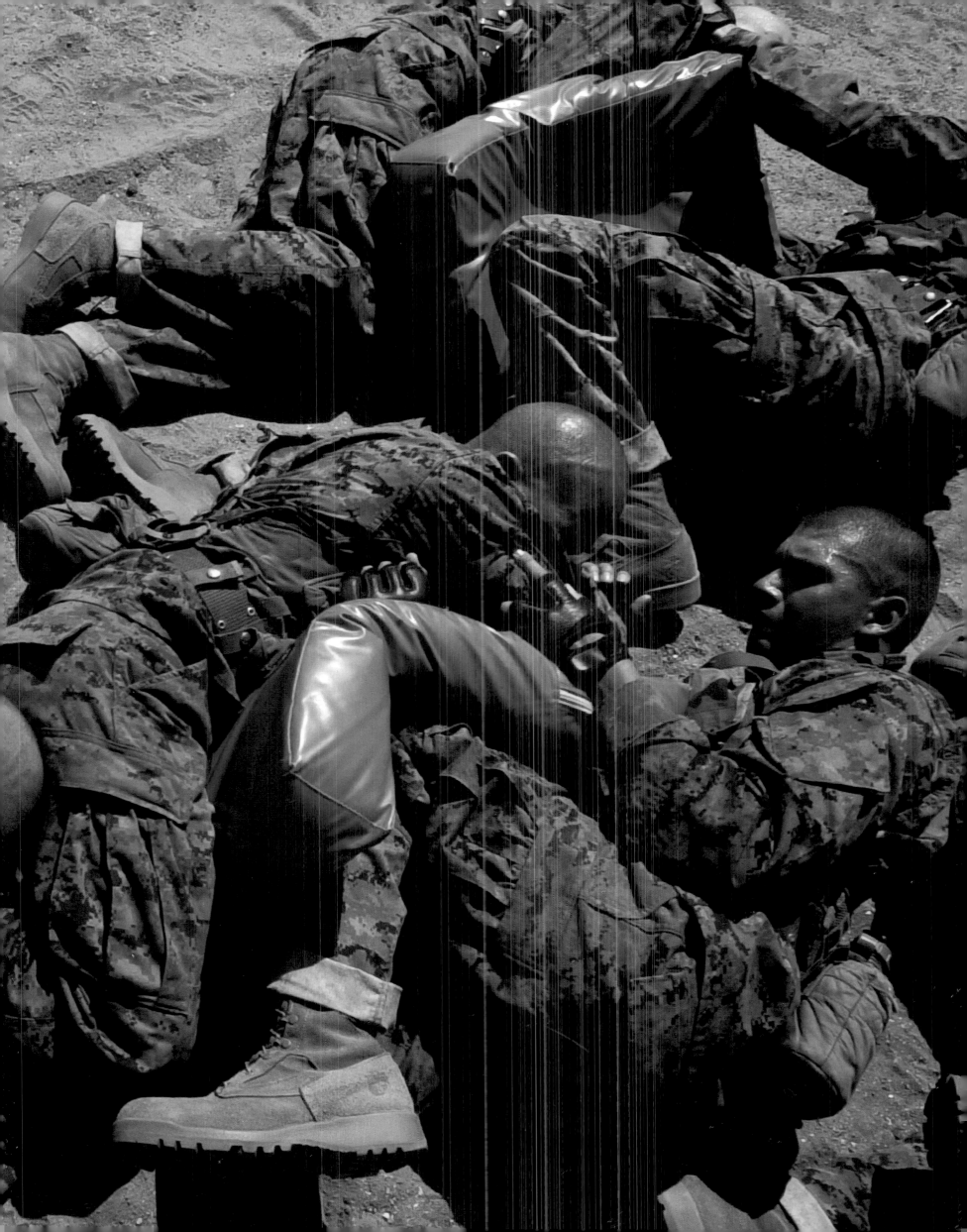

MARSHALL

When the tide is out, Charles Friend (left) harvests "grow-out" bags of Pacific oysters. He buys seed oysters, grows them in cylindrical plastic mesh sacks, and then transfers them to the bags, which are anchored in the waters of Tomales Bay until the oysters reach barbecue size.
Photo by Naomi Brookner

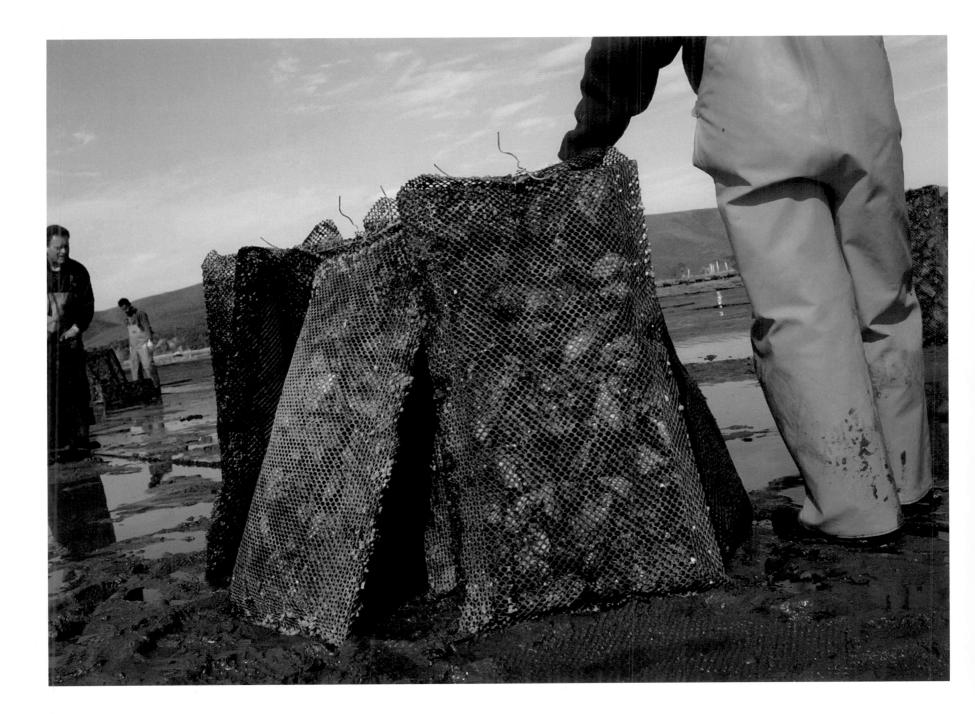

SAN DIEGO

"I moved from New Jersey to San Diego for the weather and found work in a refrigerator," says aviculturist Debbie Denton. The dimming light in the 22-degree Antarctic penguin area simulates light conditions at McMurdo Station. Soon it will be dark for the three-month Antarctic winter, with only a red light (imperceptible to penguins) allowing keepers and spectators to see.
Photo by Nadia Borowski Scott,
The San Diego Union-Tribune

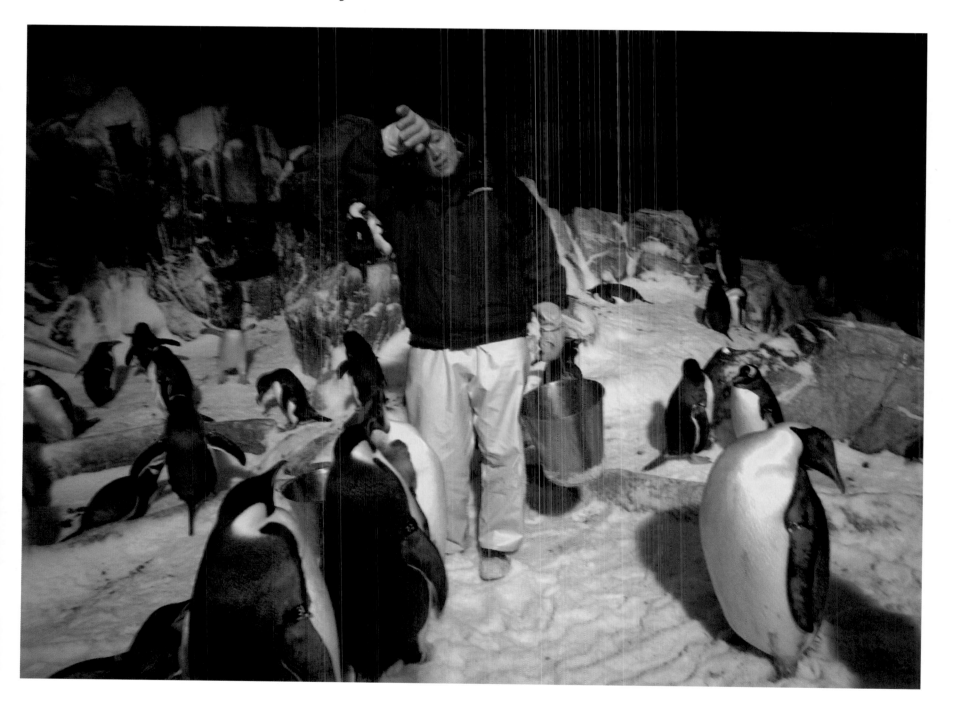

SAN FRANCISCO
A Danish container ship plows through the San Francisco Bay channel toward the Golden Gate and out to the Pacific. After 9/11, the Coast Guard began stationing sea marshalls on foreign container ships like the *Mette Maersk*.
Photo by Maggie Hallahan, Network Images

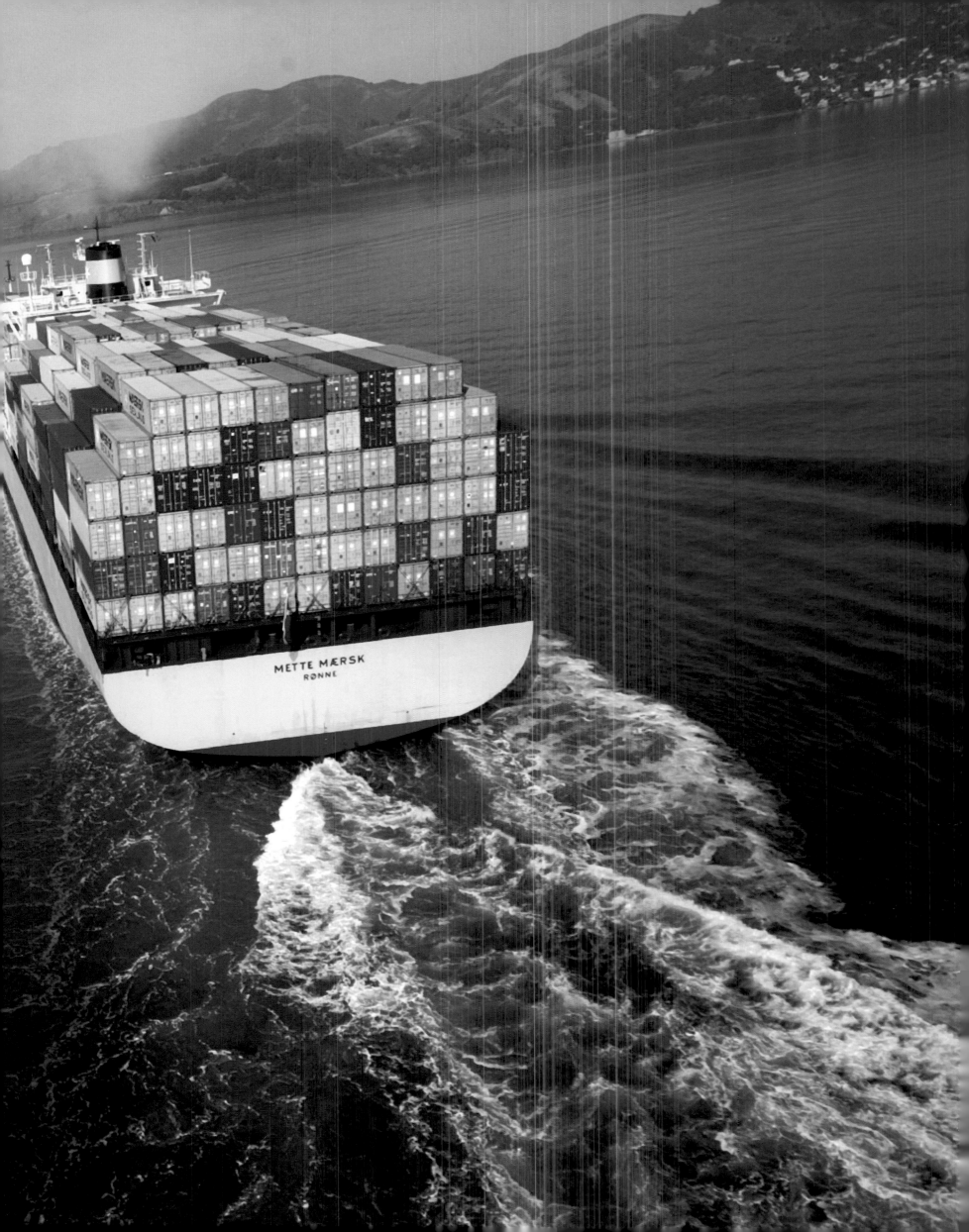

MILL VALLEY

A Mercedes-Benz gets the works at the Mill Valley Express Hand Car Wash. As Rose Royce sang, "Those cars never seem to stop comin'."
Photo by Robert Holmes

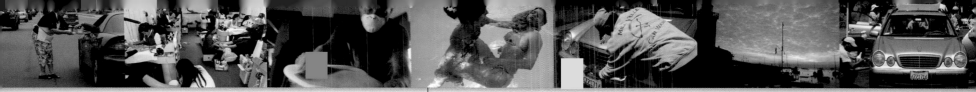

LAGUNA NIGUEL
Hydrotherapy at Two Bunch Palms resort is referred to as Aqua Soma. Masseuse Livia Pontual immerses Marcella Escobedo in warm water, moving and stretching her limbs. The tab for an hour of assisted floating? $95.
Photo by Rick Rickman

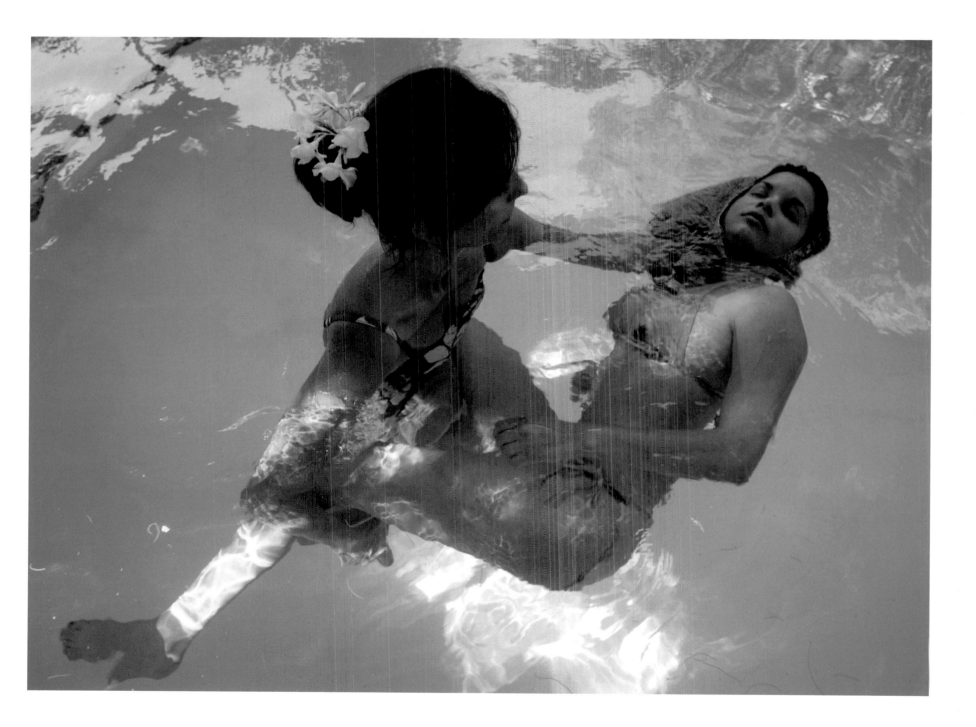

BIG SUR

George Carey receives some deep kneading from Claire Silver on the Esalen Institute's massage deck above the Pacific Ocean on the Big Sur coast. Masseuses-in-training traded techniques during one of Esalen's health and well-being workshops.
Photo by Maggie Hallahan, Network Images

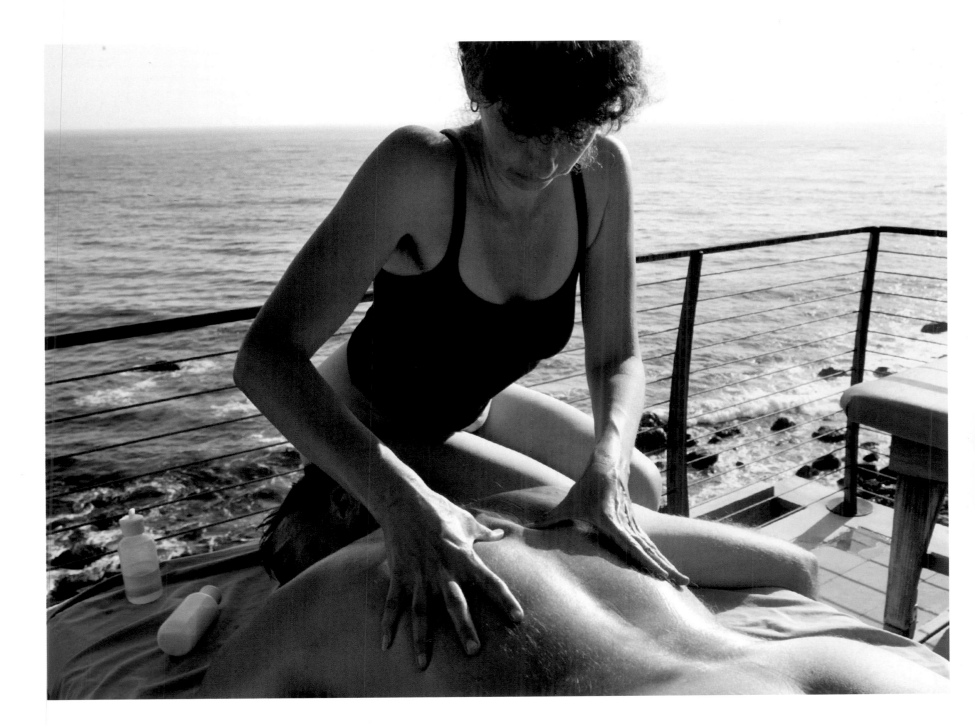

CULVER CITY

Friends and strangers get down at the gym in a dance and awareness class called Fumbling Toward Ecstasy, inspired by the Sarah McLachlan song. The idea is that movement releases the body's positive and negative experiences. "It changed my life," says Fernando Artiga (Foreground). "It's passion and meditation at the same time."

Photo by Shlomit Levy Bard

LOS BAÑOS

Insta-home: Landscapers Salvador Gonzales and David Flores finish off a new house in the Ranchwood Homes subdivision. Skyrocketing home prices are driving families from Silicon Valley and the San Francisco Bay Area into the Central Valley real estate market. The median three-bedroom home price in Los Baños in 2003 was $185,000, compared with $509,000 for a similar house in the Bay Area.

Photo by Anna Marie Dos Remedios,
The Pinnacle

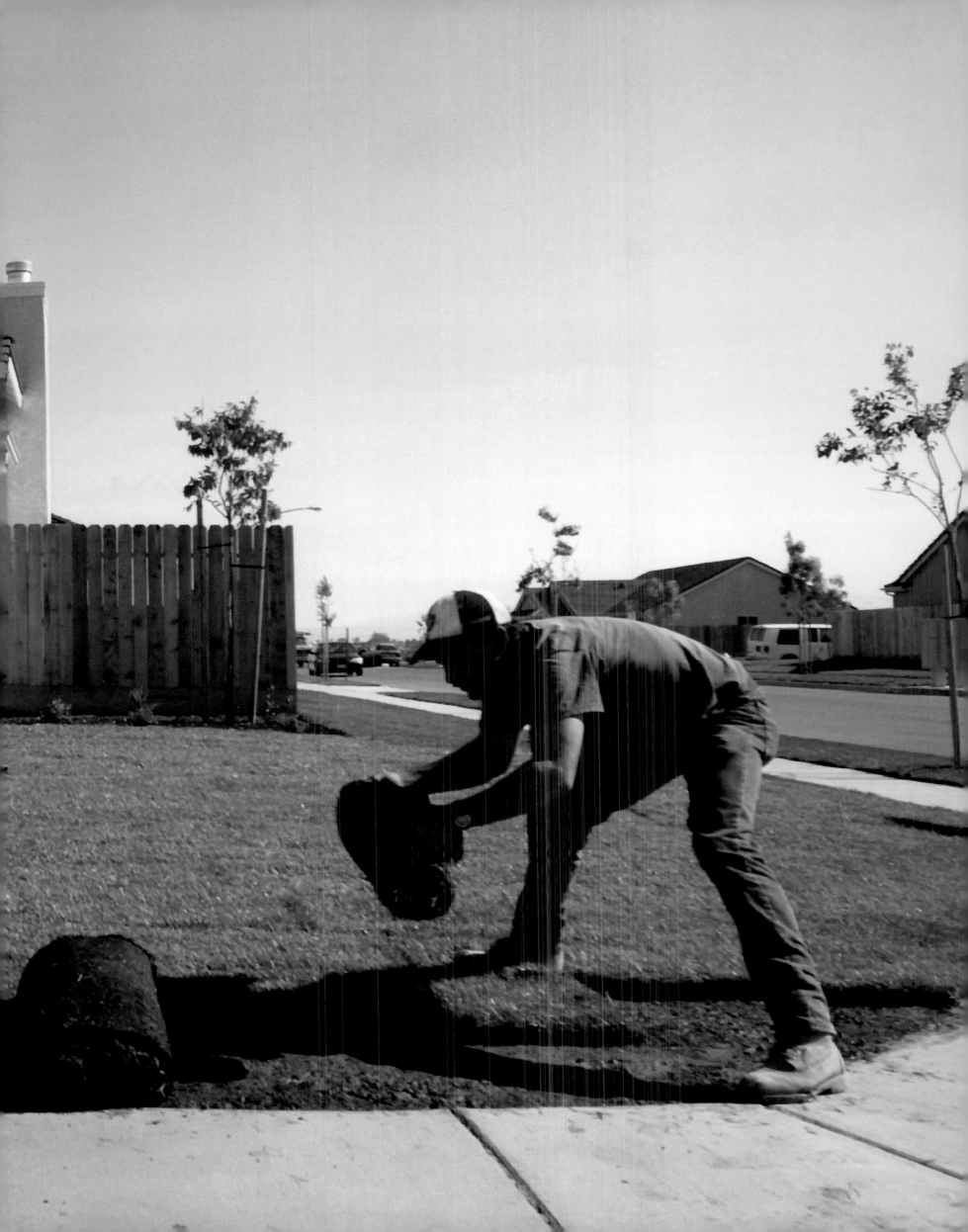

SAN JOSE
Tom Dougherty gets in the funny zone be-
fore his slapstick routine under the big top.
The professional clown is part of Circus
Chimera, a traveling show that entertains
with Cirque du Soleil–style acrobatics and
aerial artistry.
Photo by Patrick Tehan

SANTA CRUZ

Over the boardwalk: The scent of corndogs, cotton candy, and popcorn wafts skyward, while a family of three dangles above the fray on the Skyglider tram. The Santa Cruz Beach Boardwalk, opened in 1904, is California's oldest amusement park.

Photo by Maggie Hallahan, Network Images

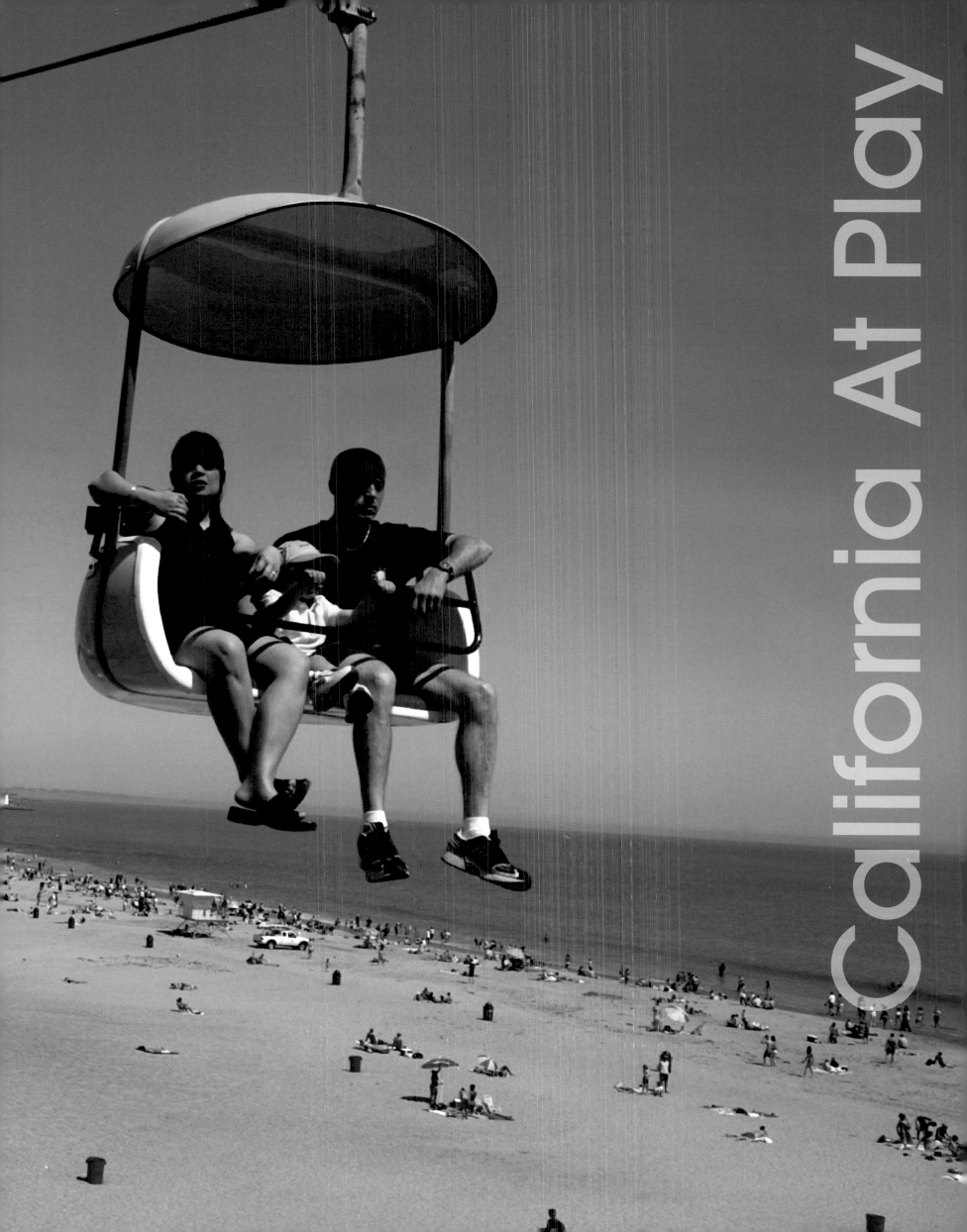

California At Play

SAN FRANCISCO
Time: 7 a.m. Water temperature: 52 degrees.
Miles logged: 8.5. Dianna Shooster strokes
through the home stretch of the Bay to
Breakers Swim, a 10-mile race from the Bay
Bridge, under the Golden Gate Bridge, to
Ocean Beach. Outdoor activity is a way of
life in San Francisco, voted the third-fittest
city in America by *Men's Fitness* magazine.
Photo by Maggie Hallahan, Network Images

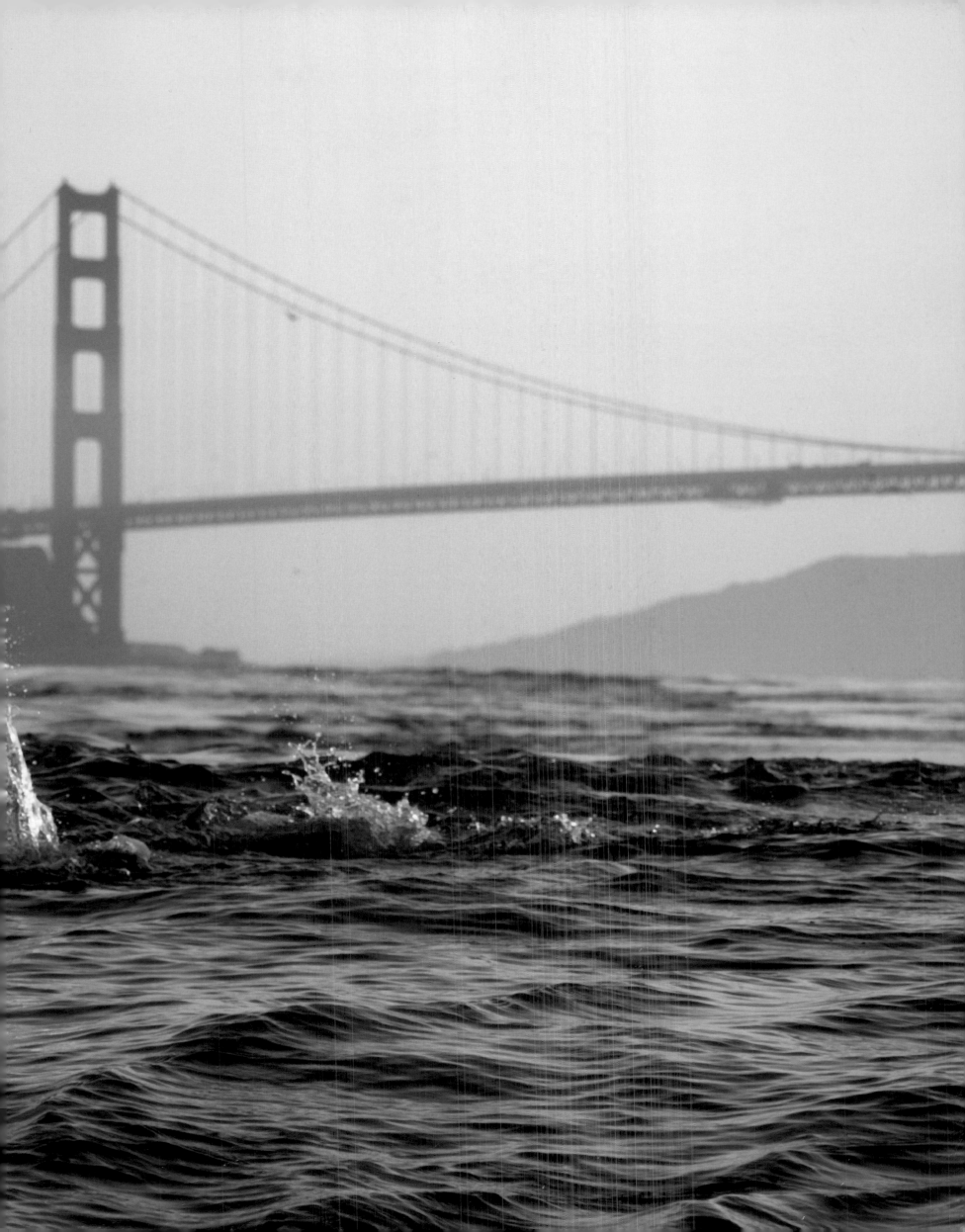

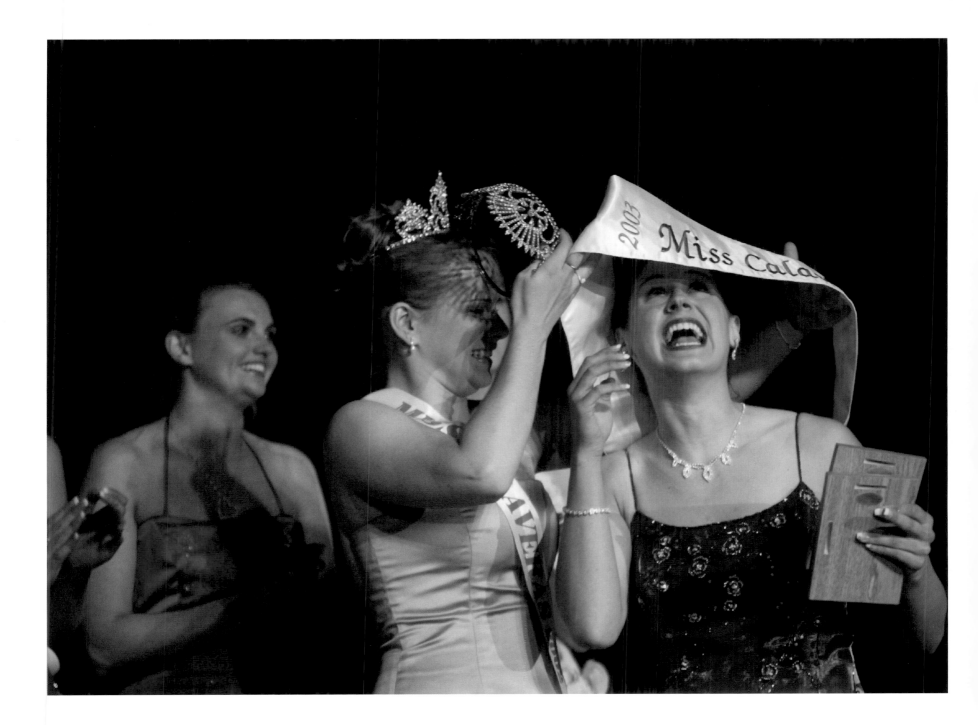

ANGELS CAMP

Crystal Jennings fulfills a dream when she's crowned 2003 Miss Calaveras and awarded a $600 scholarship. The Bret Harte High School senior wowed judges with her talent show performance, a high-energy gymnastics routine that included a cartwheel/front handspring/aerial combo.

Photos by Meri Simon

SANTA ROSA

The Santa Rosa Scorchers salute their fans after losing to the Oakland Banshees. The women's professional football team can't explain why they have the largest fan base of any squad in the 32-team Independent Women's Football League. They lost all but one game but were still able to ignite a movement they call "Scorcher Mania."

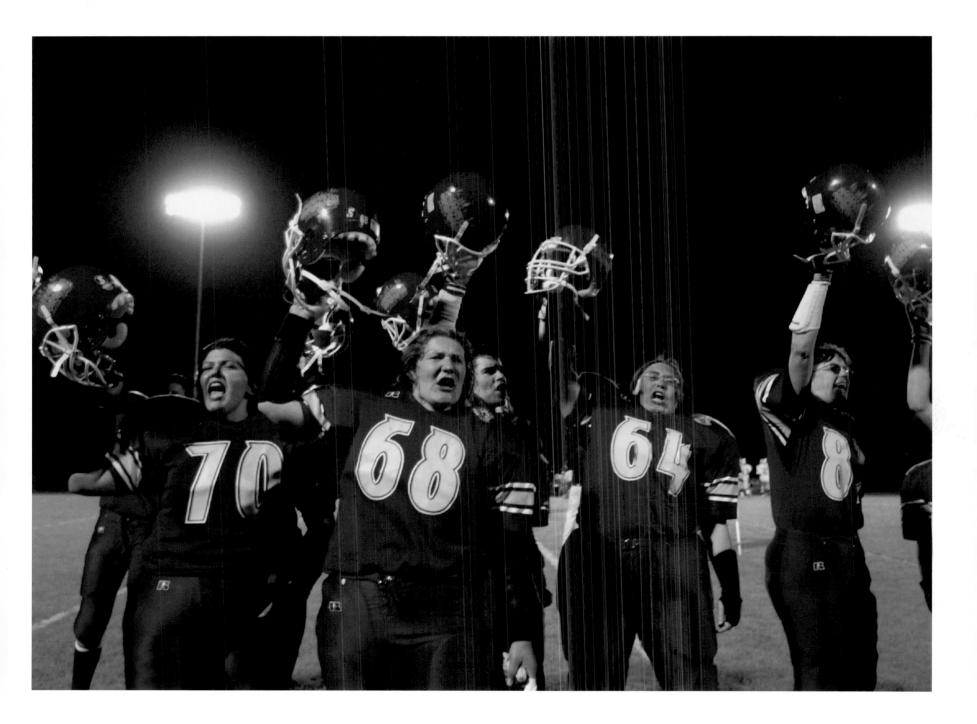

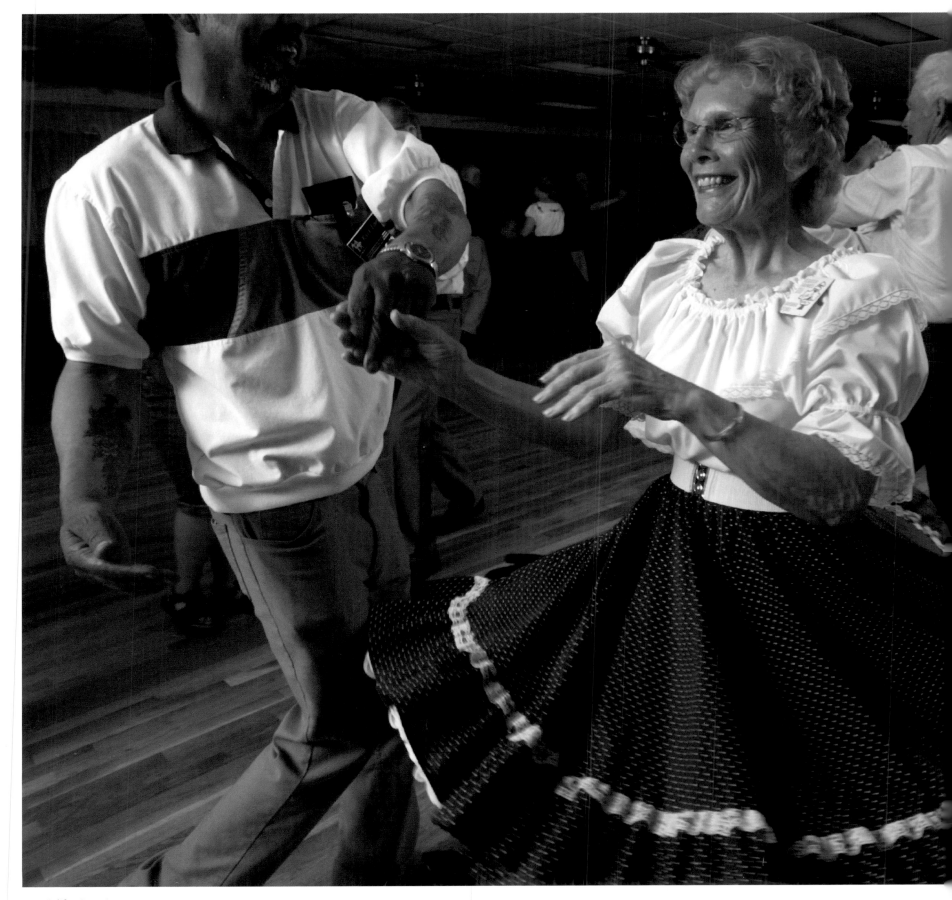

VISALIA

Aleman left and a do-si-do! Barbara Cribbs follows the caller's orders and weaves through a square of partners at the Pentecostal Park Association of Visalia's Tuesday night dance. The retired medical transcriber started dancing after her husband passed away 13 years ago. "It really saved my life," says Cribbs. "Dancing gave me something to do and a way to meet new friends."
Photo by Ryan Alex, Art Center College of Design

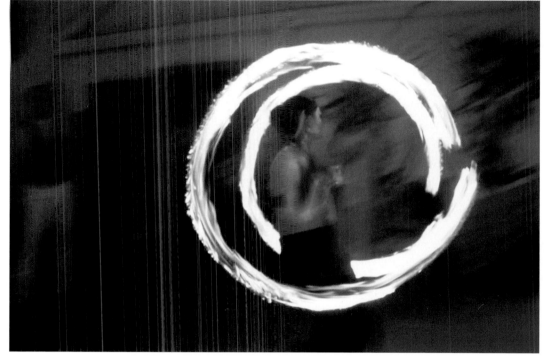

OAKLAND

Artists play with fire during a midnight performance at the Noodle Factory. Sarah Soward "spins poi," a Maori tradition of twirling weighted ropes. Spinners soak cubes of wicking in white gas and paraffin and light them. "I call them the firey chains of death, because when I was learning I was terrified," Soward says.
Photo by Aicha Nystrom

CASTROVILLE

At the Artichoke Festival, young local dancers make patterns with their Jalisco-style skirts. That's Nicole Nessick between swirling Genesis Castellanos and Cecilia Vasquez. Spanish settlers brought the artichoke to the area in the 1600s. A mere three centuries later, it caught on.
Photo by Ivan Kashinsky, San Jose State University

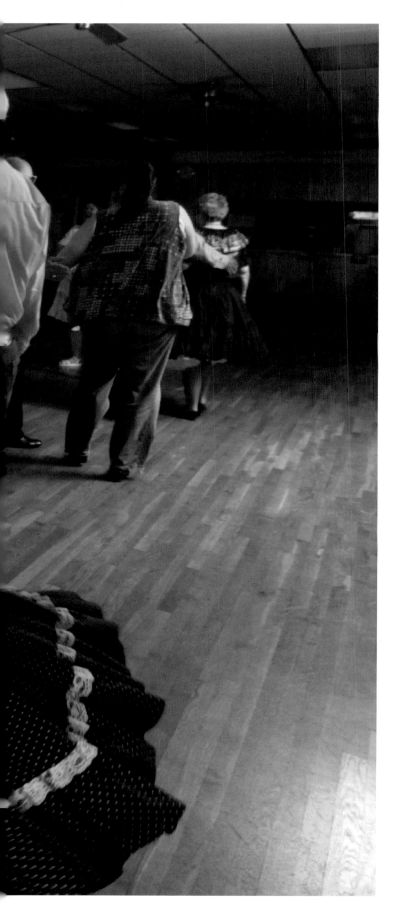

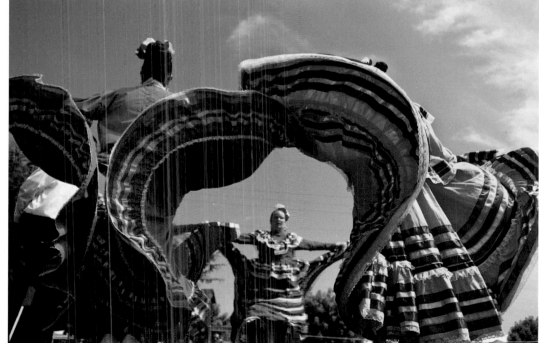

VENICE BEACH
Catch of the day: For nine years, Venice resident Greg Wodzynski has made a living creating whimsical sand sculptures.
Photos by Michael Grecco Photography, Icon International

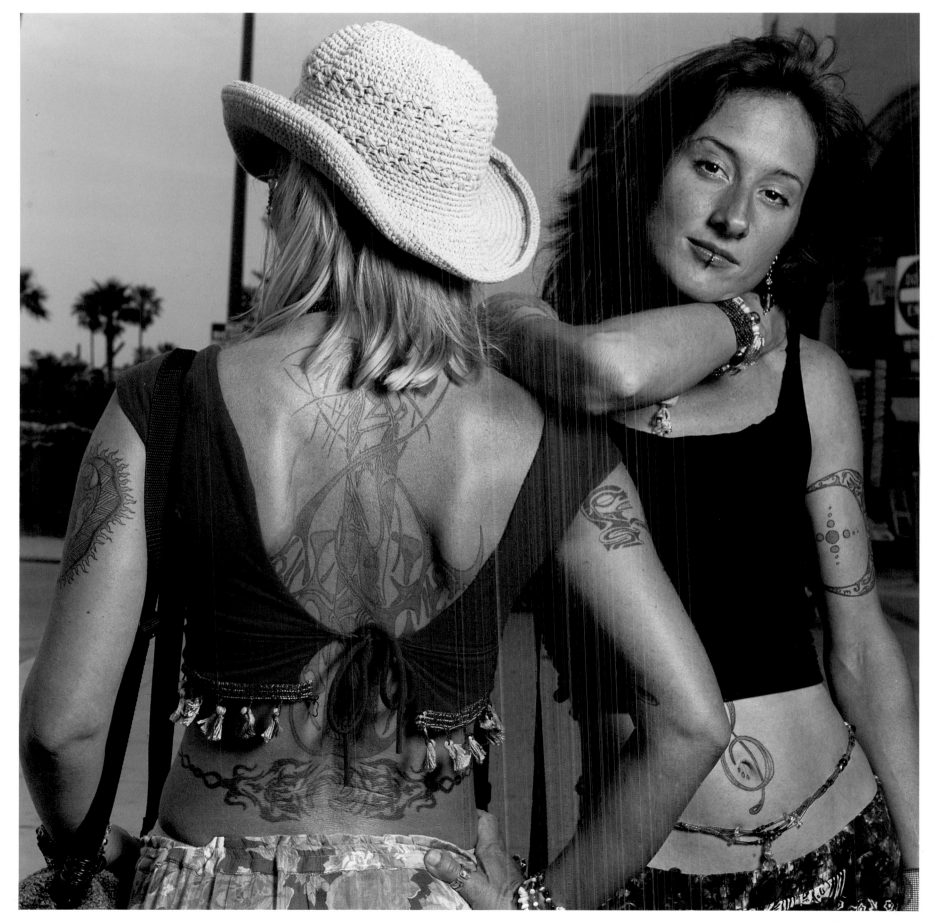

VENICE BEACH

Bonnie O'Melia and Eileen Hammerschmidt met in Jupiter, Florida, and discovered they were musical kindred spirits. Two years later, they formed the acoustical duo Just Be. Fleetwood Mac, Pat Benatar, and John Lennon's *Imagine* influence their sound, and they've come clear across the country to "share the music."

DANA POINT

Wah, wah, wah, WIPEOUT! After school lets out, the line-up can get a little congested at Doheny State Beach. One way to minimize the wait time is to board-pool—unless, of course, your board-mate wipes out right after you catcn a nice wave.

Photo by Francis Specker

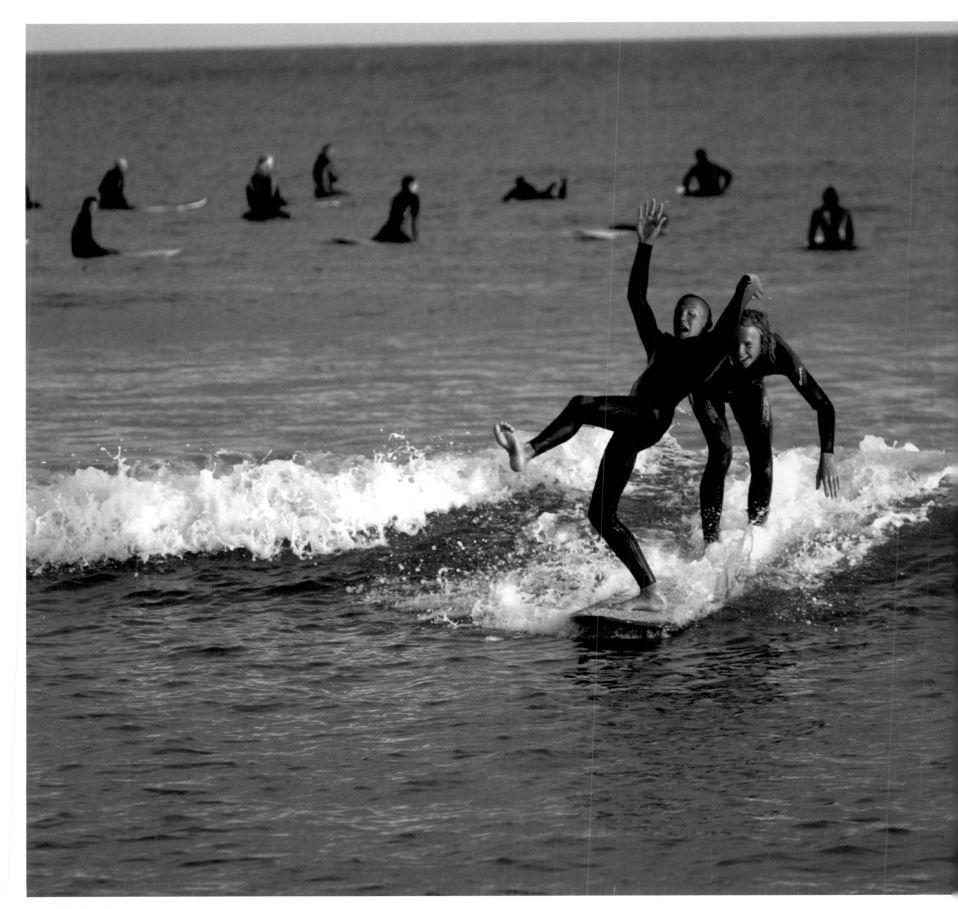

SAN CLEMENTE

Must be the negative ions: Eve Fletcher, 76, after an express on session at San Onofre State Beach Eve may be the oldest Roxy Girl in the world. Hale, hearty, and widely admired, she's been surfing San Onofre's Trestles break three times a week for 50 years.
Photo by Rick Rickman

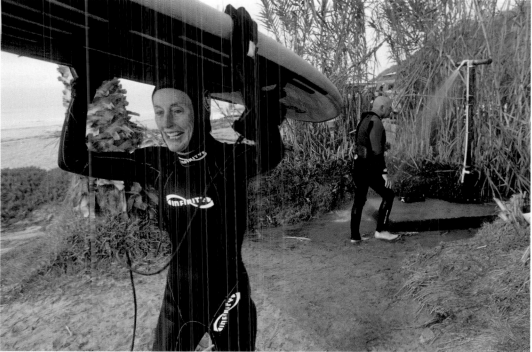

SAN FRANCISCO
Yoga teacher Tim Floreen sustains a Peacock
in Lotus pose. Learning to put his legs in the
lotus position was easy, he says. Balancing
was not. Floreen teaches Bikram yoga, which
mandates heated studios. The 115-degree
class at Funky Door Yoga on Polk Street lasts
two hours.
Photo by Naomi Brookner

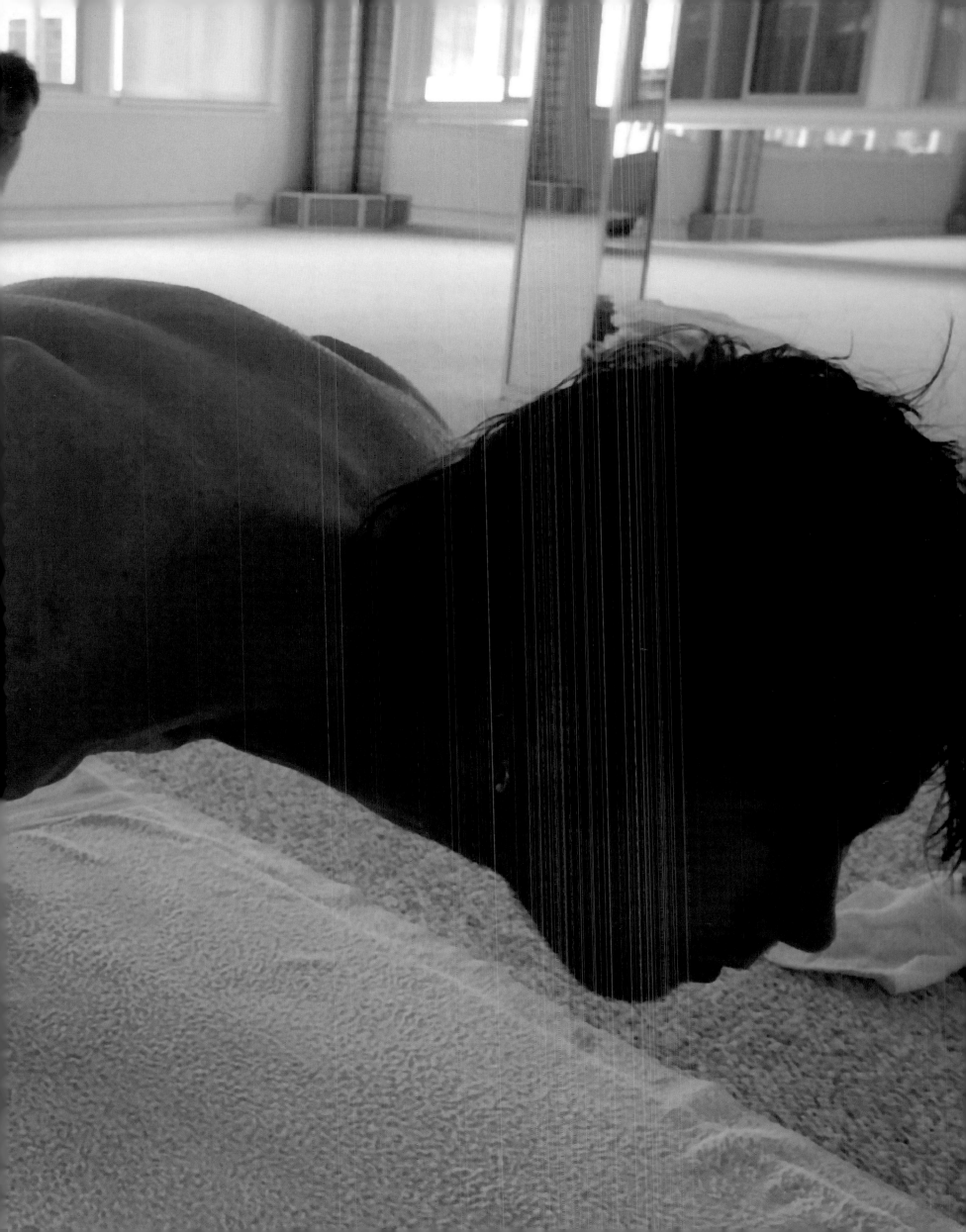

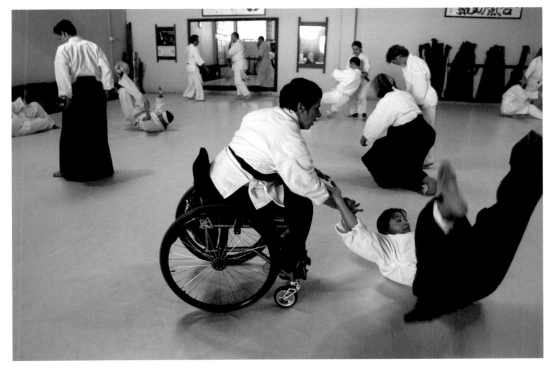

REDWOOD CITY

In 1995, Molly Hale was in a car accident and suffered a spinal cord injury that left her paralyzed below the shoulders. Her doctors predicted she would never regain movement—but Hale proved them wrong. In 2002, she earned her black belt in aikido.

Photo by Sisse Brimberg

SANTA CRUZ
It's a bird! It's a plane! It's a BMXer! Joel Hulsey of
Walnut Creek pulls a "Superman" on his stunt
bike during a competition at the Santa Cruz Art,
Wine & Jazz Festival.
Photo by Salim Madjd

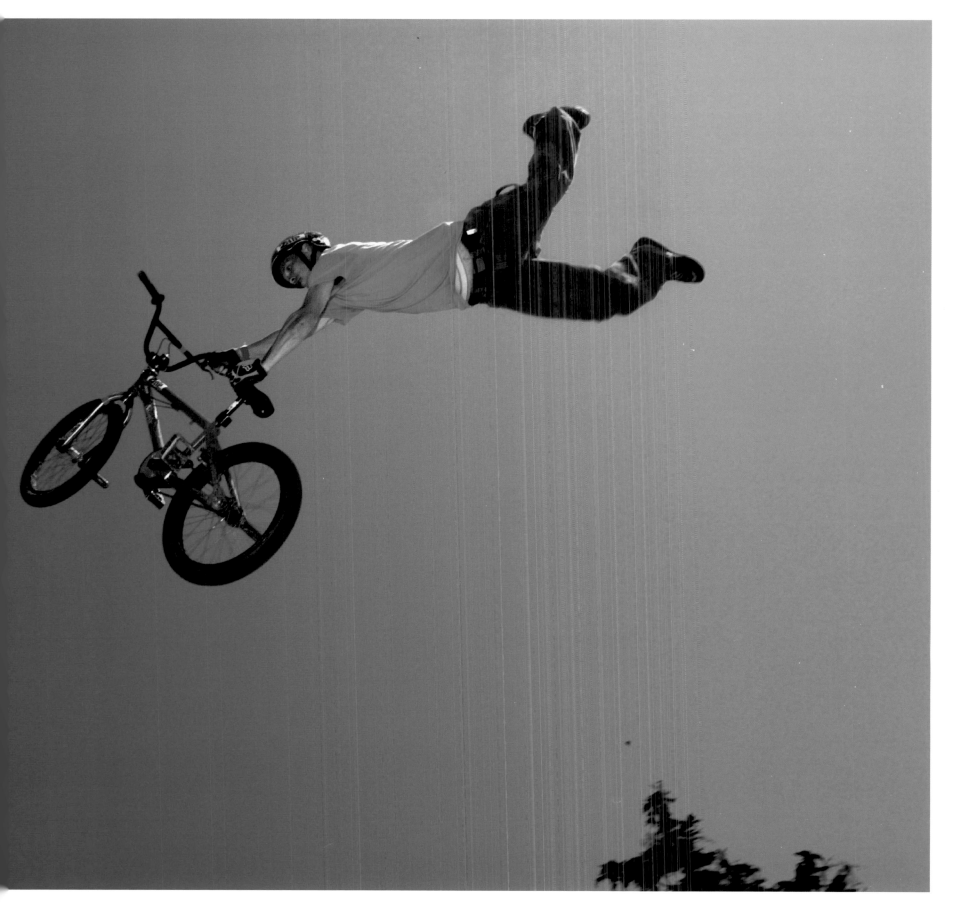

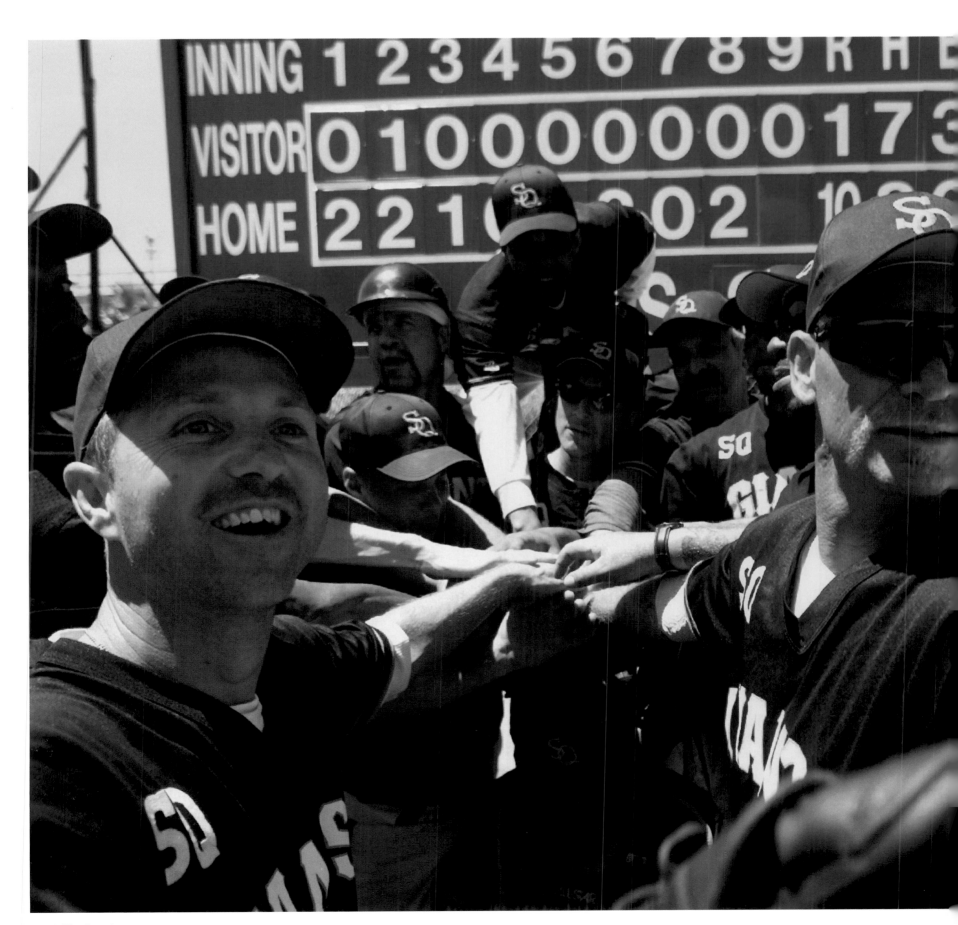

SAN QUENTIN

Home field advantage: The San Quentin Giants, a prison team, exult in their victory over the Oakland Oaks, an over-30 citizen ball club. Prisoners must be free of major rules violations before they can try out for the team that's been fielded since 1923. The San Francisco Giants donate uniforms, and the club plays only home games.

Photo by Lou Dematteis

SAN FRANCISCO

Go Giants. At the city's celebrated bayside stadium, Pac Bell Park, the home team takes on the Montreal Expos. Unless you're Canadian, you don't want to know the score.
Photo by Deanne Fitzmaurice,
San Francisco Chronicle

FAIRFAX
Razz on wheels: Gary Fisher, local pioneer of mountain-bike manufacturing, gets into a friendly taunt while passing cyclists on a hilly back road in Marin County. Recognizing him, they ask why his Gary Fisher bike is in the back seat. Is it broken? The answer in brief is *no*.
Photo by Victor Fisher

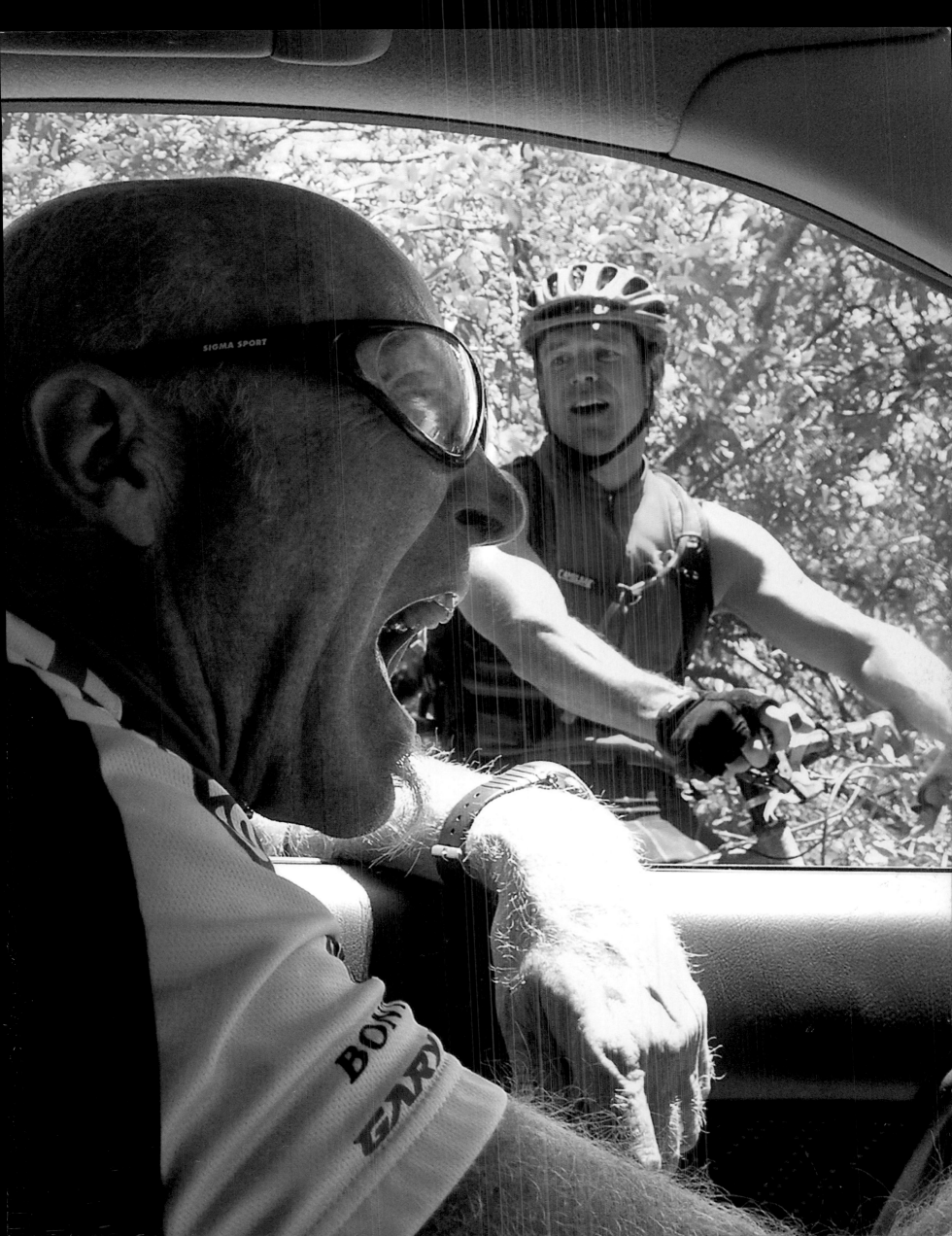

LONG BEACH
Olympic-style judging ranks marchers along
Ocean Avenue during the annual Long Beach
Lesbian and Gay Pride Festival and Parade.
With 125,000 participants and 200 marching
groups and floats, the two-day festival is the
third-largest gay pride parade in America.
Photo by Jeff Gritchen,
Long Beach Press-Telegram

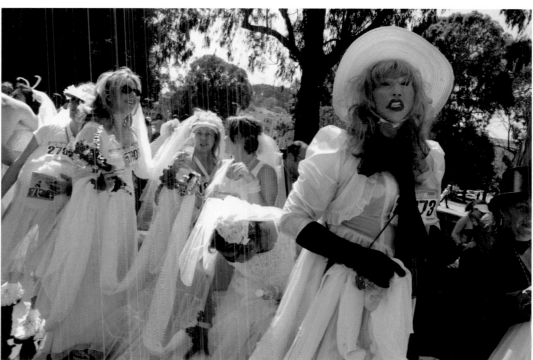

SAN FRANCISCO

A chain of 12 brides (about half of them men) "run" San Francisco's Bay To Breakers race. When compared with the popular race's naked contingent, the bridal party is downright conservative. For most runners, costumes mean more than speed. Finish times range from 35 minutes to, oh, four hours or so.

Photo by Marla Aufmuth

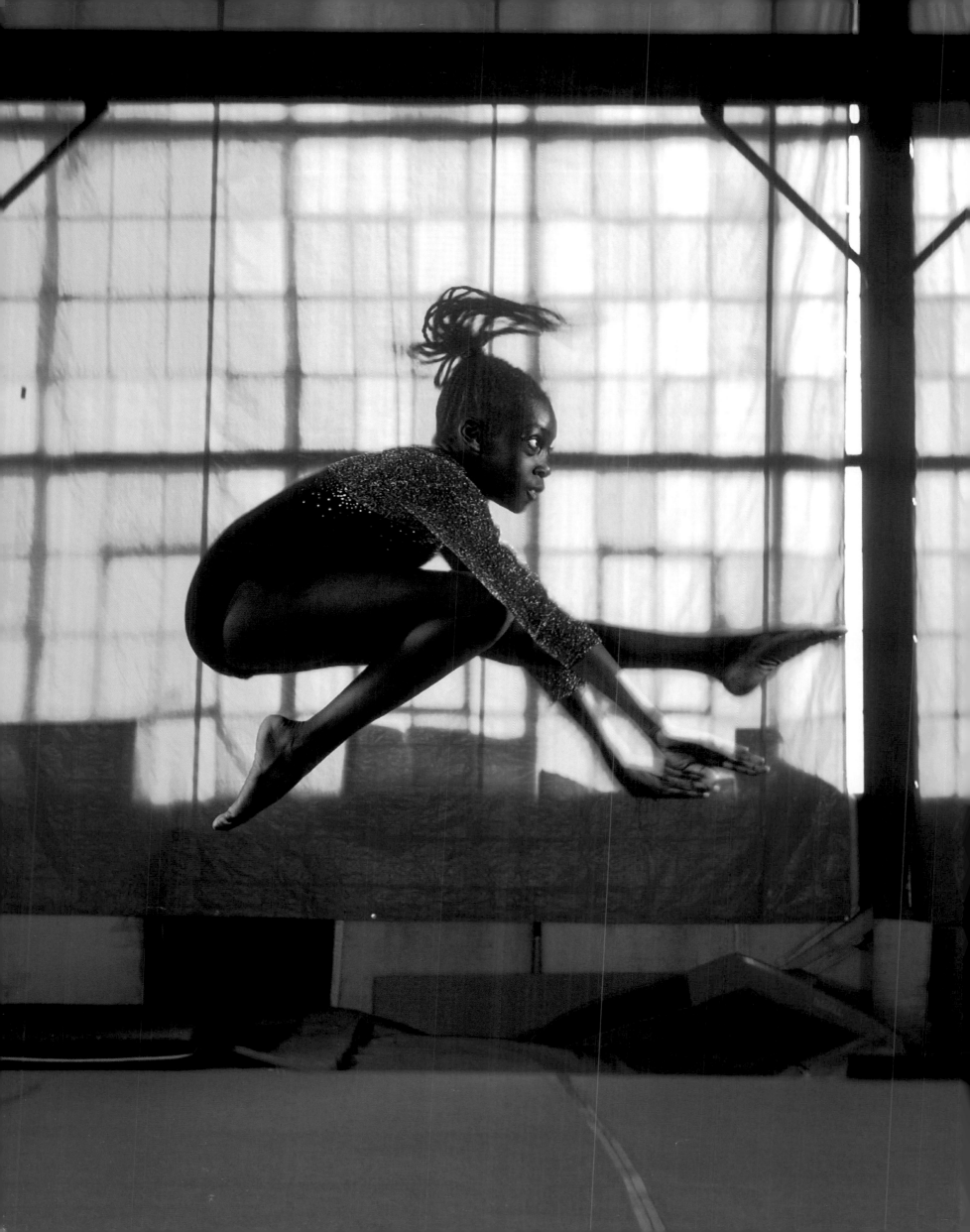

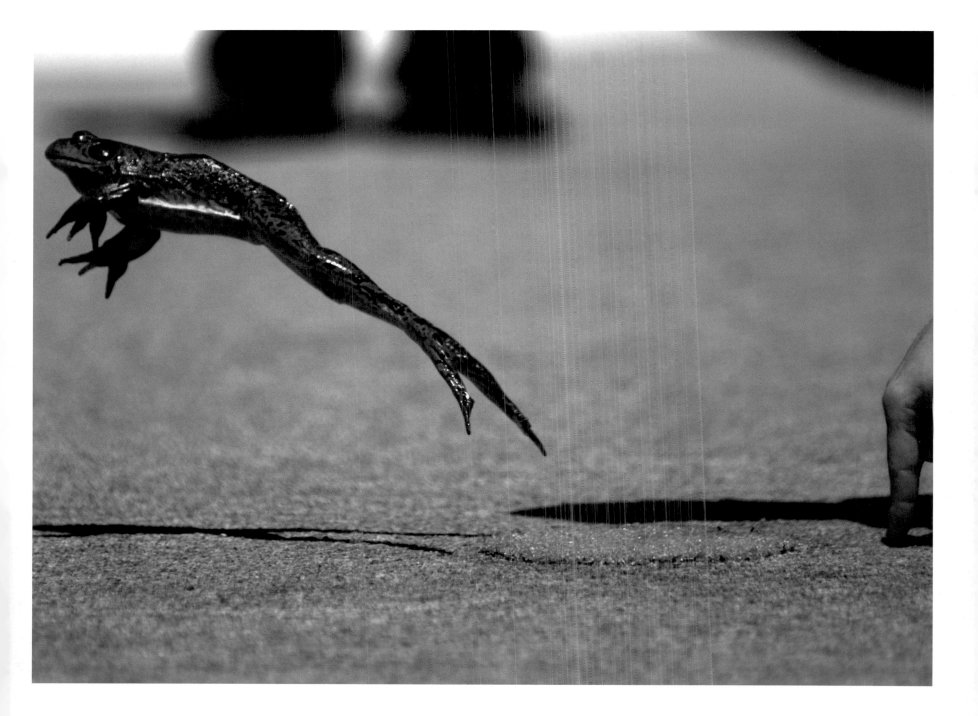

EMERYVILLE

Just do it: Perfecting her wolf jump, Chanell Rensch practices gymnastics at Head Over Heels, where she has taken classes for four years. Unlike many kids, Chanell's not in it for competition— she does it for fun.

Photo by Lise Dumont

ANGELS CAMP

"You never see a frog so modest and straight-for'ard as he was, for all he was gifted....He could get over more ground at one straddle than any animal of his breed." So wrote Mark Twain in "The Celebrated Jumping Frog of Calaveras County." This long-legged amphibian comes close to Twain's paragon at the Calaveras County Jumping Frog Jubilee.

Photo by George Wedding, GEOPIX

SAN FRANCISCO
Members of Leung's White Crane Lion & Dragon Dance Association cruise the streets of China-town to entertain the hordes of tourists on the weekends in the spring and summer.
Photo by Deanne Fitzmaurice,
San Francisco Chronicle

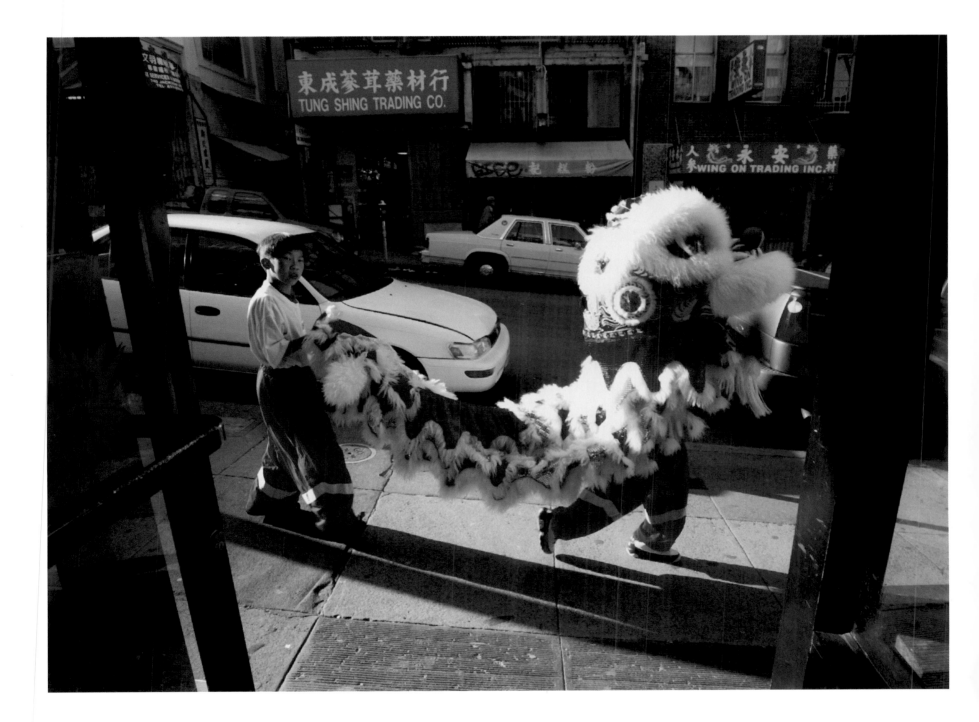

REDDING

The Redding Rodeo 2003 Queen Rochelle Taylor, 20, gets her hair and her horse Bandit ready for the rodeo's opening ceremonies.
Photo by Jim Merithew

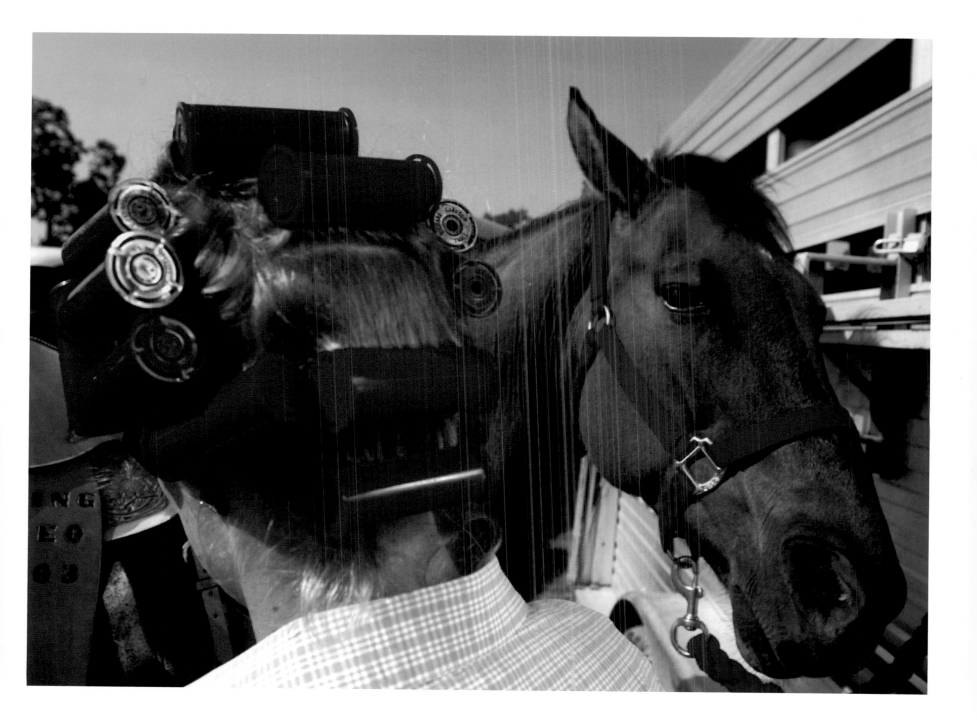

BISHOP
Students of Bishop's Mountain Light photography workshop practice perspective in an iris field below the White Mountains.
Photo by Frans Lanting, www.lanting.com

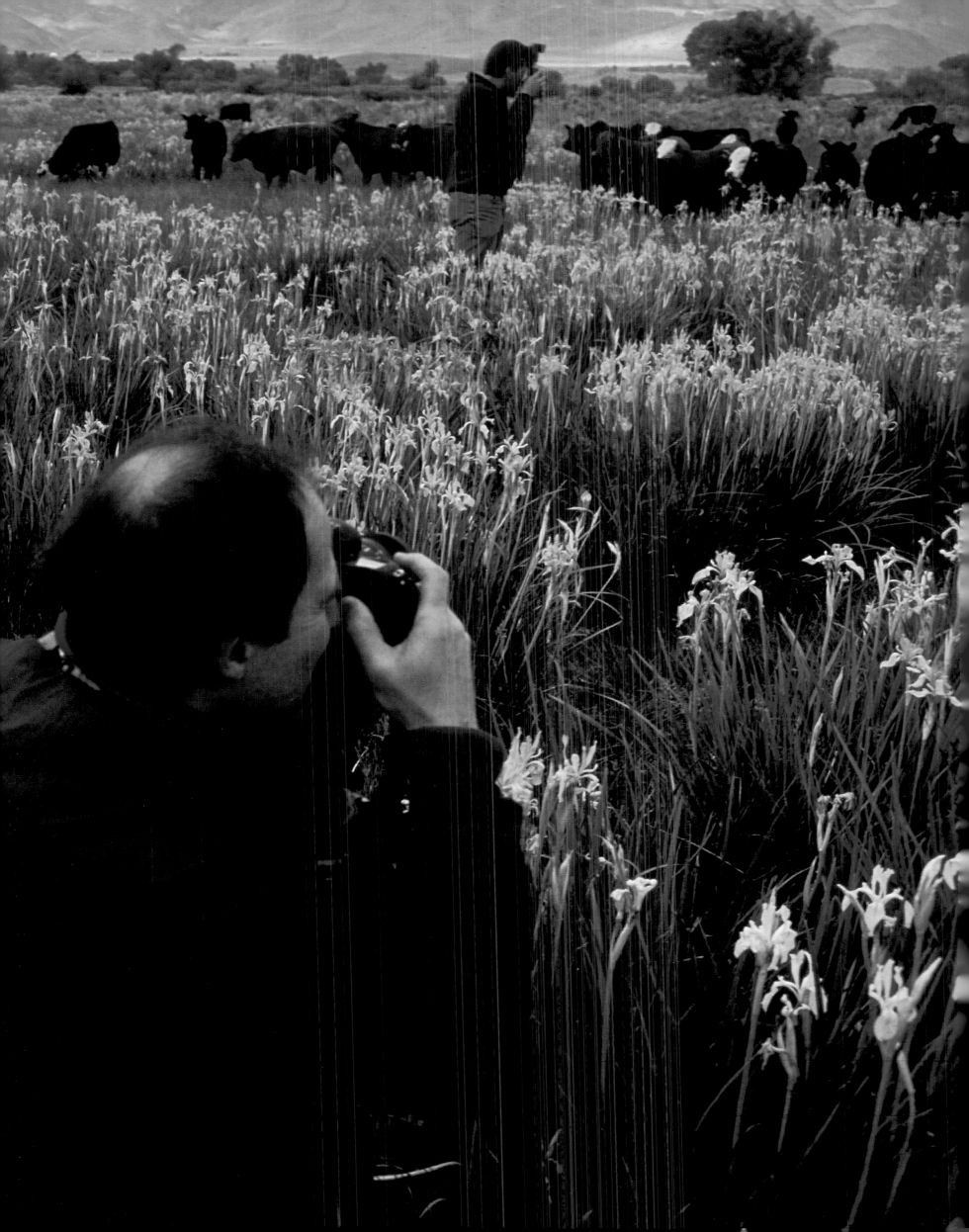

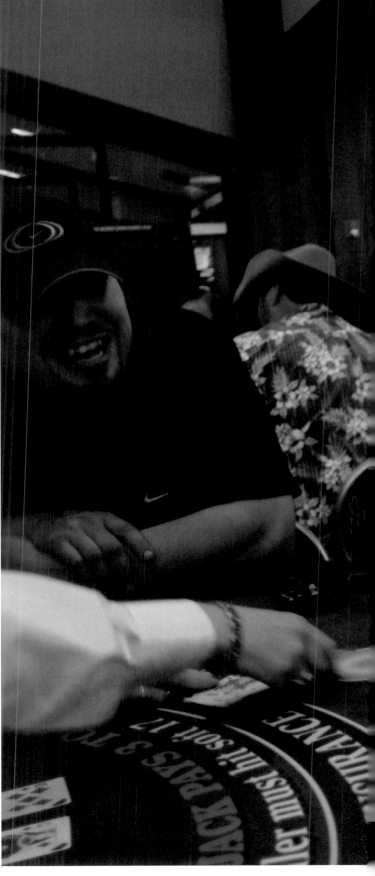

WOODLAND HILLS

Bingo is the game-oh: Every Friday afternoon, Irene Collier tries her luck at the Motion Picture and Television Fund campus lodge. Known as the "actor's retirement home," the Fund's lodge also provides health and child care. Collier did not act, but her husband, Richard Collier (1919–2000), was a film and television character actor whose work included *Blazing Saddles* and *Bonanza*.
Photo by Laura Kleinhenz

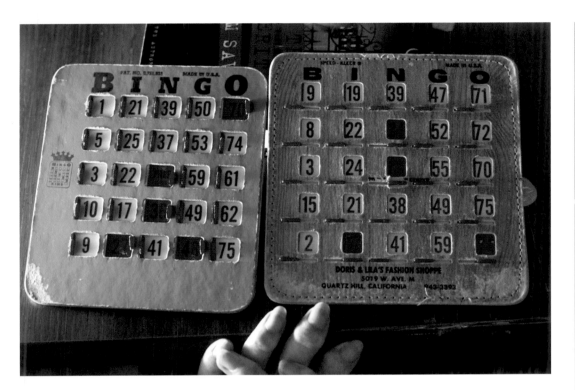

BLUE LAKE

Blackjack tables are new in Blue Lake, a small northwest California logging town next to the Mad River. Roger Linn, Sara Kayes, and Amber Bradley drove two hours from southern Humboldt County to take their chances at the Blue Lake Casino. Built in 2002, the Indian casino stirred up the community. It brought jobs, but also too much traffic.

Photo by Josh Haner

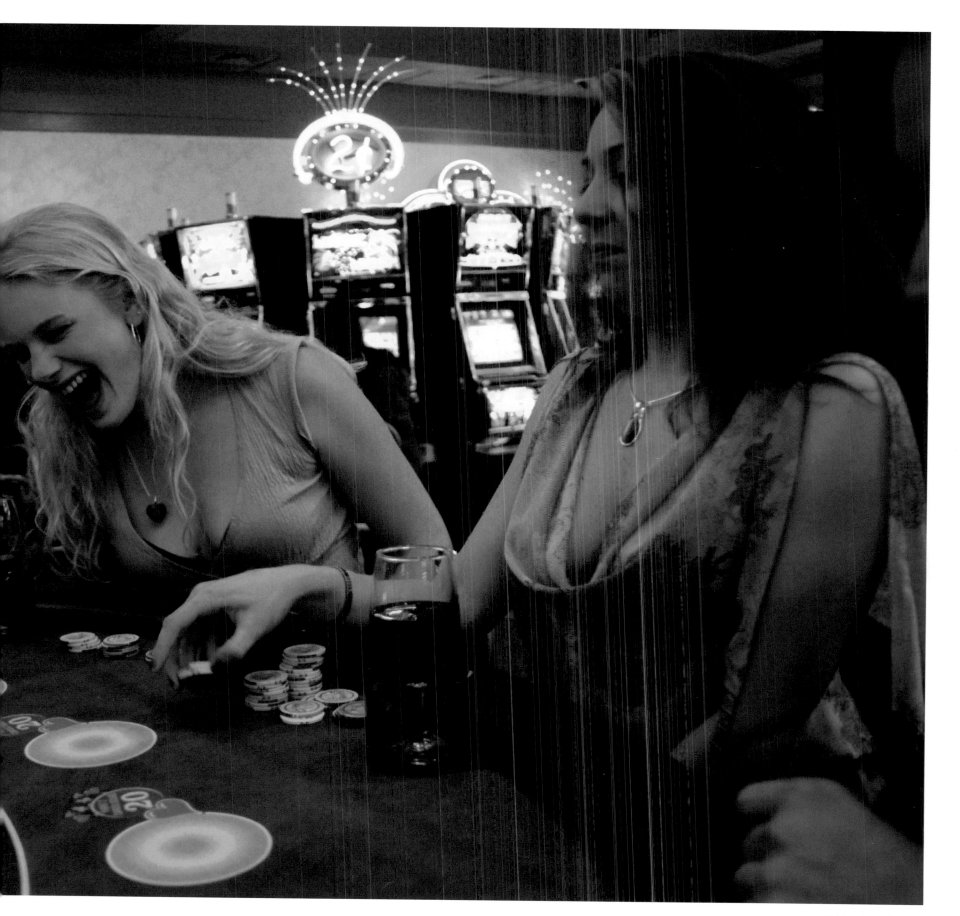

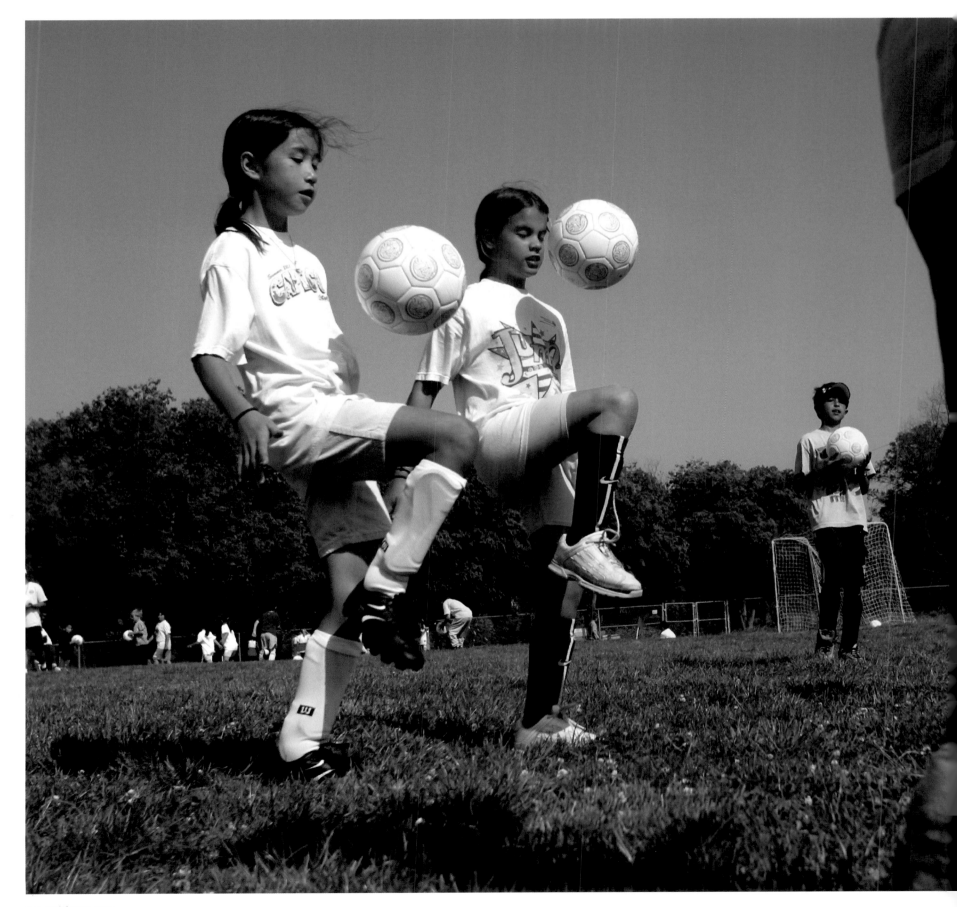

SAN JOSE
Olivia Grace Wing and Tasha Flowers juggle in tandem during practice at Rogers Middle School. San Jose's well-established youth soccer leagues produce some of the top female soccer talent in the world, including U.S. National Team star Brandi Chastain.
Photo by Jim Gensheimer,
The San Jose Mercury News

The post-prom party at Torrey Pines High School
includes a few strikes, some spares, and countless
gutter balls. Graduating senior Sarah Dabby says
she scored "about 100."

Photo by Mela Louise Norman

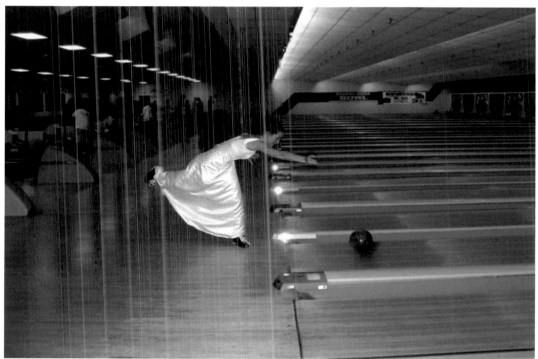

LATON

An obstinate *toro* is no match for the Turlock Suicide Squad, a team of eight hands-on *forcado* bullfighters who collectively wrestle the bull to the ground. The events are held in bullrings tucked away on farms in the Central Valley. The region's tight-knit Portuguese community packs the bleachers for monthly competitions advertised by word of mouth.
Photo by Patrick Tehan

LATON

Above all else, a matador must maintain composure and grace when facing a charging bull. Cesar Castañeda dabs nervous sweat from his face before taking on his four-legged opponent at a private bullfight. The sport is illegal in the U.S., but an exception exists for Portuguese-style bloodless bullfighting, which is performed with Velcro-tipped darts instead of spears.
Photo by Patrick Tehan

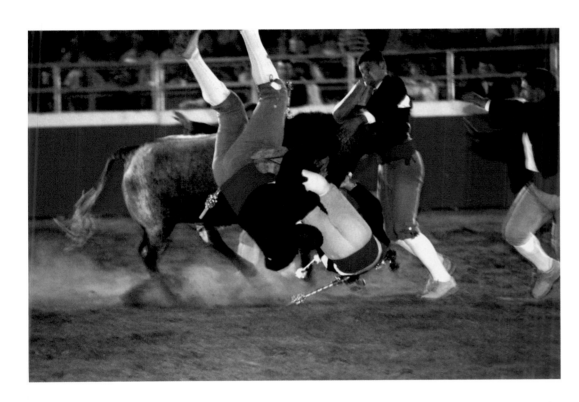

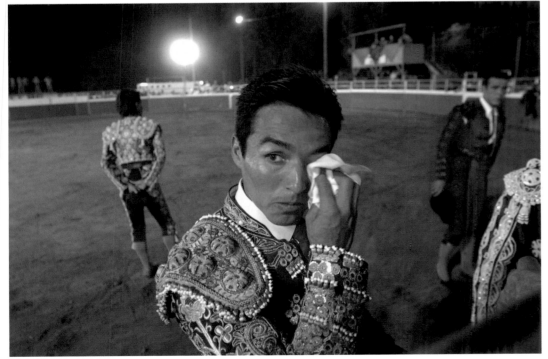

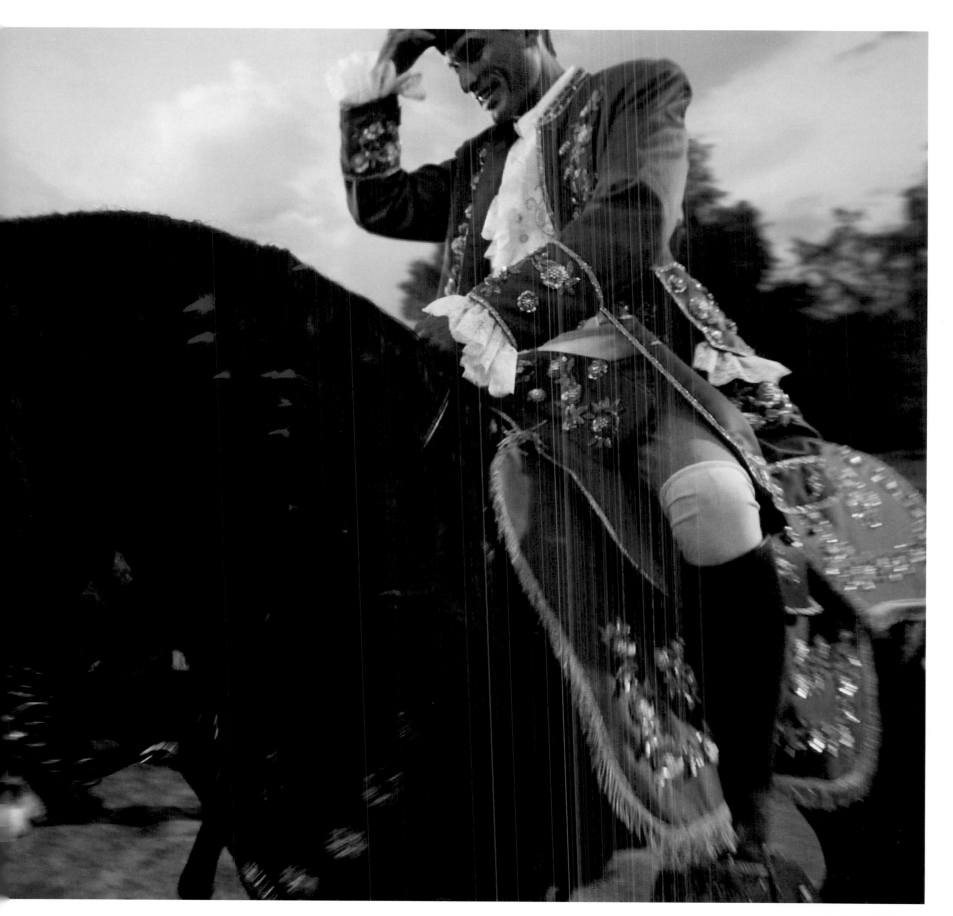

LATON

Eduardo Costa and his impeccably groomed horse court the crowds before the *corrida*, held during the annual Our Lady of Fatima festival.
Photo by Ryan Alex, Art Center College of Design

SAN FRANCISCO
Proud godfather Arthur Friedman holds
Alexandra Wilkinson before her baptism
at Glide Memorial Church. The infant is
resplendent in her maternal great-grand-
father's baptismal gown.
Photo by David Paul Morris

Reason To Believe

CHULA VISTA
Haero Dizaye, whose parents fled Kurdistan and made their way to California, is a kindergarten and first-grade teacher, a rap artist, and a devout Muslim. While recording a new song, "Gangsta Ways," in a friend's home studio, she puts a compass on the floor to find Mecca and prays.
Photo by Peggy Peattie,
The San Diego Union-Tribune

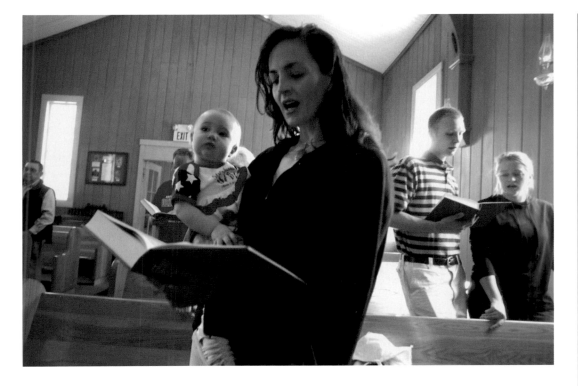

YOSEMITE NATIONAL PARK
Julie Riley and daughter Peyton are a few of the regulars at Yosemite Community Church, located amidst the granite domes, giant sequoias, and majestic waterfalls of Yosemite Valley. Most of the Sunday service's attendees are visitors passing through High Sierra country on vacation.
Photo by Kim Komenich

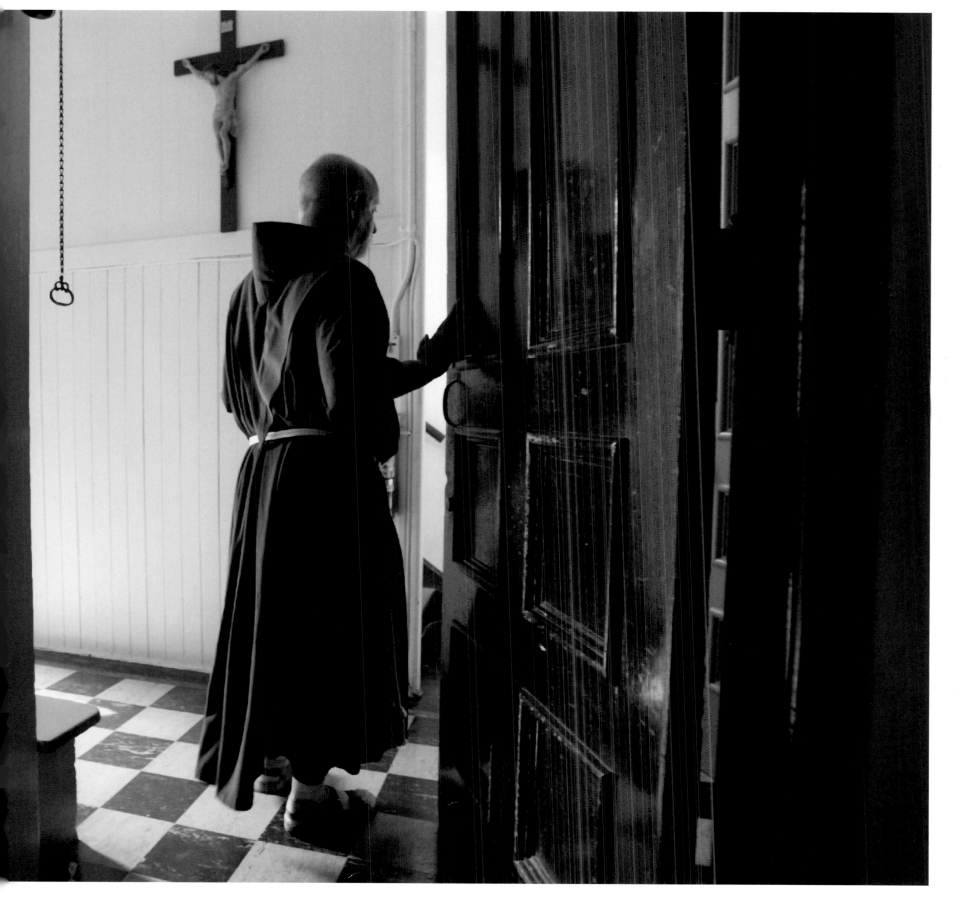

SAN FRANCISCO
"We're here to help anybody who needs help,"
says Brother Nicholas, a Franciscan friar who lives
at St. Boniface Church in the Tenderloin District.
The order runs the St. Anthony Dining Room,
which offers free lunches. Three years ago, a busy
day meant serving 1,500 people. Today, the friars
will serve as many as 2,000.
Photo by Deanne Fitzmaurice,
San Francisco Chronicle

PALM SPRINGS

A motorist is memorialized along a desolate stretch of desert near San Gorgonio Pass. Most of California's wind farms are located in three blustery locales: the Altamont Pass outside of San Francisco, Tehachapi Pass in the San Bernadino Mountains, and this sweep outside of Palm Springs. These three wind districts produce one third of the *world's* wind-generated energy.
Photo by Francis Specker

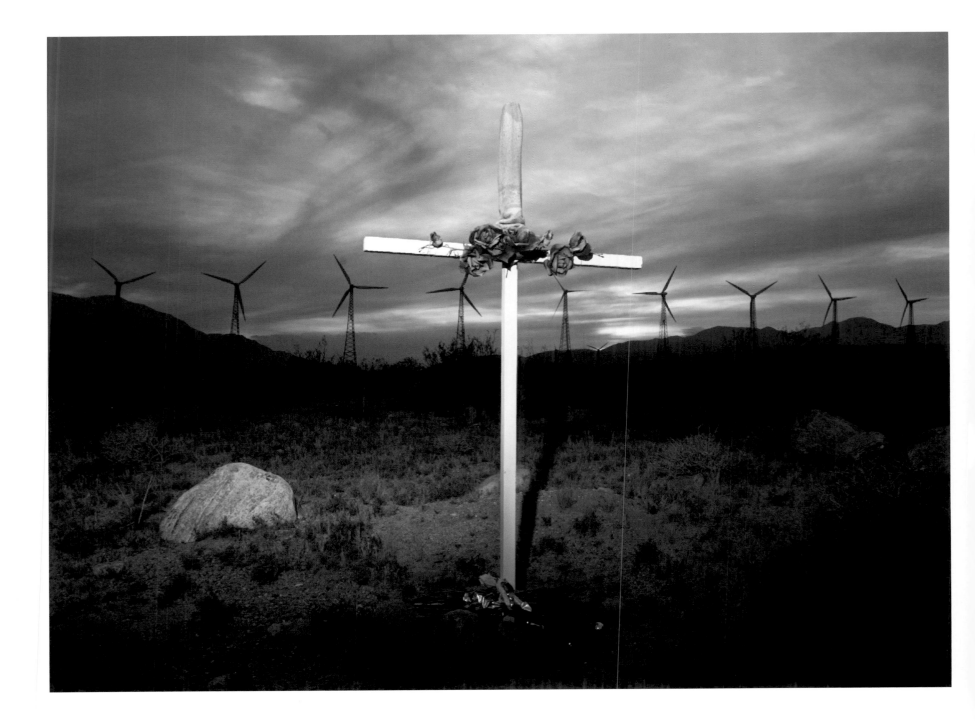

SANTA BARBARA

The 10th of 21 California missions founded by Spanish Franciscans, Mission Santa Barbara was dedicated on the Feast of St. Barbara, December 4, 1786. Converting native Americans along the way, Franciscans traveled up *El Camino Real* from San Diego to Sonoma.

Photo by Ed Bystrom

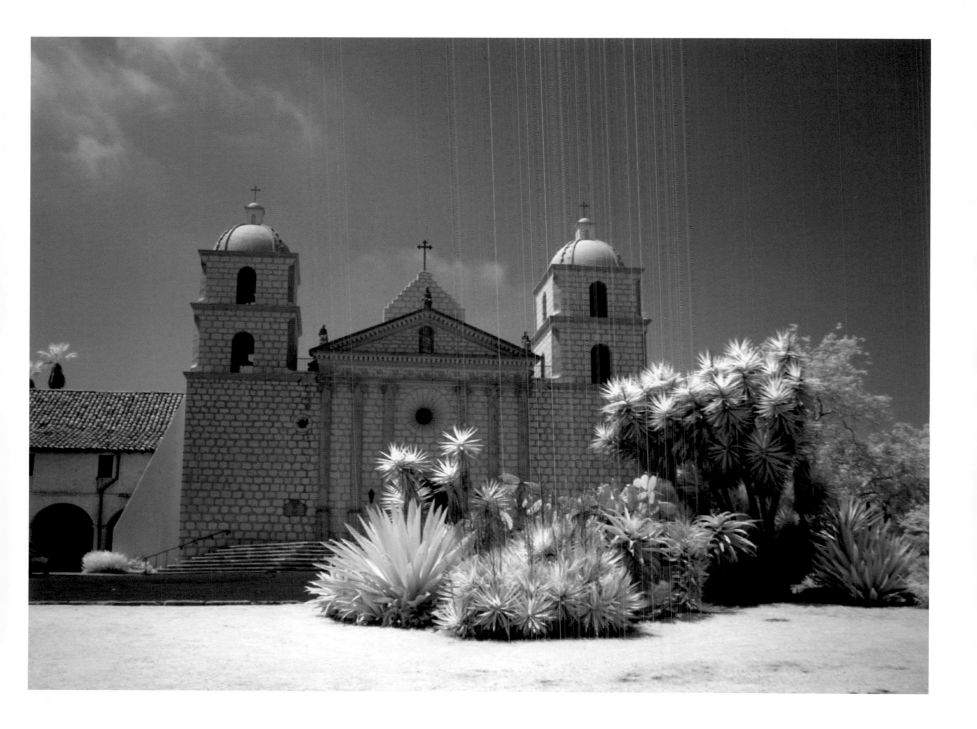

ONTARIO

The Transport For Christ ministry for truck drivers distributes crosses made of front running lights. Carolyn Young, wife of the Ontario ministry pastor, says truckers use the crosses to light up their grilles at night. The chapels, fitted out in donated semitruck trailers, serve 32 truck stops around the country.

Photo by Hector Mata

FRESNO

Michael Culver spreads the word of Jesus in the Fulton Mall. Just so there's no mistaking his purpose, Culver holds a laminated portrait of his savior and proclaims his devotion over a portable speaker.

Photo by Kurt Hegre

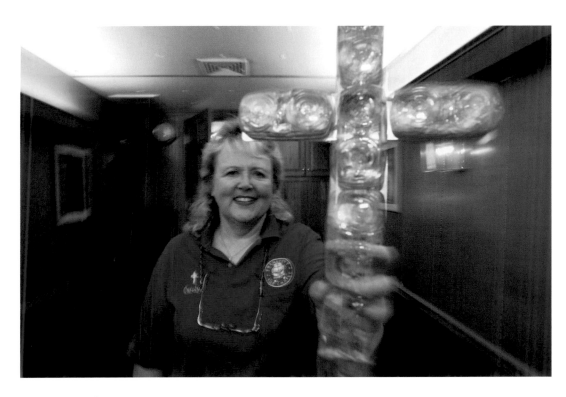

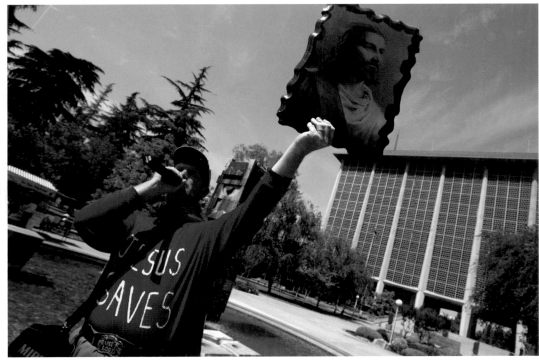

SAN FRANCISCO

In the Tenderloin's St. Boniface Church, the dispossessed take afternoon naps between services while Nicholas Hermandez sweeps the aisle. The Franciscan church also runs the St. Anthony soup kitchen next door.

Photo by Jim Merithew

SAN DIEGO
Matushka (mother) Natalie Marzev reads psalms during an all-night vigil at St. John of Kronstadt Russian Orthodox Church Abroad. "Matushka" indicates Marzev is married to a priest, or Batushka.
Photo by Nadia Borowski Scott,
The San Diego Union-Tribune

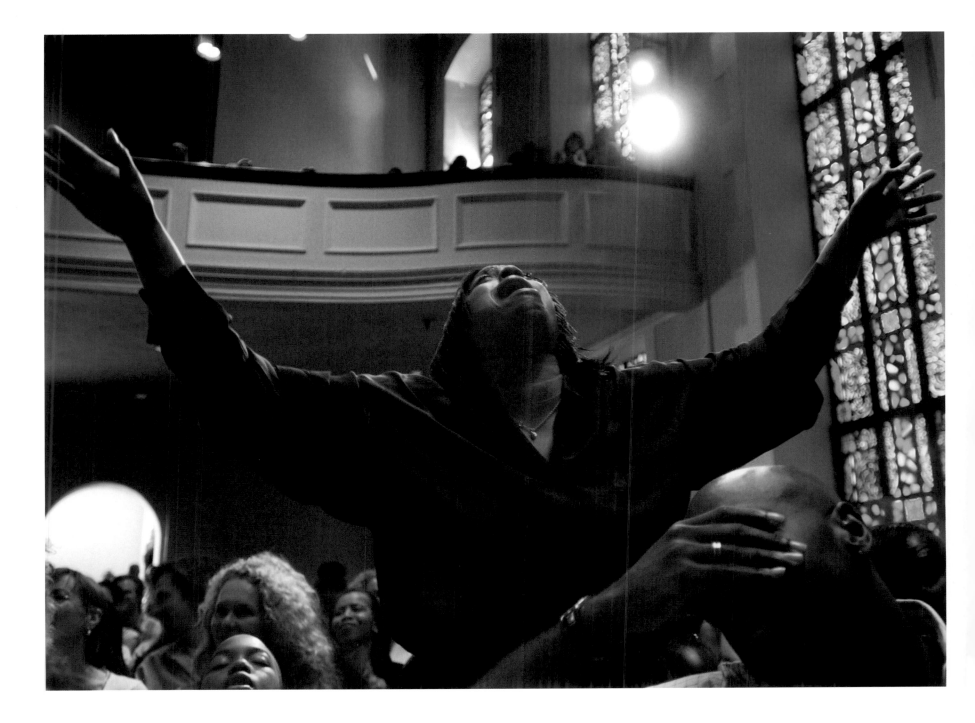

SAN FRANCISCO
Hallelujah! Tracy Noriega feels the rapture during Sunday services at Glide Memorial Church. Renowned for its electrifying, gospel-belting services and many outreach programs (more than a million free meals served each year), Pastor Cecil Williams's 10,000-member church has been ground zero for San Francisco's multicultural ecumenical fervor for 37 years.
Photo by David Paul Morris

MENLO PARK

Mike Wilkerson, an Oakland-based real estate consultant, receives his second baptism at the Abundant Life Christian Fellowship. "I wanted to experience baptism as an adult, now that I have a real understanding of what it means," says Wilkerson.

Photo by Jim Gensheimer,
The San Jose Mercury News

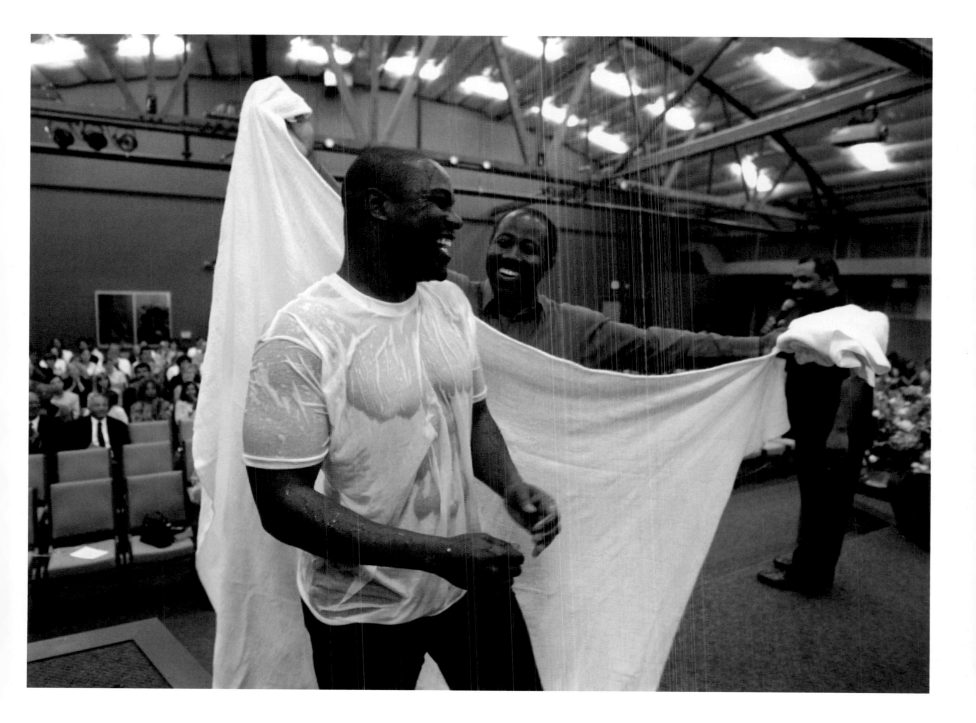

SAN FRANCISCO
Maria Carmona gets help filling out a form at Queen of Peace, a home for pregnant women and their infants run by Missionaries of Charity, the order founded by Mother Teresa. The nuns have beds for up to eight women, who can stay for a month after giving birth.
Photos by Deanne Fitzmaurice,
San Francisco Chronicle

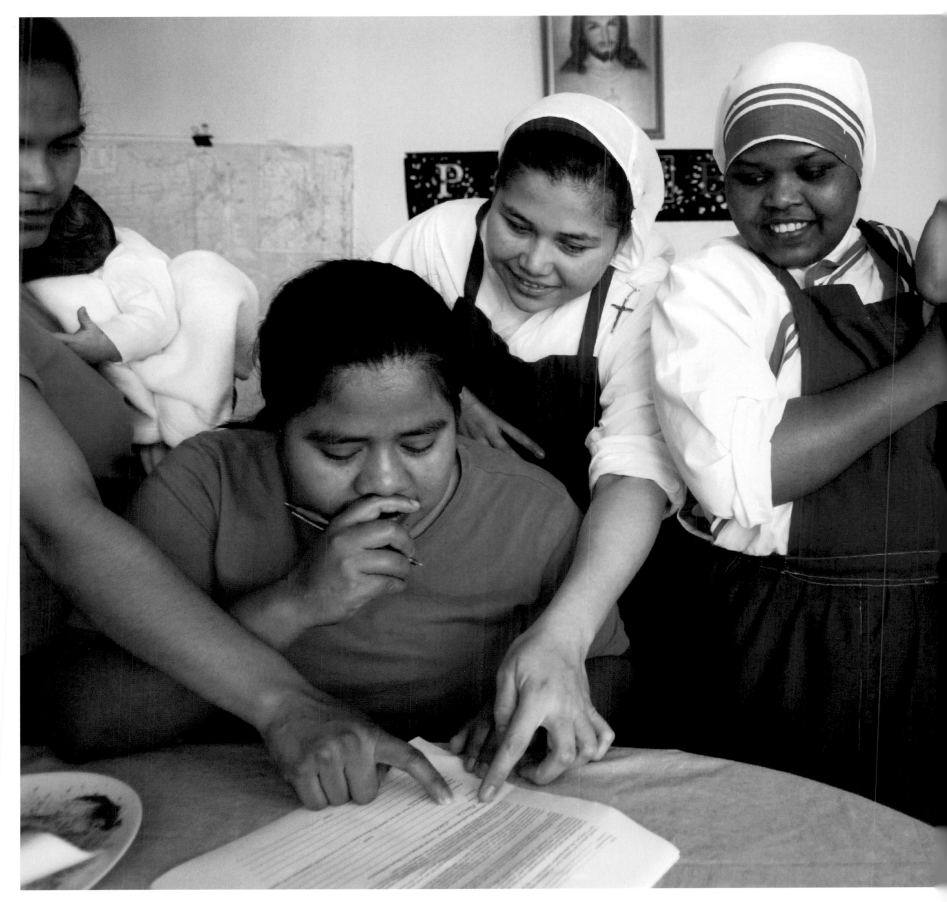

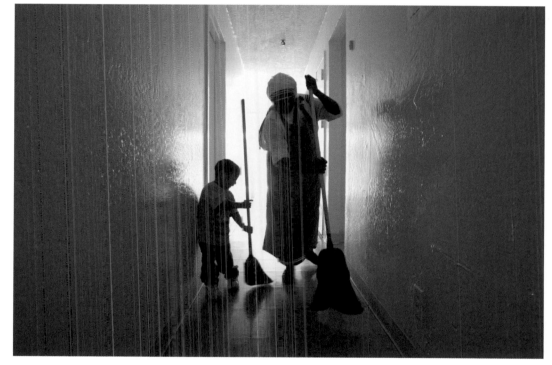

SAN FRANCISCO

Two-year-old Andres Arguijo, whose mother has just had a baby, helps Sister Jermina sweep a hallway. While the mothers stay at Queen of Peace, they're expected to help with chores.

SAN FRANCISCO

When the mothers-to-be gather in the sitting room (no television allowed), they play various kinds of music in English and Spanish, from rock to oldies to rap. After they've left, Sister Andrew steps up to turn off the music.

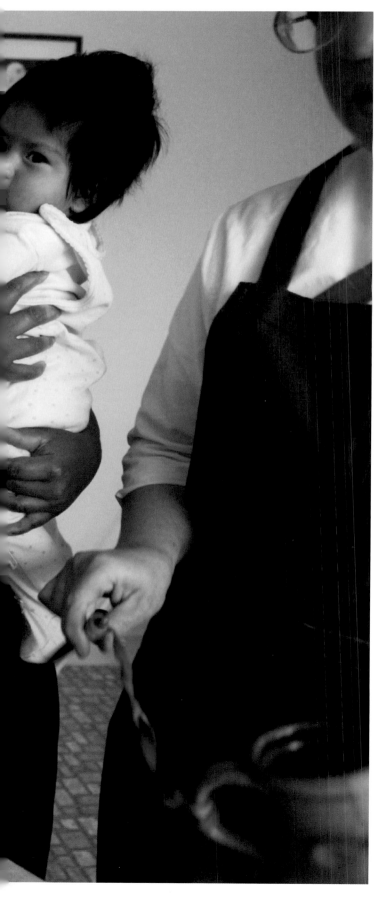

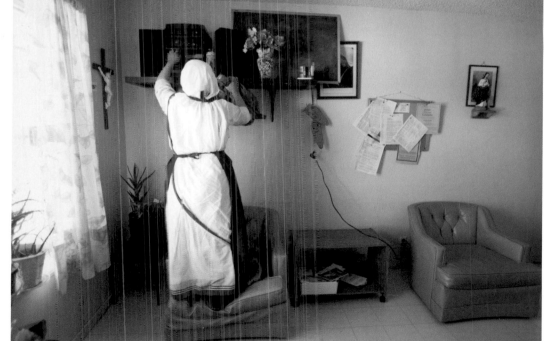

SAN JOSE
Darshan Hothi, 81, waits to enter the San Jose Sikh temple. Hothi immigrated from the Punjab region of India in 1976 after his brother-in-law secured him a visa. Over the next six years, his five children followed. The Hothis are among the 50,000 Sikhs who live in the Bay Area.
Photo by Patrick Tehan

WESTMINSTER
An incense ring is ready to burn at Bao Quang, a Vietnamese Buddhist temple. The spiral shape burns for four hours, repelling insects and providing fragrant smoke for meditation.
Photo by Tony Nguyen-Campobello

SAN JOSE

Sweet 15. Vanessa Paniagua offers flowers at the altar of Our Lady of Guadalupe before her *quinceañera*, an elaborate coming-of-age party that marks her transition into adulthood.
Photo by Patrick Tehan

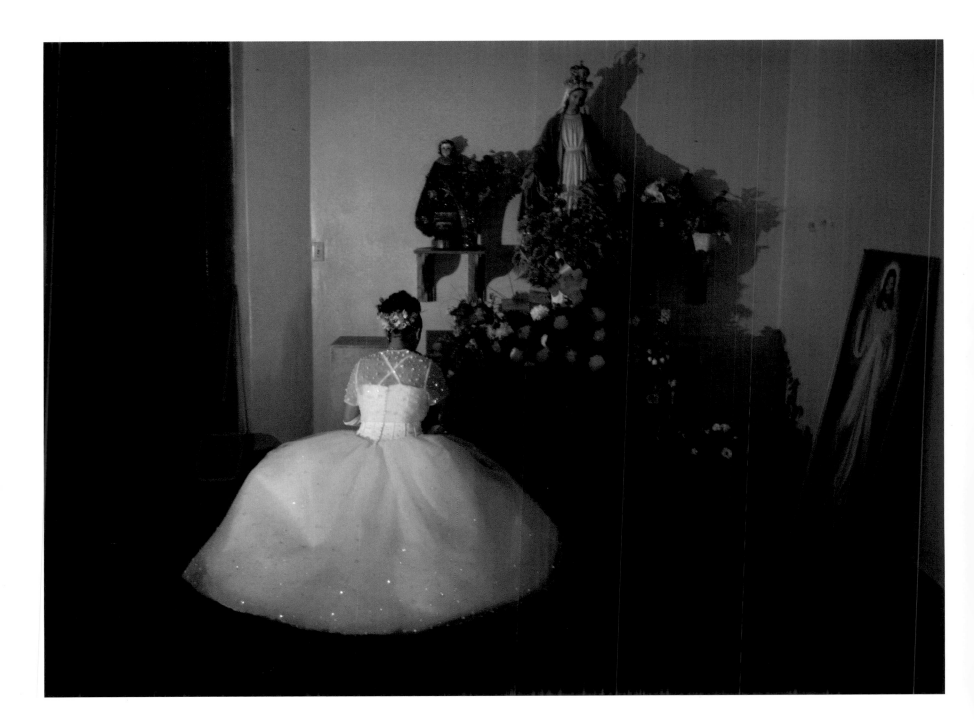

VENICE BEACH

Beach-loving psychic Luann "Luna" Hughes reads
tarot cards and charts palms for Venice visitors
who seek answers about life, money, and love.
Photo by Michael Grecco Photography,
Icon International

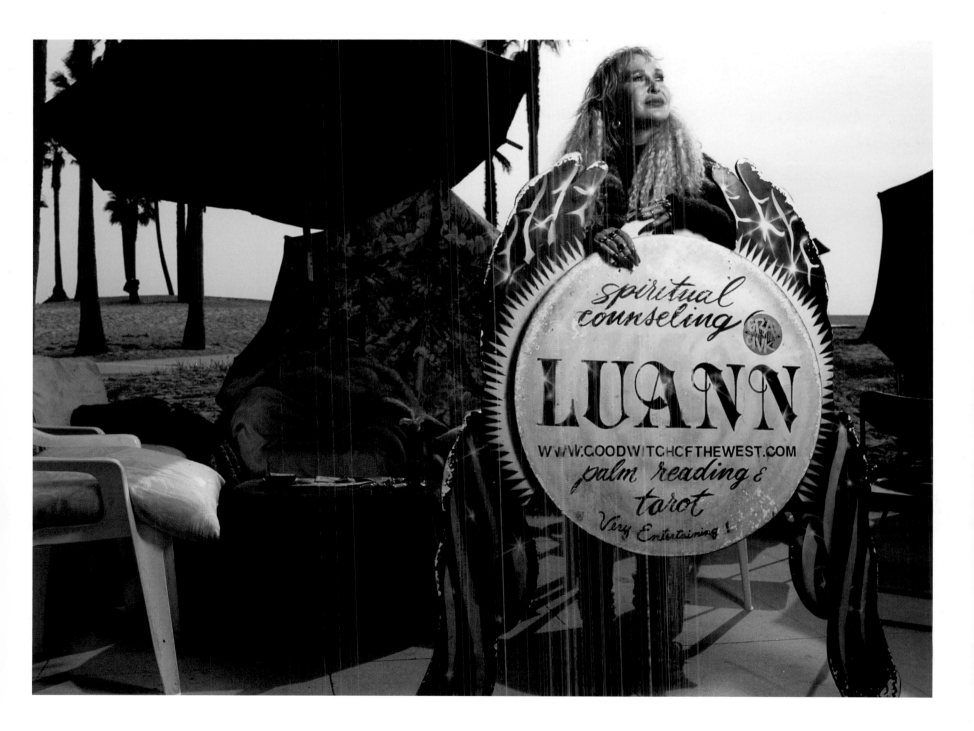

LONG BEACH
The Queensway Bay Bridge transports cars and pedestrians between downtown Long Beach and the docks. At the end of the 19th century, town fathers touted Long Beach as a healthful seaside resort, but its estuarine bay and the discovery of oil at Signal Hill in 1921 rendered it an industrial port city.
Photo by Thomas P. Mcconville

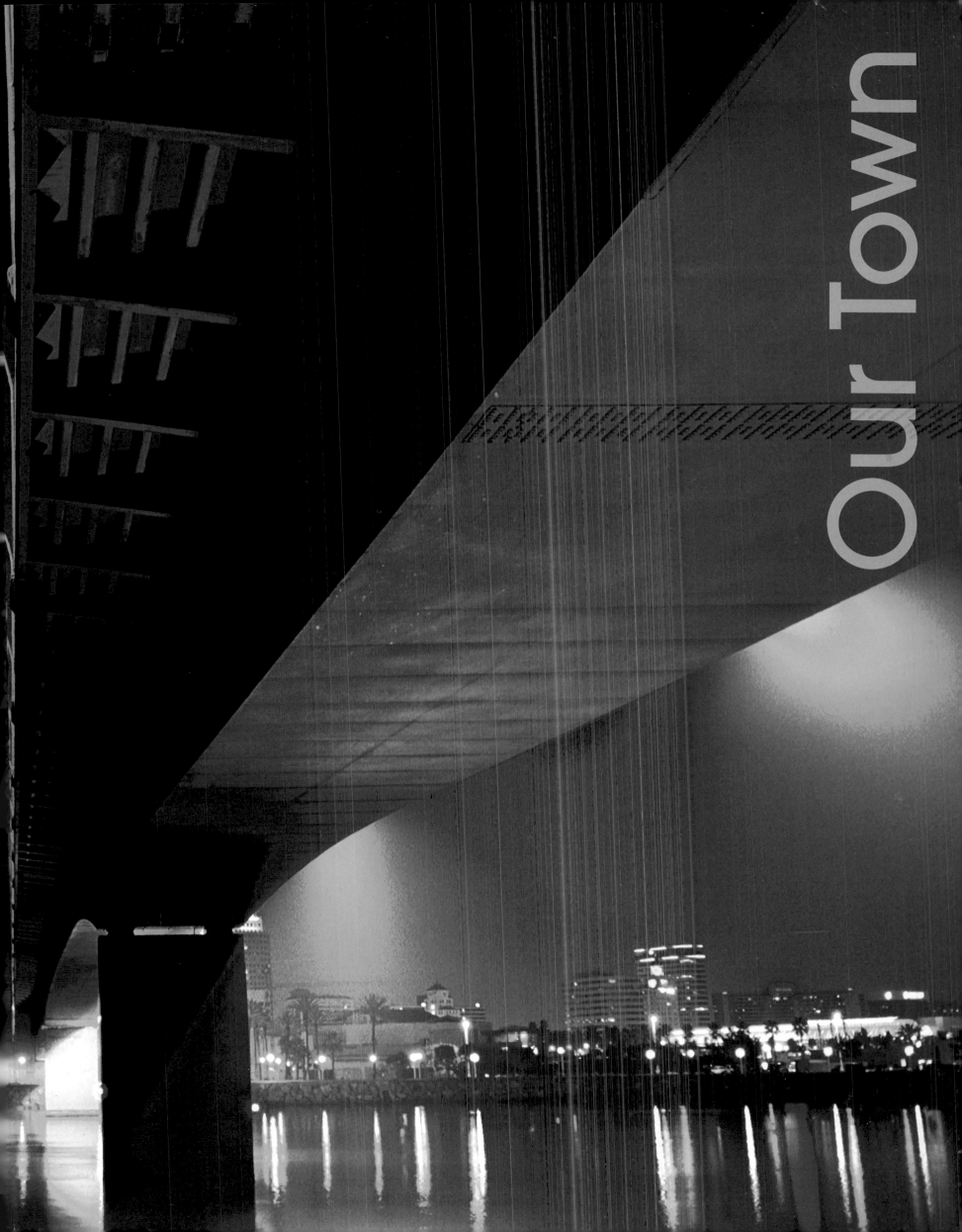

Our Town

UNIVERSAL CITY
In the global village, few personalities are as oversized as movie star Jim Carrey. At the May 14 premier of his latest film, *Bruce Almighty*, Carrey steps off the red carpet and into the crowd to sign autographs and pose with fans.
Photo by Jeffrey Aaronson, Network Aspen

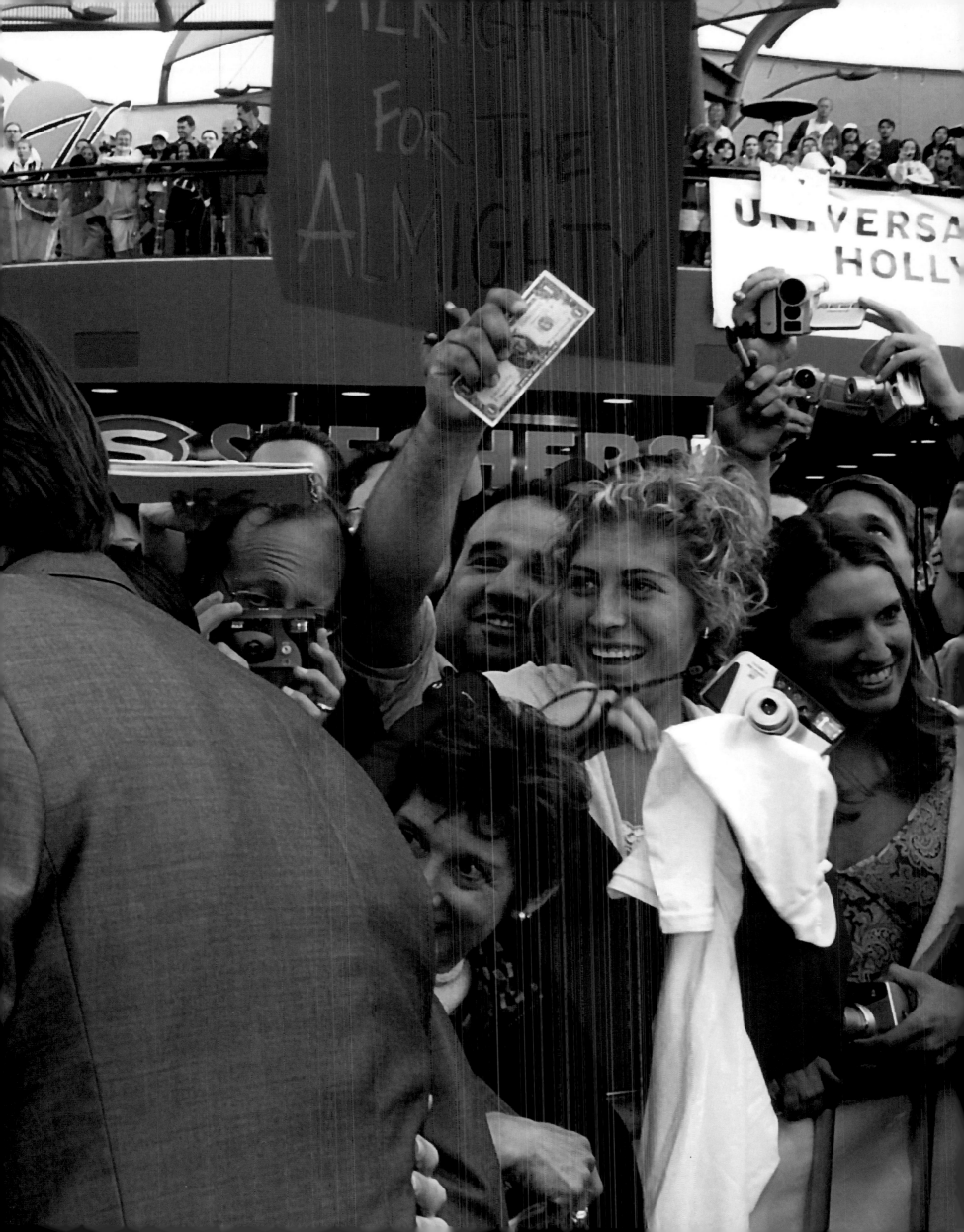

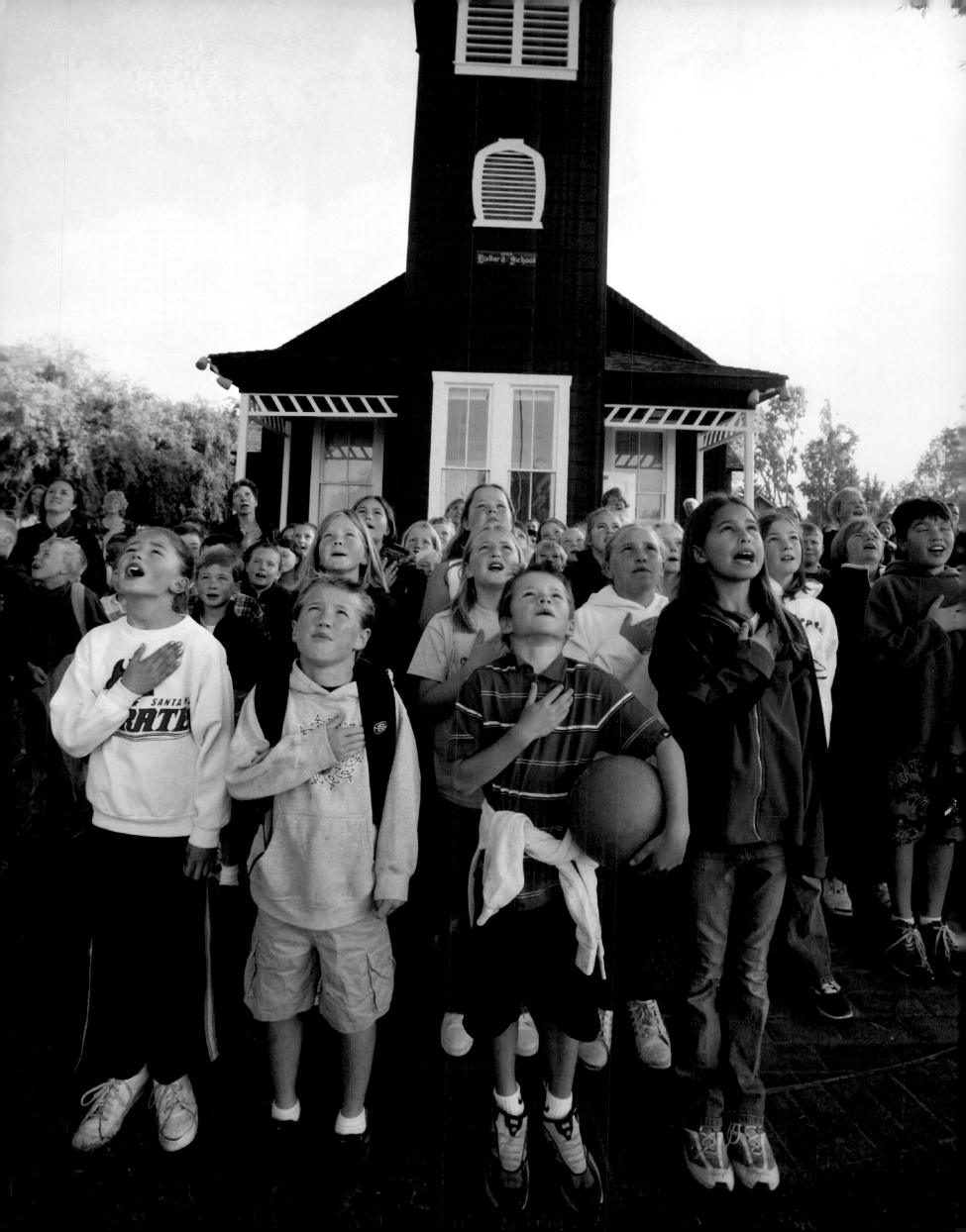

SOLVANG

The Little Red Schoolhouse is still in action, as it has been since 1883. Every morning, one of the 128 children at Ballard School (housed in Little Red and two other buildings) rings the bell in the tower and then leads the K–6 ensemble in the Pledge of Allegiance.
Photo by Jeffrey Aaronson, Network Aspen

SACRAMENTO

Bladerunner: Mathew Mine, 11, steals a ride down the California State Capitol steps before Highway Patrol officers stationed inside throw him off. Bicycling, skateboarding, and inline skating are forbidden on the Capitol building grounds—but the rule is often flouted.
Photo by Paul Kitagaki, Jr.

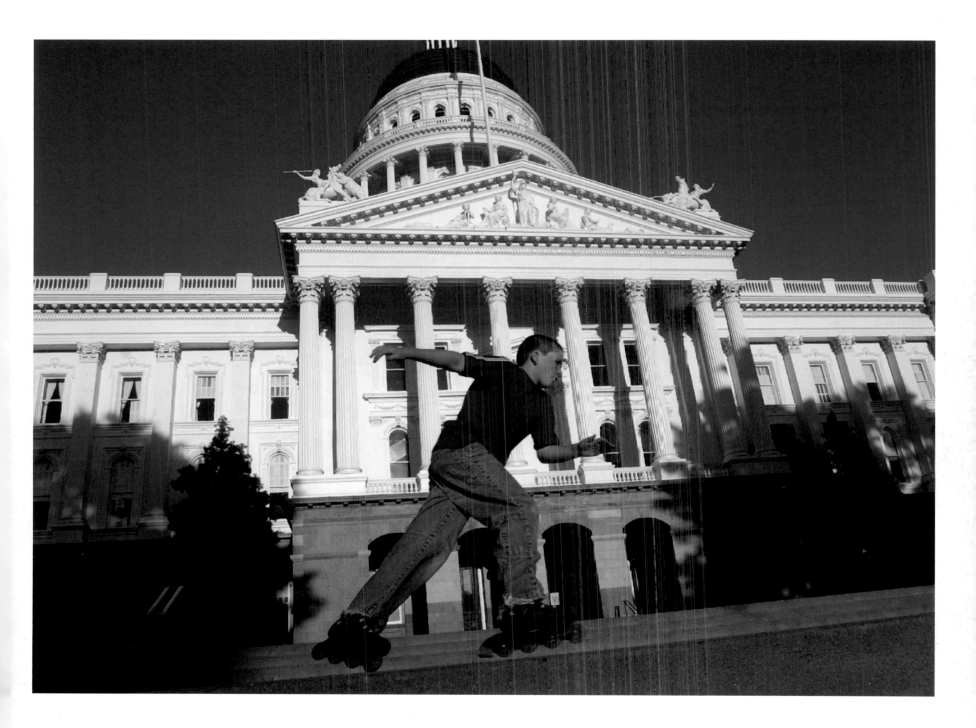

SARATOGA

Baby, you can drive my car: It doesn't take much coaxing to get Jacob Gensheimer to Gene's Fine Foods. Parents and kids love the kiddy carts, dubbed "Shoppers in Training." The only downside is the inevitable meltdown in the checkout line when it's time to leave.

Photo by Jim Gensheimer,
The San Jose Mercury News

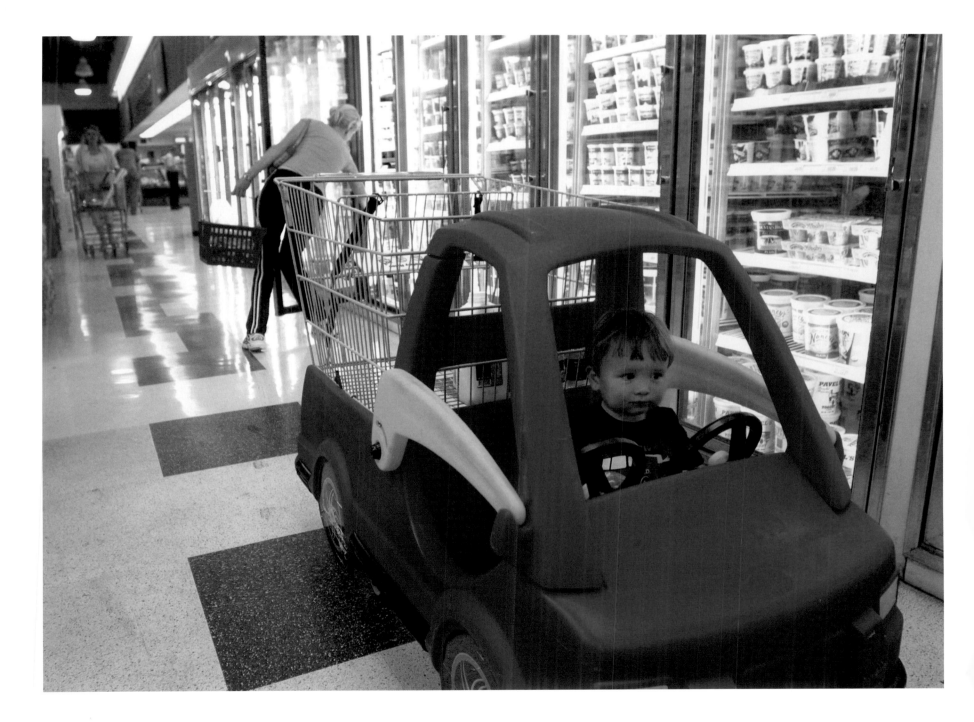

PASADENA

At the NASA Jet Propulsion Laboratory open house, Principle Scientist Bruce Banerdt demonstrates the ins and outs of roaming the Red Planet. Kids provide the terrain as he steers a miniature version of a Mars Exploration Rover. JPL builds spacecraft, telescopes, and robots and oversees NASA's deep space exploration program.
Photo by Laura Kleinhenz

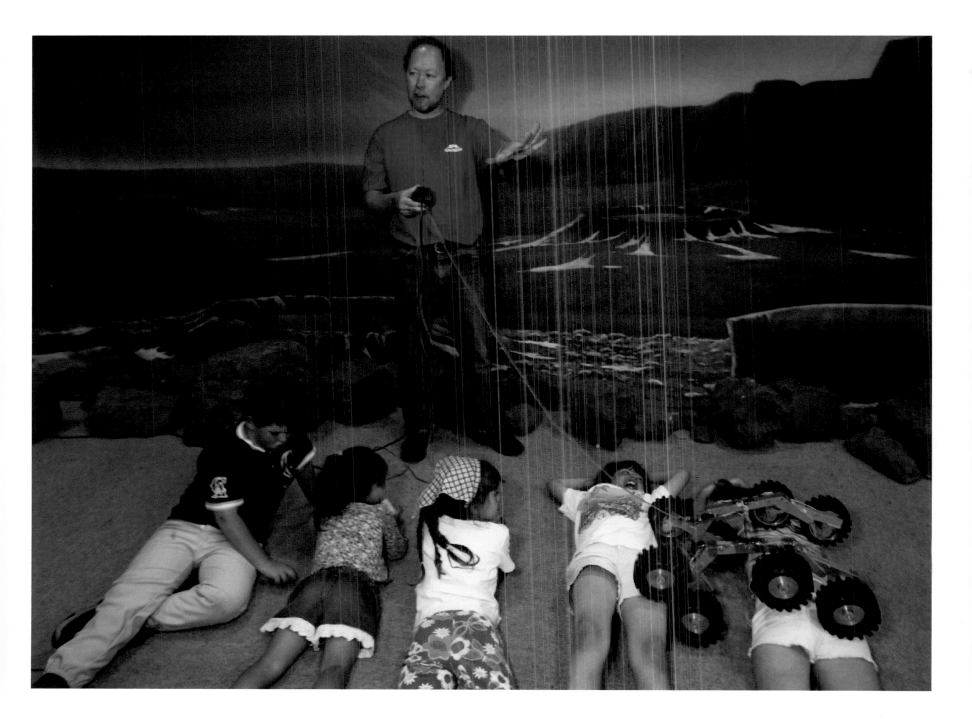

HOLLYWOOD

Deer crossing. Employee Tomas Banitaz moves a small head past some large ones at C.P. Three, one of four warehouses owned by Omega Cinema Props. Omega claims to offer the largest selection of props in the industry. The Easter Island–style noggins made their debut years ago in a Janet Jackson video.

Photo by Jeffrey Aaronson, Network Aspen

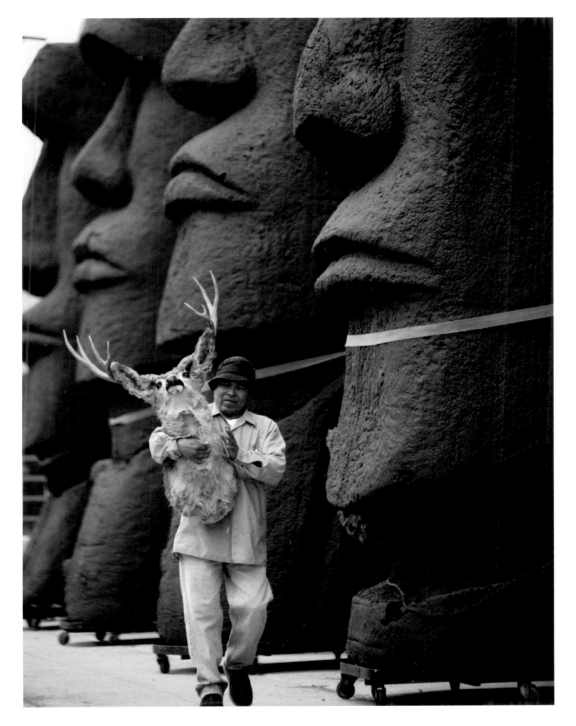

LOS ANGELES

Just east of the Los Angeles River, the Boyle Heights neighborhood centers around Mariachi Plaza, where locals go to get a good taco, do laundry, and hear mariachi bands hoping to get hired out for parties.

Photo by Hector Mata

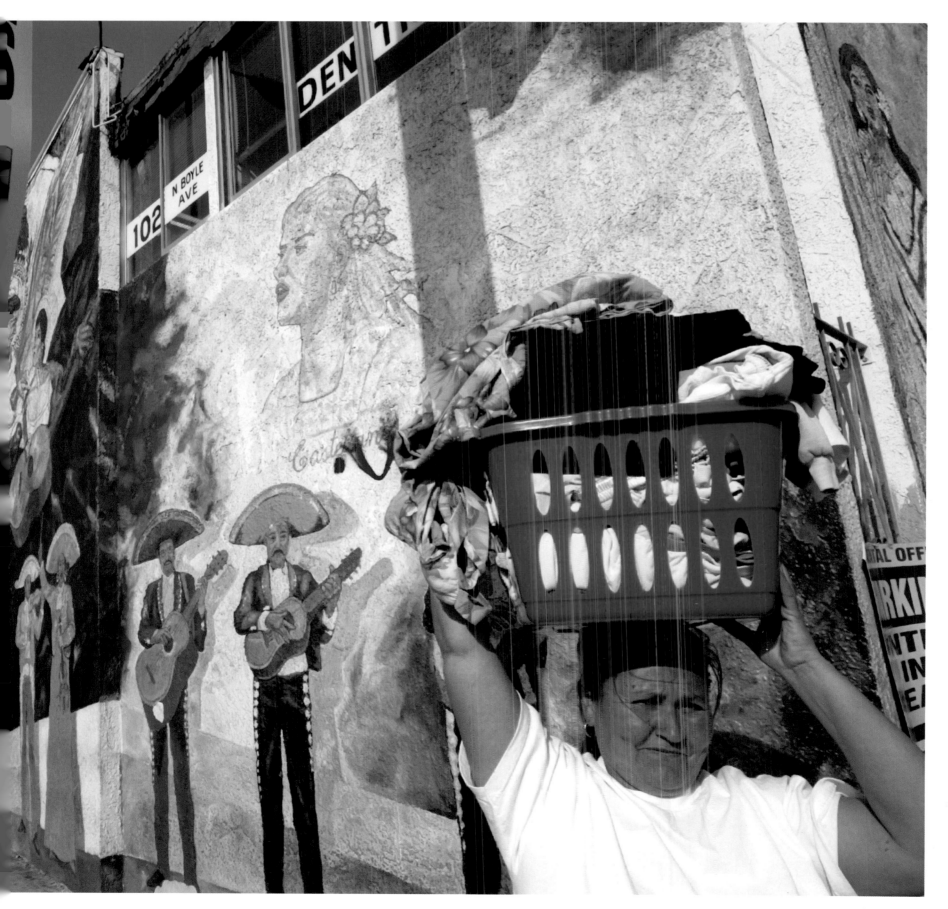

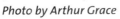

MALIBU
Muralist David Legaspi III puts the finishing touches on *The Little Bridge Between the Mountain and the Sea Where the Kelp Plant Meets the Sycamore Tree.* Legaspi and 500 children from the greater Los Angeles area painted the mural on the Pacific Coast Highway underpass in Leo Carrillo State Park to commemorate the park's 50th anniversary.
Photo by Arthur Grace

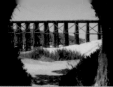

MONTEREY

At the Monterey Bay Aquarium, volunteer divers wash the Kelp Forest exhibit windows. More than 2,000 gallons of seawater per minute are pumped into the tank, causing the massive plants to swing and sway as they would in the ocean. Wild kelp is harvested for the emulsifier algin, found in beer, toothpaste, and ice cream.

Photo by Julia Coburn

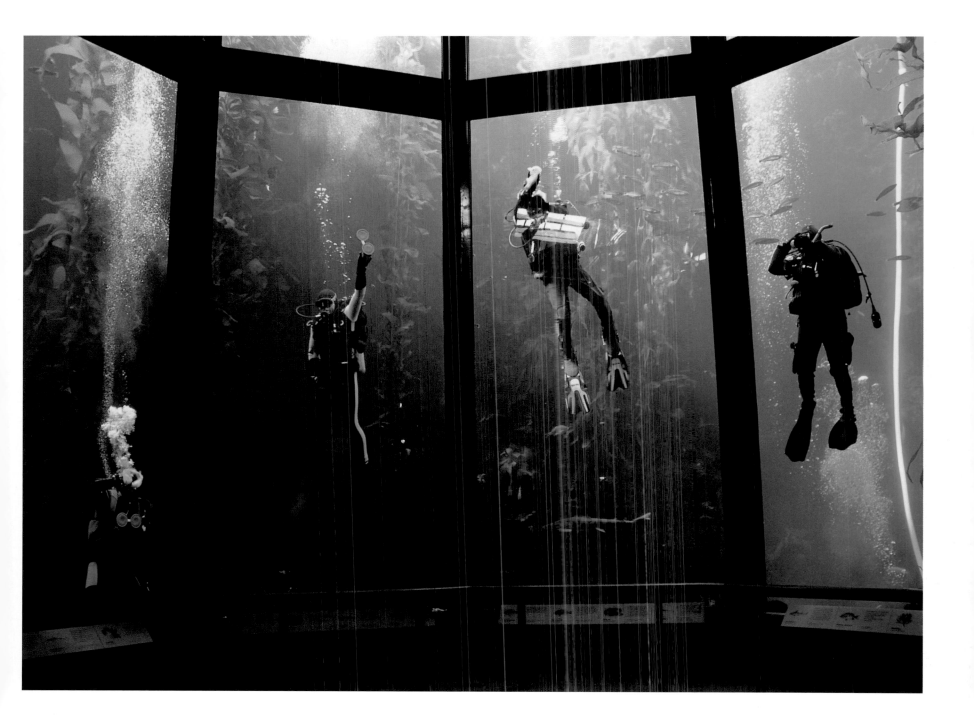

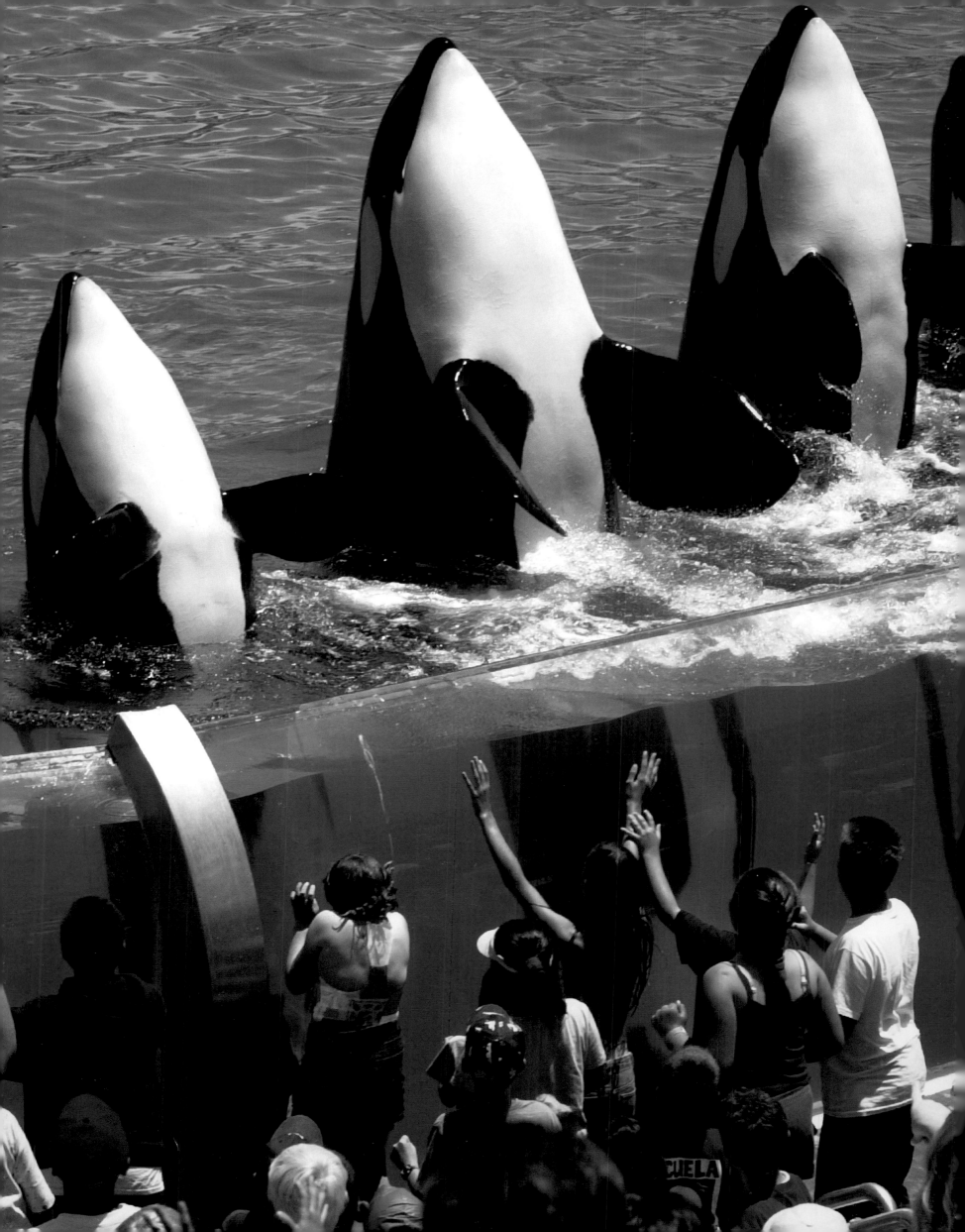

SAN DIEGO

Killer whales give a "pec wave," thrilling spectators at SeaWorld San Diego. The marine mammals learn such performance behavior through a long, trusting relationship with their handlers. Denizens of every ocean (especially the Arctic and Antarctic), killer whale images have been found in 9,000-year-old Norwegian cave drawings.
Photos by Nadia Borowski Scott,
The San Diego Union-Tribune

SAN DIEGO

Greg Streicher, a Wild Arctic team member at SeaWorld, puts his hand up and Nanuq, a 20-year-old Beluga whale, rises out of the 55-degree water. In the wild, the whales do this same "spy hop" maneuver to look around above water. Belugas do well in confinement; they are accustomed to constricted space because they mostly stay under pack ice to avoid predators.

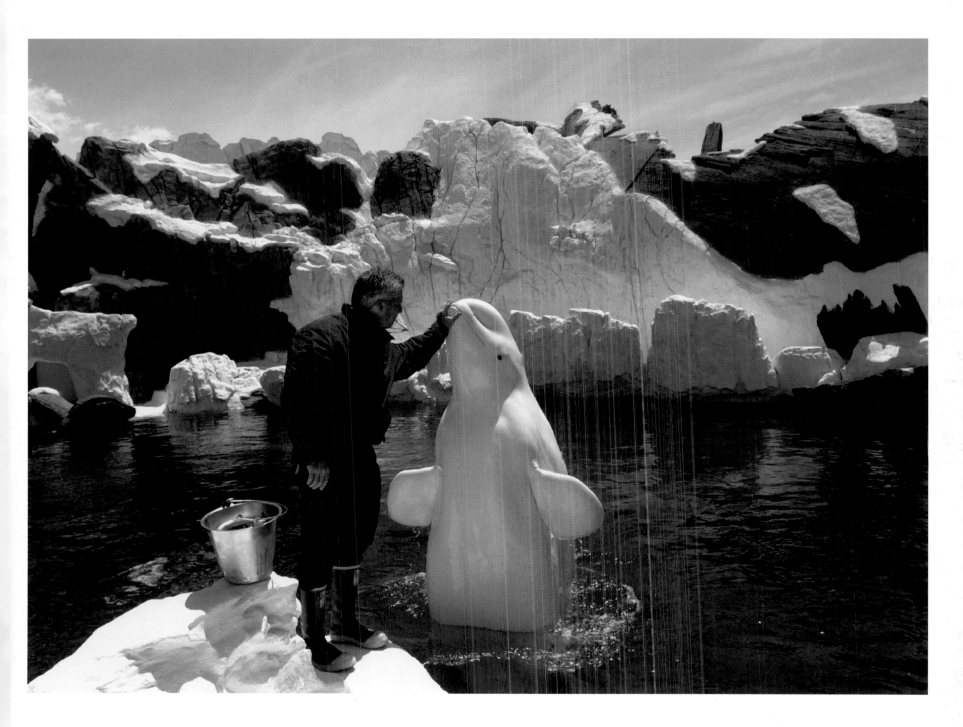

CALEXICO
The 80-mile All-American Canal along the Mexican border not only irrigates California's Imperial Valley, it also serves as a perfect swimming spot. Although climbing through the border fence into America is technically illegal, on particularly hot days the Border Patrol tends to look the other way.
Photo by Peggy Peattie,
The San Diego Union-Tribune

SAN FRANCISCO

Ari Max Bachrach props up a wall in front of Atlas Cafe in the Mission District. The dog-friendly cafe caters to the artistic and computer-toting hipster interlopers of this primarily Latino neighborhood. "I like the barbecued tofu with nori," says Bachrach, who oversees publications for Health Initiatives for Youth.
Photo by Ed Kashi

SAN FRANCISCO

This elderly man has walked from trash can to trash can in Chinatown, removed the contents, culled what he wants, and then meticulously replaced what he doesn't. In 2003, the San Francisco mayor's office estimated the city's homeless population at as many as 15,000. The city's Coalition on Homelessness insists the number is much higher.
Photo by Deanne Fitzmaurice,
San Francisco Chronicle

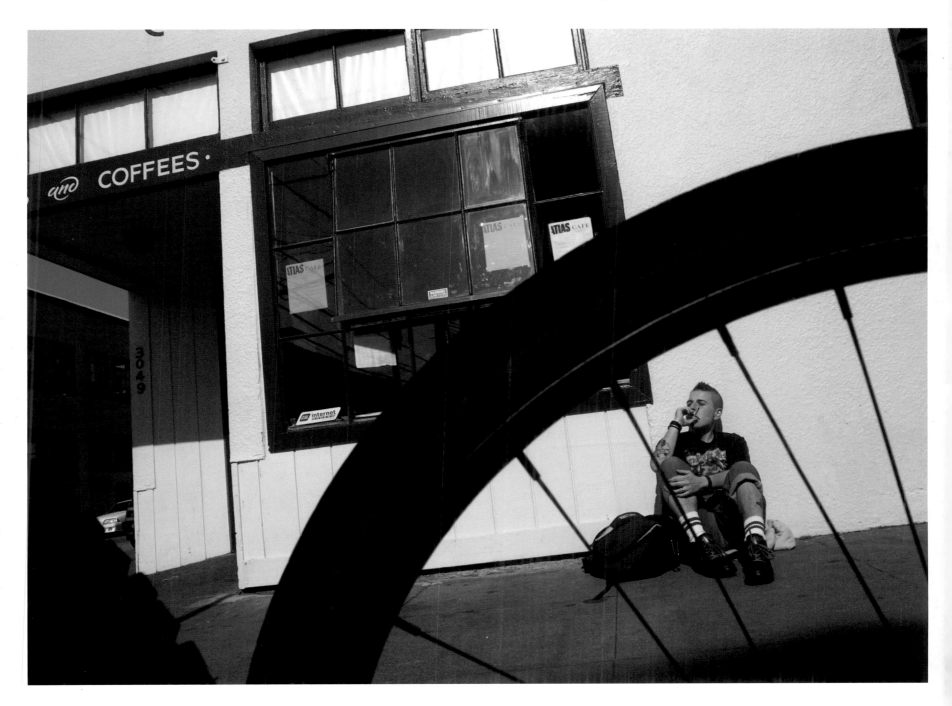

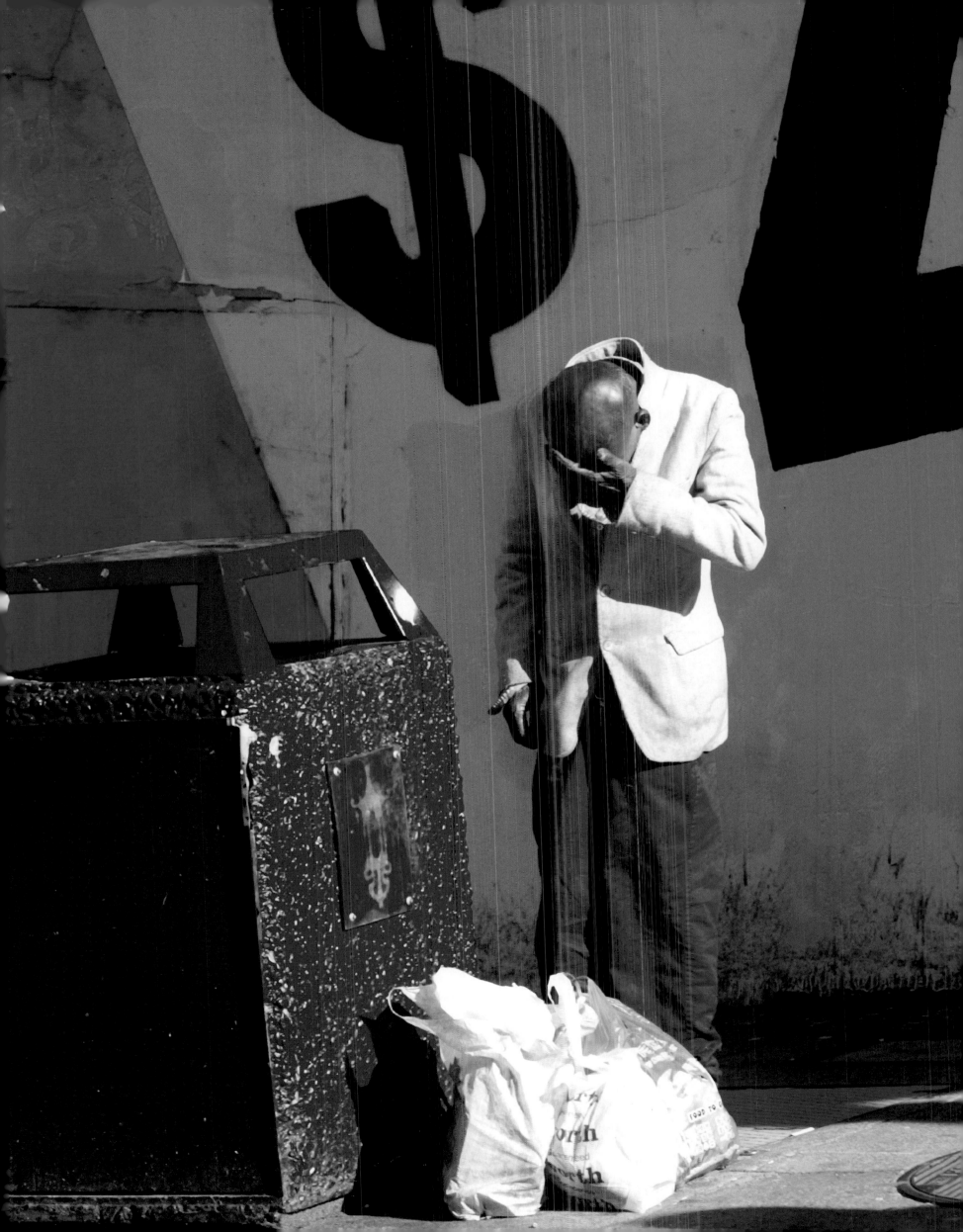

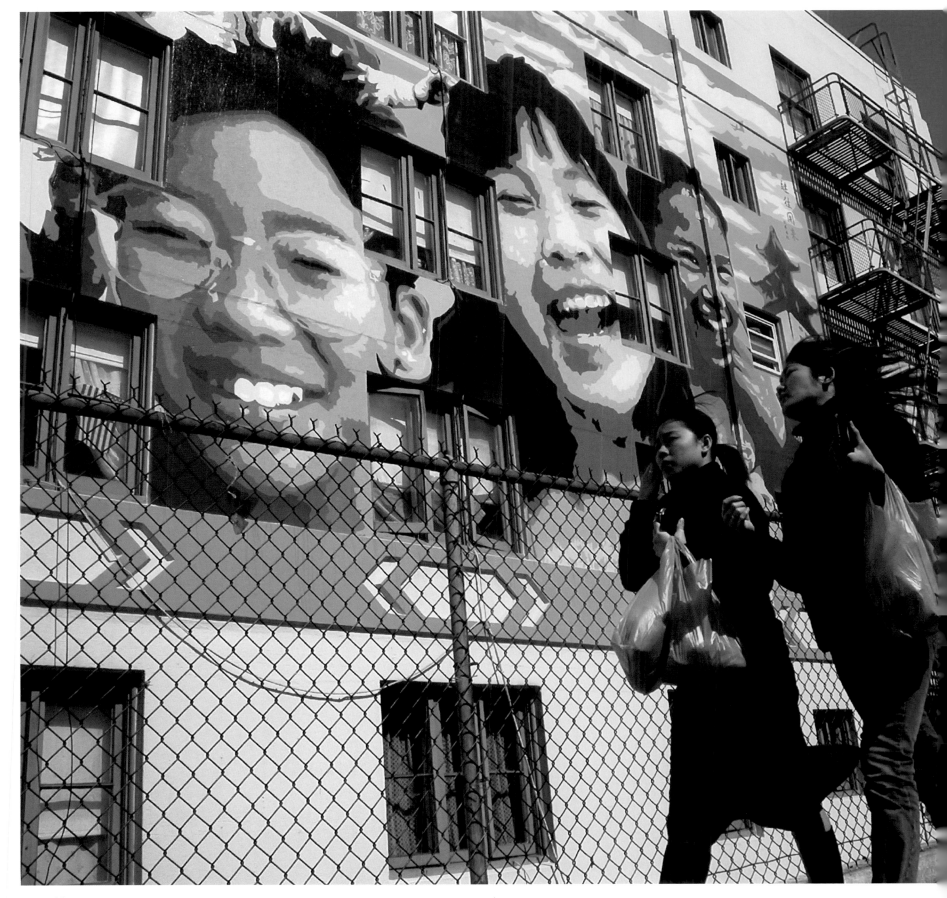

SAN FRANCISCO

Rumors of California gold reached China in the late 1840s and lured thousands of men to *Gum San*, or Gold Mountain. But anti-Chinese sentiment flared when the economic boom went bust, and Congress banned further immigration with the Chinese Exclusion Act of 1882. When it was finally repealed in 1943, San Francisco built this Chinatown housing complex to accommodate the second wave of immigrants.
Photo by David Gregory

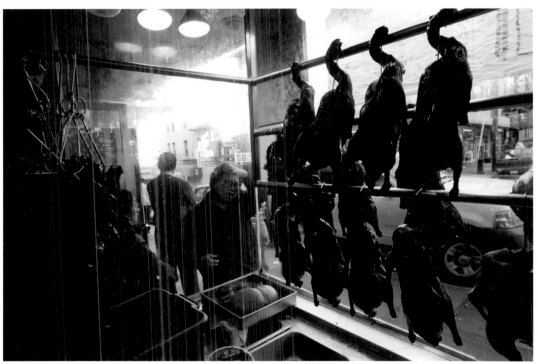

SAN FRANCISCO
Rows of Peking ducks hang in the window of King Tin restaurant on Washington Street in Chinatown. Repeated roasting at various temperatures imparts the brilliant scarlet color. A glaze of honey and vinegar imparts the sweet and sharp taste.
Photo by Deanne Fitzmaurice,
San Francisco Chronicle

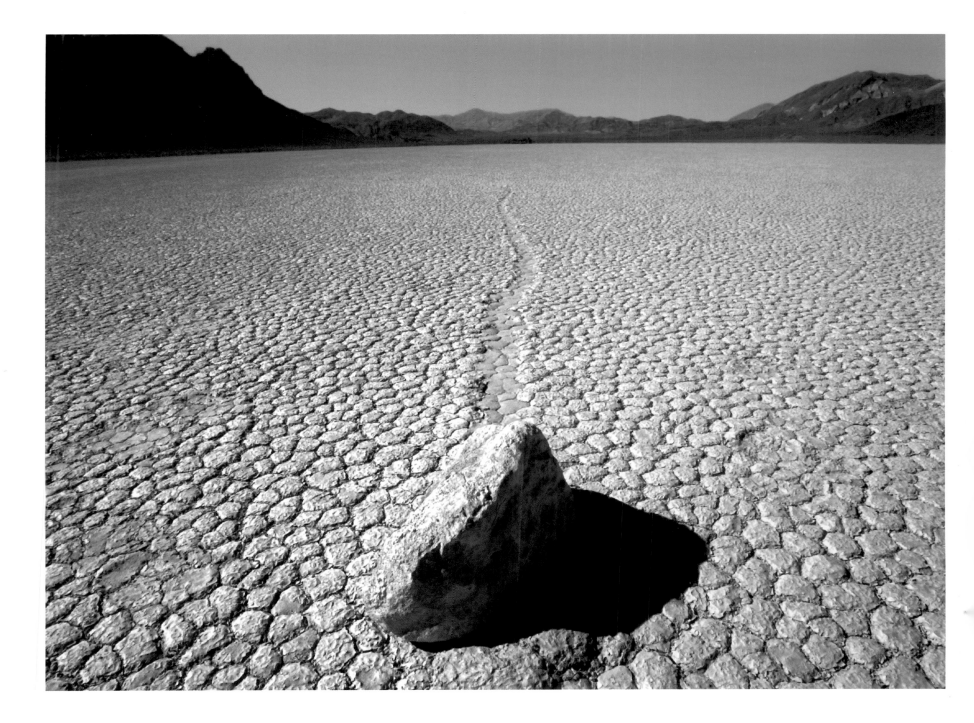

DEATH VALLEY

Rock don't run: There have been no known eye-witnesses to rocks moving at the "Race Track" on the valley floor. Theories abound. The most prevalent one: Rain and high winds move the rocks along the silt lake bed.
Photo by Brian D. Schultz

LOS ANGELES

Home of the Los Angeles Philharmonic Orchestra,
the 2,265-seat Disney Concert Hall was scheduled
for completion in the fall of 2003. Designed by
celebrated architect Frank Gehry, the dramatic,
steel-clad building, with its sculpted interior of
Douglas fir, puts Los Angeles in the first rank of
world cities for music and architecture buffs.
Photo by Hector Mata

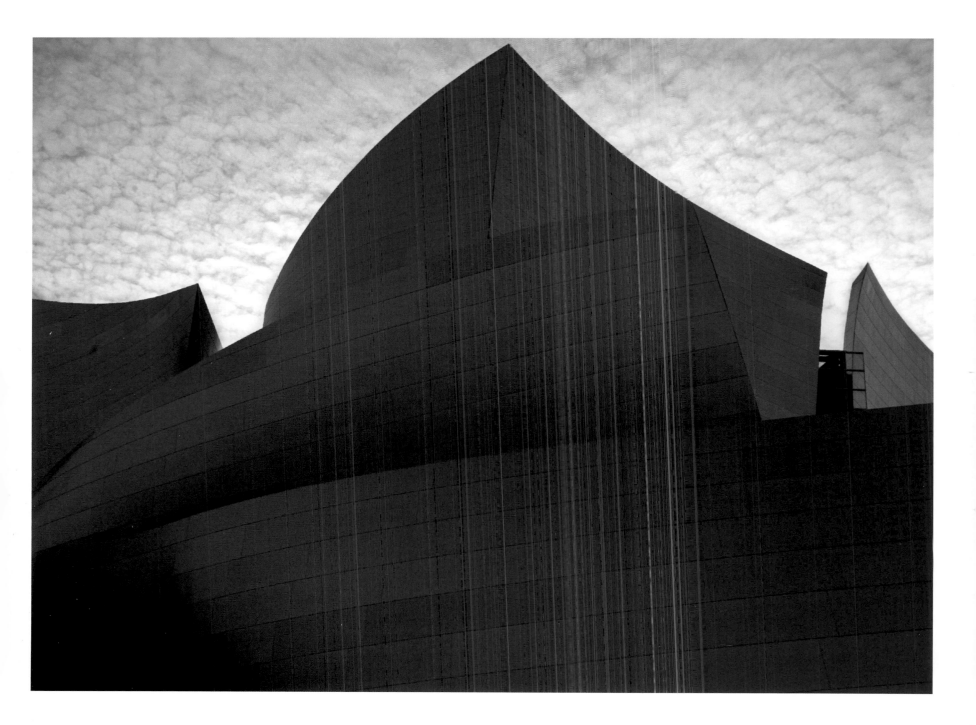

MT. SHASTA

"As lone as God, and white as a winter moon, Mount Shasta starts up sudden and solitary from the heart of the great black forests of Northern California," wrote 19th-century poet Joaquin Miller of the second-highest mountain in the Cascade Range. At 14,162 feet, the dormant volcanic peak dominates the scenery along I-5 through Northern California.
Photo by George Wedding, GEOPIX

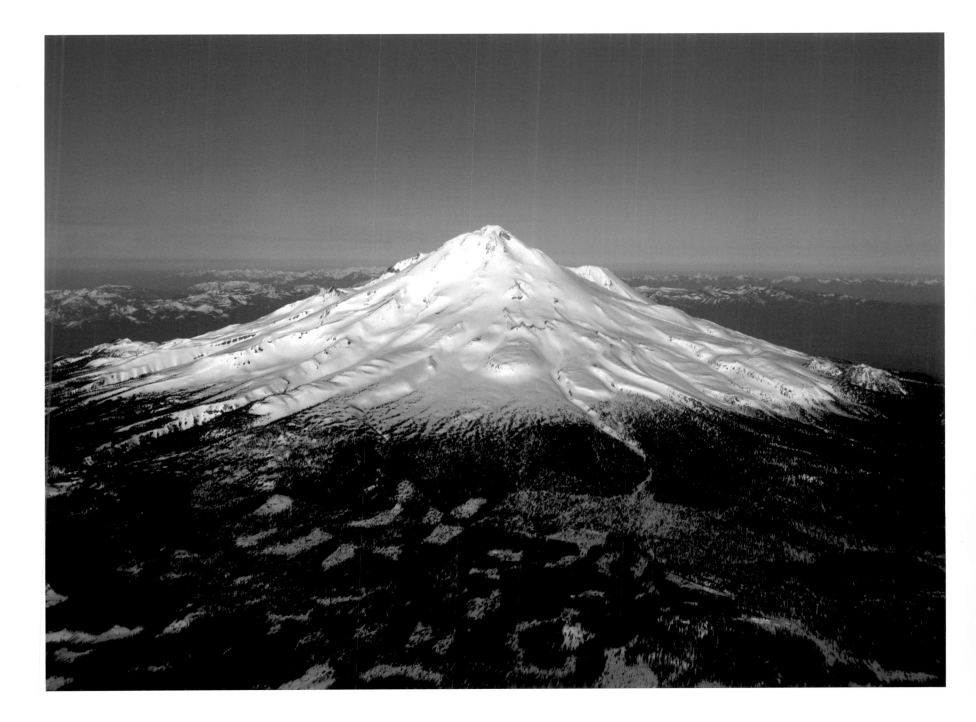

MADELINE

A delivery truck blends into the High Sierra horizon. Contrary to appearances, the Colorado beer is an outsider here: This is Anheuser-Busch country, far and away the state's top-selling brew.
Photo by Kim Komenich

ORICK

The legend of a giant logger and his hardworking helper, Paul Bunyan and Babe the Blue Ox, migrated west from midwestern lumber camps. Proud symbols of the once-booming northcoast timber industry, the duo greets tourists in the parking lot of a roadside stop called Trees of Mystery.

Photo by Josh Haner

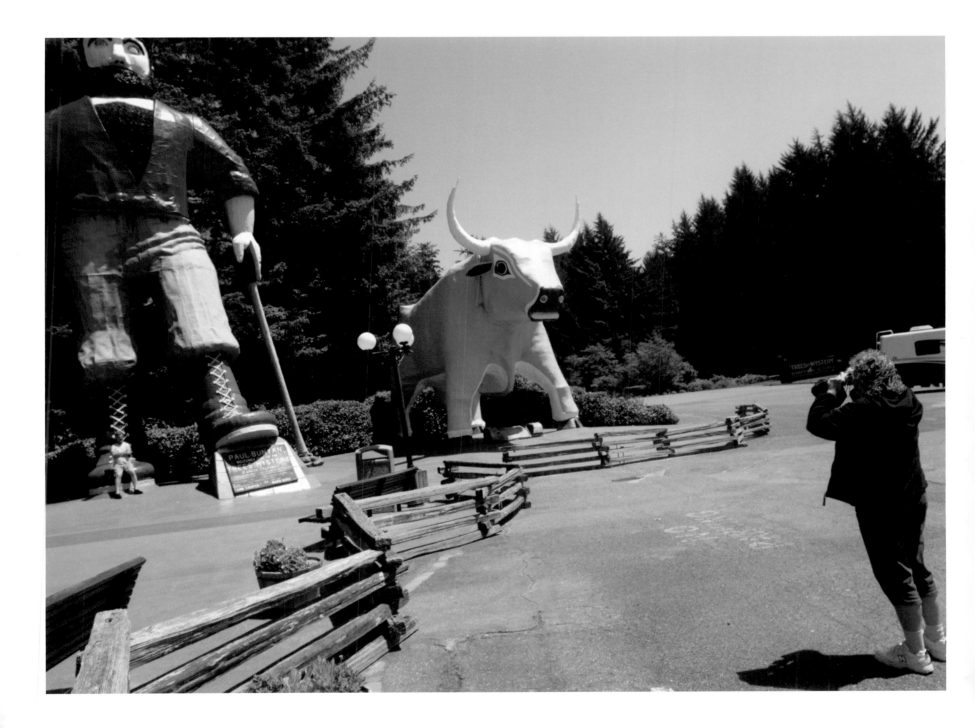

THREE RIVERS

This giant bull effigy housed a mobile hamburger grill when it was in Visalia. Now it's just an attention-grabber at the Kaweah General Store in the Sierra Nevada foothills, pulling in traffic headed to Sequoia National Park on Route 198.

Photo by Kurt Hegre

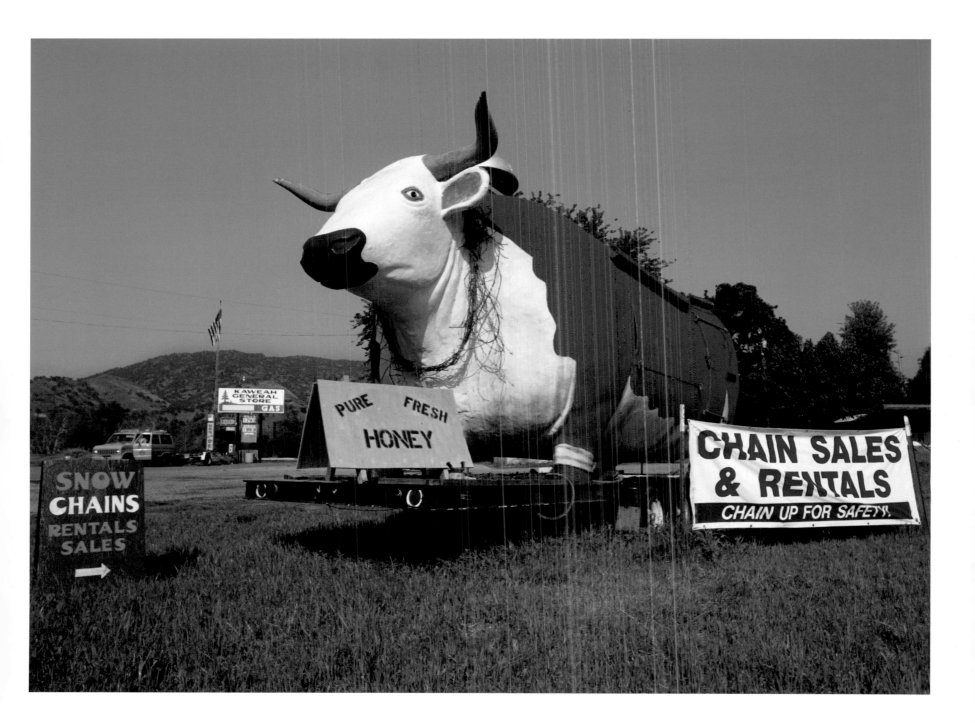

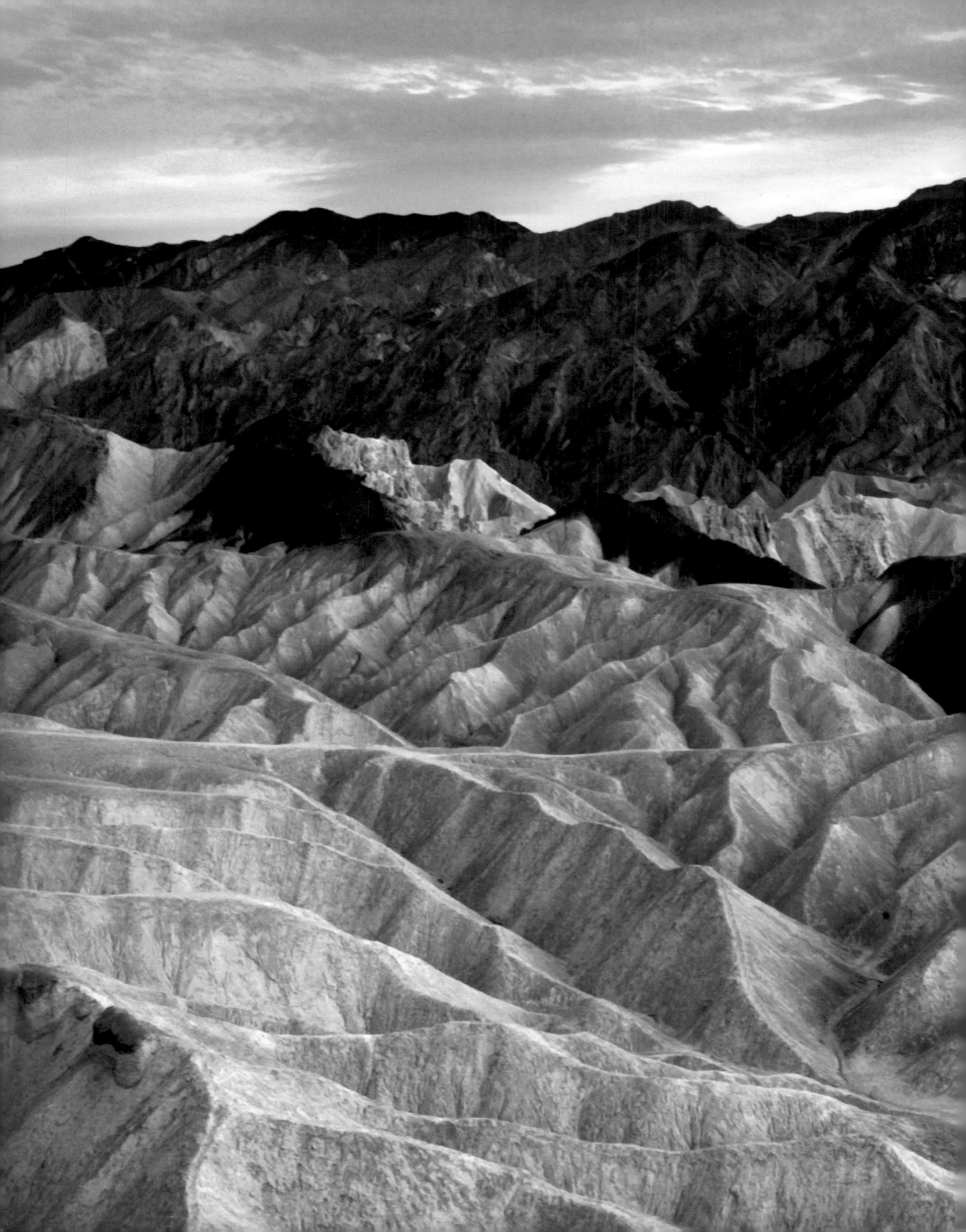

DEATH VALLEY

The magnificent view from Zabriskie Point to the southeast glides from the golden badlands of Furnace Creek to the older, darker hills of Artist Drive Formation. Both are mineral-rich, mile-deep floors of ancient inland seas. The darker hills may be 24 million years old.

Photo by Brian D. Schultz

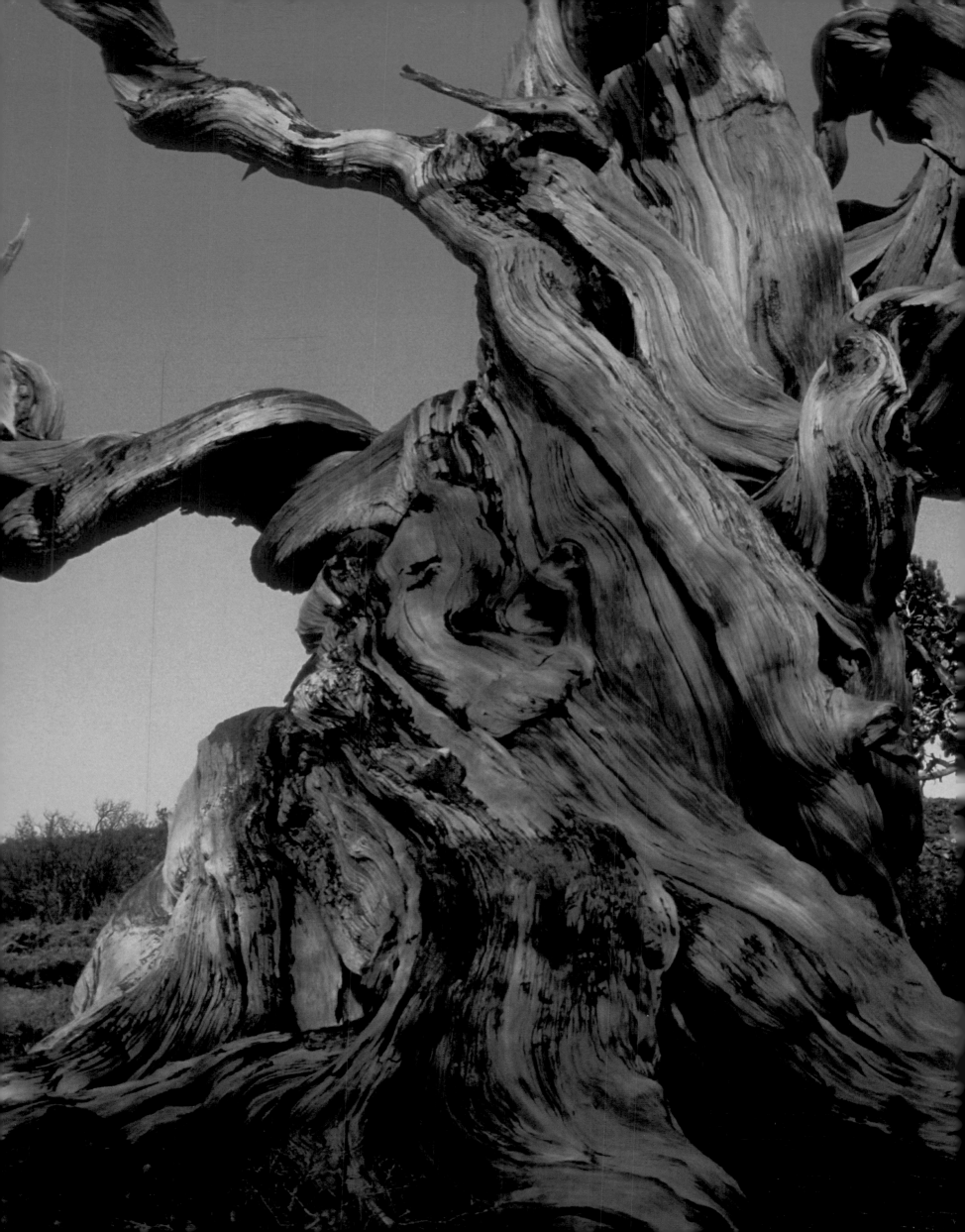

WHITE MOUNTAINS
In the mountains north of Death Valley, bristlecone pines have adapted to arid conditions. The range is in the rain shadow of the Sierra Nevada and receives only 12 inches of precipitation a year, usually in the form of winter snow. The resinous trees thrive on the cold, dry climate, and some, at nearly 5,000 years of age, are Earth's oldest living inhabitants.
Photo by Frans Lanting, www.lanting.com

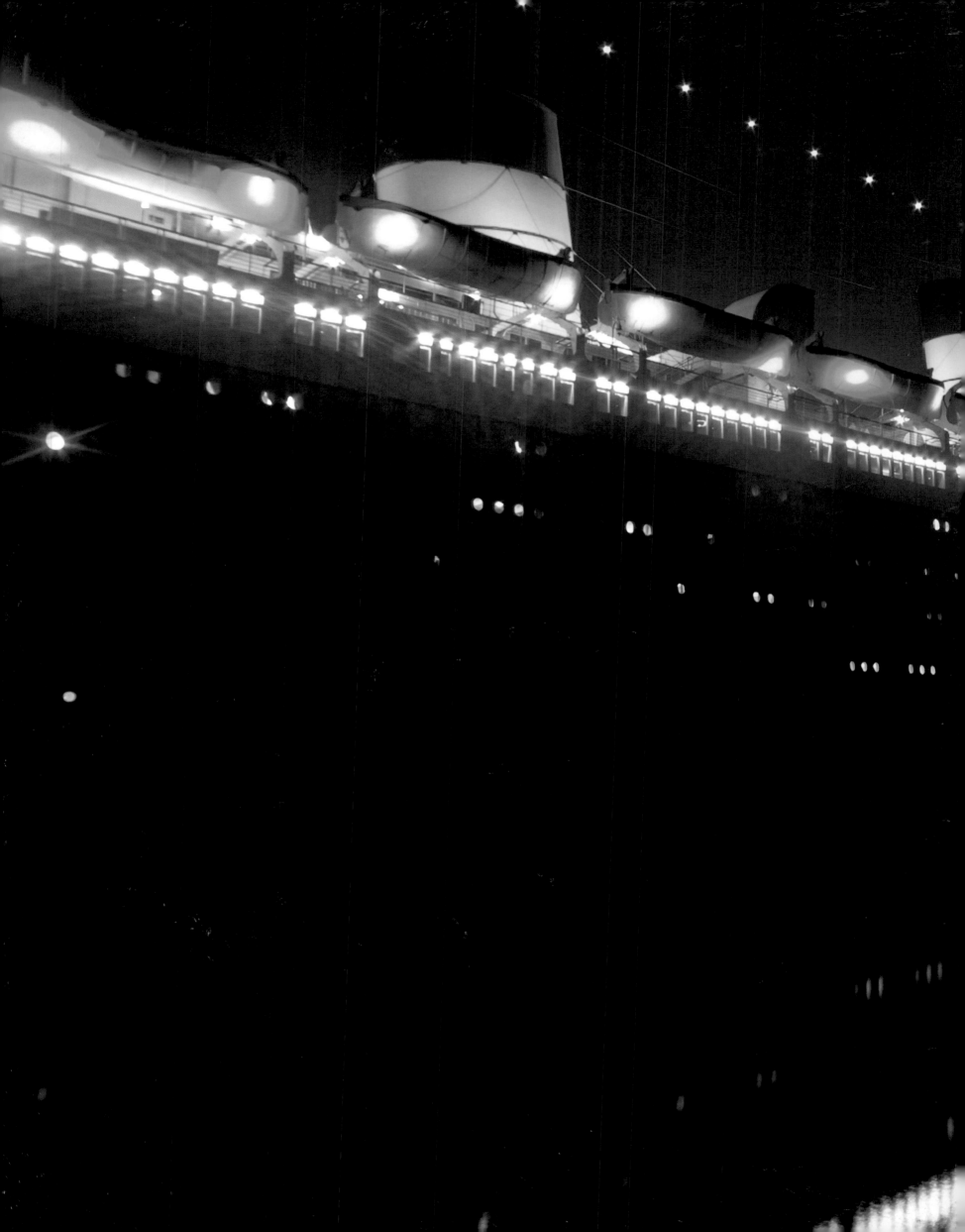

LONG BEACH

For 36 years, the *Queen Mary* has tugged at her mooring lines in Long Beach. The Cunard ocean liner and World War II troopship, known as "the Grey Ghost" during her service, made 1,001 transatlantic crossings before becoming a floating hotel and tourist attraction at this sprawling port.
Photo by Thomas P. Mcconville

SAN JOSE

The Albertsons grocery store on Saratoga Avenue politely dims its lights for stargazers at the Lick Observatory on Mount Hamilton, 30 miles away. The city of San Jose implemented a light pollution ordinance in the early 1980s to maximize the cosmic view from the observatory. For its efforts, the International Astronomical Union named an asteroid after the city in 2001.
Photo by Jim Gensheimer,
The San Jose Mercury News

POINT REYES

The pale sands of Limantour Beach betray no trace of the more than 2 million visitors who use the 17,000-acre Point Reyes National Seashore in a year. The patterns etched in sand by the Pacific were also seen by the area's original inhabitants, Miwok Indians, digging for clams at low tide.
Photo by Don Taylor, aPictureStory.com

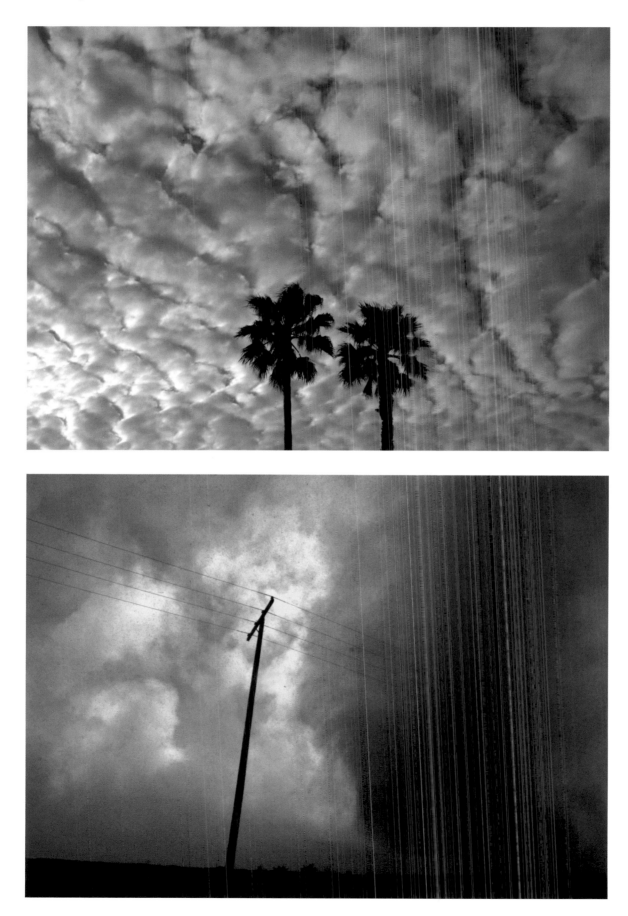

SARATOGA

A cold front moves in and crusts over a suburban San Jose sky. Photographer Jim Gensheimer has passed these palms a thousand times—he sees them from his driveway—but he never recognized their potential until these marbled clouds caught his attention. "I can't believe I've lived here for 10 years and haven't seen this picture," he says.

Photo by Jim Gensheimer,
The San Jose Mercury News

CALIPATRIA

In a field off Rutherford Road in the northern Imperial Valley, a combination of hot winds and smoke from a burning crop wrap themselves into a spontaneous twister.

Photo by Peggy Peattie,
The San Diego Union-Tribune

LONG BEACH
The Aquarium of the Pacific is home to 12,500 aquatic creatures, including a touch pool of nurse sharks. Designed to resemble ocean waves, the building sits on the edge of Rainbow Harbor.
Photo by Thomas P. Mcconville

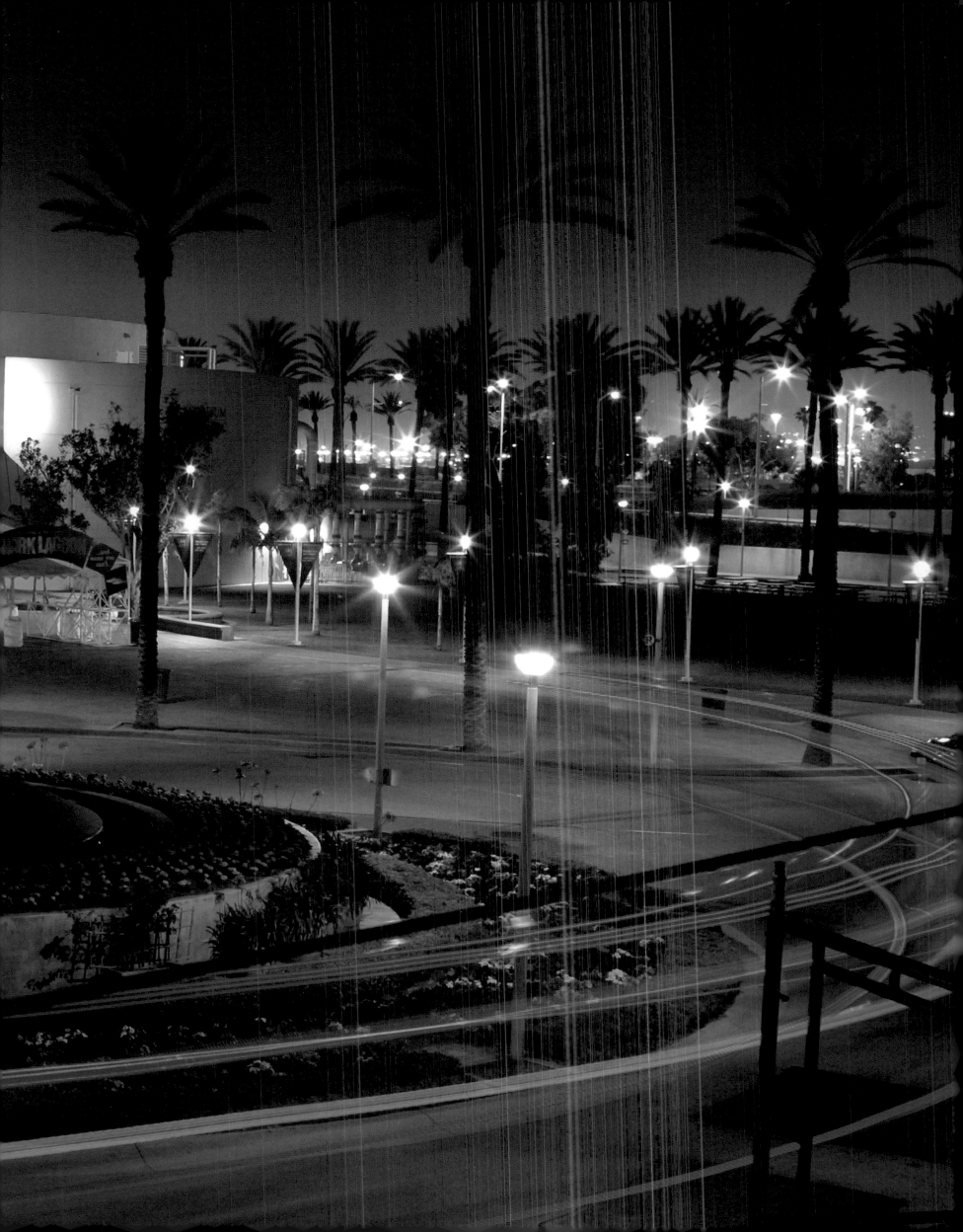

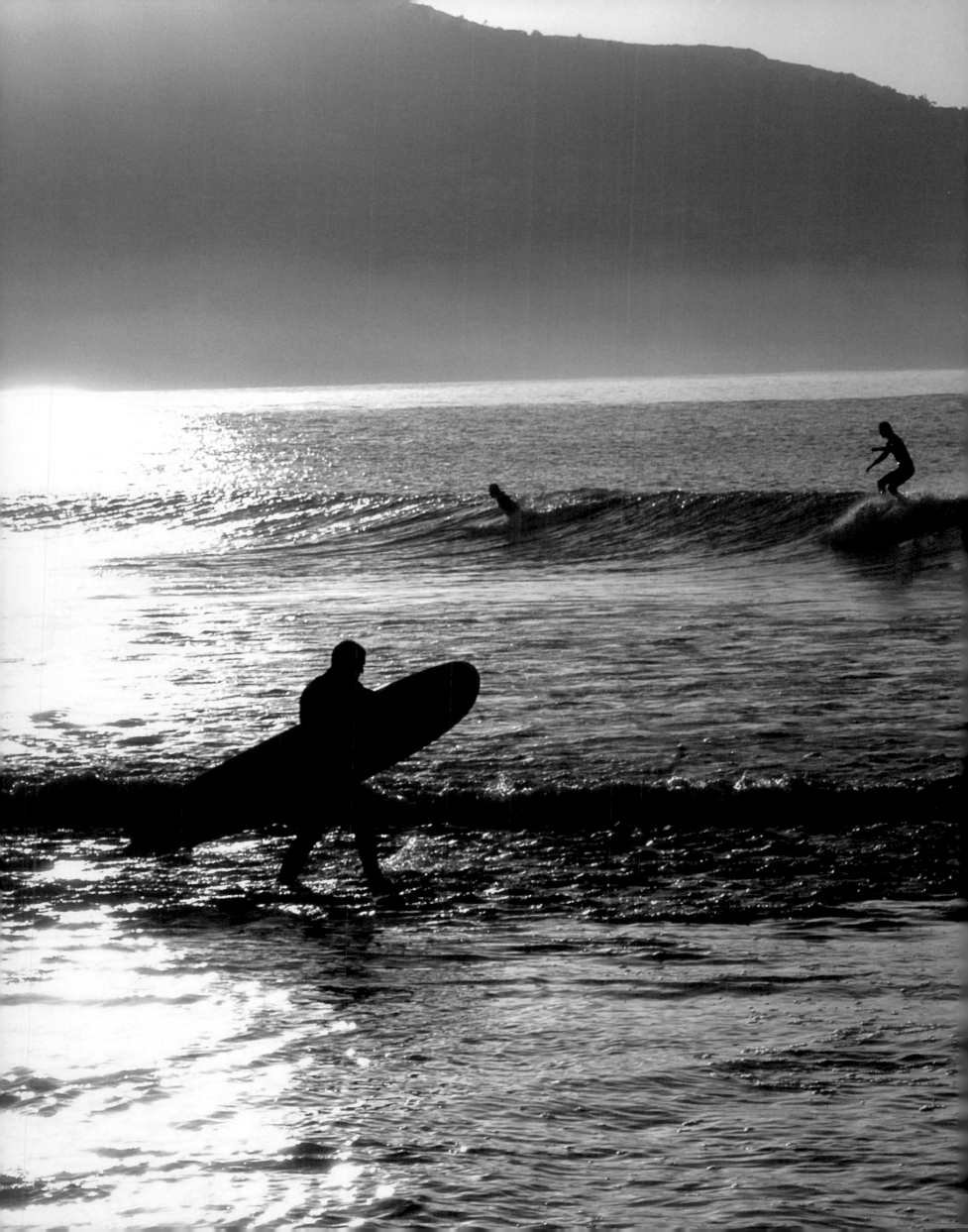

MALIBU
Catching the south swell at dawn, surfers
claim their bit of territory off Surfrider Beach
next to the Malibu Pier.
Photo by Michael Lambert

How It Worked

The week of May 12-18, 2003, more than 25,000 professional and amateur photographers spread out across the nation to shoot over a million digital photographs with the goal of capturing the essence of daily life in America.

The professional photographers were equipped with Adobe Photoshop and Adobe Album software, Olympus C-5050 digital cameras, and Lexar Media's high-speed compact flash cards.

The 1,000 professional contract photographers plus another 5,000 stringers and students sent their images via FTP (file transfer protocol) directly to the *America 24/7* website. Meanwhile, thousands of amateur photographers uploaded their images to Snapfish's servers.

At *America 24/7*'s Mission Control headquarters, located at CNET in San Francisco, dozens of picture editors from the nation's most prestigious publications culled the images down to 25,000 of the very best, using Photo Mechanic by Camera Bits. These photos were transferred into Webware's ActiveMedia Digital Asset Management (DAM) system, which served as a central image library and enabled the designers to track, search, distribute, and reformat the images for the creation of the 51 books, foreign language editions, web and magazine syndication, posters, and exhibitions.

Once in the DAM, images were optimized (and in some cases resampled to increase image resolution) using Adobe Photoshop. Adobe InDesign and Adobe InCopy were used to design and produce the 51 books, which were edited and reviewed in multiple locations around the world in the form of Adobe Acrobat PDFs. Epson Stylus printers were used for photo proofing and to produce large-format images for exhibitions. The companies providing support for the *America 24/7* project offer many of the essential components for anyone building a digital darkroom. We encourage you to read more on the following pages about their respective roles in making *America 24/7* possible.

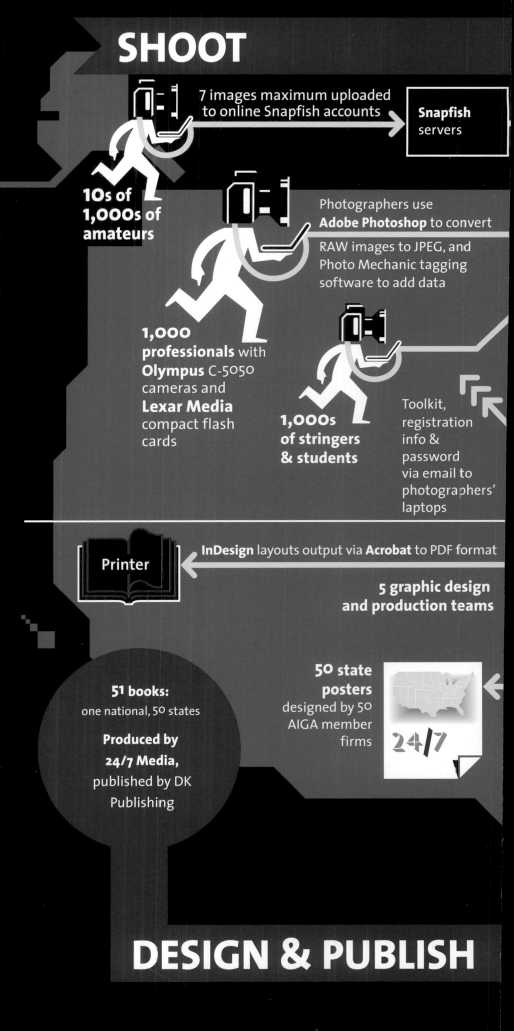

SHOOT

7 images maximum uploaded to online Snapfish accounts → **Snapfish** servers

10s of 1,000s of amateurs

Photographers use **Adobe Photoshop** to convert RAW images to JPEG, and Photo Mechanic tagging software to add data

1,000 professionals with **Olympus** C-5050 cameras and **Lexar Media** compact flash cards

1,000s of stringers & students

Toolkit, registration info & password via email to photographers' laptops

InDesign layouts output via **Acrobat** to PDF format

Printer

5 graphic design and production teams

51 books: one national, 50 states

Produced by 24/7 Media, published by DK Publishing

50 state posters designed by 50 AIGA member firms

24/7

DESIGN & PUBLISH

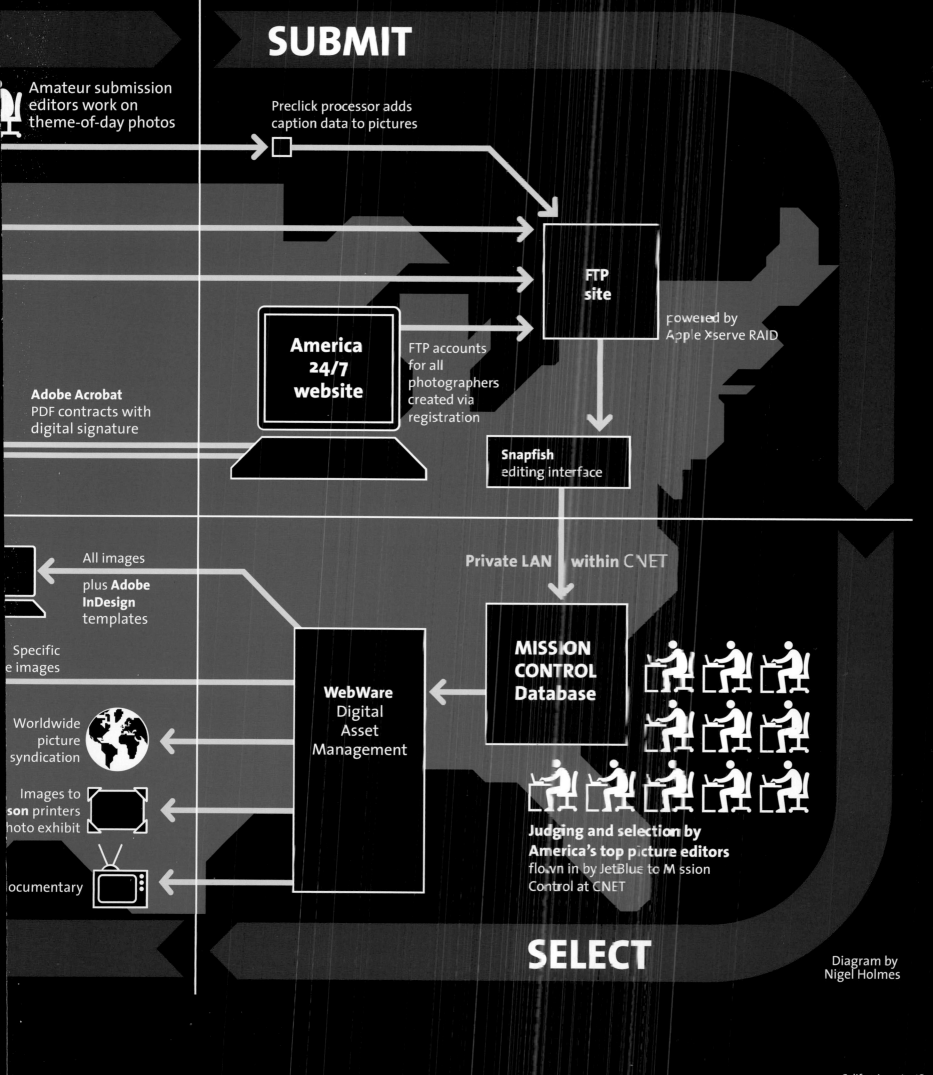

SUBMIT

Amateur submission editors work on theme-of-day photos

Preclick processor adds caption data to pictures

FTP site

Powered by Apple Xserve RAID

Adobe Acrobat PDF contracts with digital signature

America 24/7 website

FTP accounts for all photographers created via registration

Snapfish editing interface

All images

plus **Adobe InDesign** templates

Private LAN within CNET

Specific images

MISSION CONTROL Database

WebWare Digital Asset Management

Worldwide picture syndication

Images to **son** printers photo exhibit

Judging and selection by America's top picture editors flown in by JetBlue to Mission Control at CNET

ocumentary

SELECT

Diagram by Nigel Holmes

Participating Photographers

California Coordinator: Susan Gilbert, Director of Photography, *San Francisco Chronicle*

Jeffrey Aaronson, Network Aspen

John B. Adrain

Larry Angier

Marla Aufmuth

Helen Bae

PF Bentley, PFPIX.com

Nadia Borowski Scott,
The San Diego Union-Tribune

Thorin Brentmar

Sisse Brimberg

Naomi Brookner

Ed Bystrom

Stephen Carr

Julia Coburn

Courteney Coolidge

Rita Coury

Sabrina Dalbesio

Lou Dematteis

Anna Marie Dos Remedios, *The Pinnacle*

Lise Dumont

Victor Fisher

Deanne Fitzmaurice,
San Francisco Chronicle

Carolyn Fox

Jim Gensheimer, *The San Jose Mercury News*

Paul F. Gero

Jody Gianni

Arthur Grace

Michael Grecco Photography,
Icon International

David Gregory

Jeff Gritchen, *Long Beach Press-Telegram*

Maggie Hallahan, Network Images

Josh Haner

Kurt Hegre

David Hodge

Robert Holmes

Sandy Huffaker

Jean Jarvis

Stephen Johnson

Ed Kashi

Ivan Kashinsky, San Jose State University

Paul Kitagaki, Jr.*

Laura Kleinhenz

Kim Komenich*

Ryan Krauter, Art Center College of Design

Michael Lambert

Frans Lanting, www.lanting.com

Shlomit Levy Bard

Salim Madjd

Dennis A. Maloney

Sheila Masson

Hector Mata

Thomas P. Mcconville

Jim McCullaugh

Ron McDevitt

William Mercer McLeod

Jim Merithew

David Paul Morris

Tony Nguyen-Campobello

Mela Louise Norman

Aicha Nystrom

Celso Onofre, BayoPhoto.com

Charles O'Rear

Darcy Padilla

Peggy Peattie,
The San Diego Union-Tribune

Brent Reeves

Alon Reininger, Contact Press Images

Roger Ressmeyer, Visions of Tomorrow

Rick Rickman*

Brian D. Schultz

Meri Simon

David Simoni

Jan Sonnenmair, Aurora

Francis Specker

David Sprague, *Daily News*, Los Angeles

H. Chris Stocker,
Olympus Camedia Master

Gregory Stringfield

Lexey Swall, *Napies Daily News*

Vernon Tabirara

Don Taylor, aPictureStory.com

Patrick Tehan

Shmuel Thaler, *Santa Cruz Sentinel*

Chris Trim

George Wedding, GEOPIX

Brian Wytcherley,
Brooks Institute Of Photography

* Pultizer Prize winner

Thumbnail Picture Credits

Credits for thumbnail photographs are listed by the page number and are in order from left to right.

20 Jim Gensheimer, *The San Jose Mercury News*
Sandy Huffaker
Victor Fisher
Peggy Peattie, *The San Diego Union-Tribune*
Jim Gensheimer, *The San Jose Mercury News*
Victor Fisher
Victor Fisher

22 Darin Fong, www.darinfong.com
Gregory Stringfield
Ed Kashi
Gregory Stringfield
David Sprague, *Daily News*, Los Angeles
Jean Jarvis
Gregory Stringfield

24 Celso Onofre, BayoPhoto.com
Ronald Cohn, The Gorilla Foundation, koko.org
Jody Gianni
Sabrina Dalbesio
Salim Madjd

George Wedding, GEOPIX
Meri Simon

25 Jody Gianni
George Wedding, GEOPIX
Patrick Tehan
Celso Onofre, BayoPhoto.com
Patrick Tehan
Jeff Wong
Celso Onofre, BayoPhoto.com

26 Jody Gianni
Peggy Peattie, *The San Diego Union-Tribune*
Michael Lambert
David Simoni
Josh Haner
Larry Angier
Sandy Huffaker

27 Ed Kashi
Suzanne Mapes
Josh Haner

Rick Rickman
Paul Kitagaki, Jr.
Laura Kleinhenz
Samantha Kuppig

28 Jan Sonnenmair, Aurora
Jan Sonnenmair, Aurora
Paul Kitagaki, Jr.
Darin Fong, www.darinfong.com
Aicha Nystrom
Paul Kitagaki, Jr.
Jan Sonnenmair, Aurora

29 Suzanne Mapes
Jan Sonnenmair, Aurora
Michael Grecco Photography, Icon International
Jan Sonnenmair, Aurora
Paul Kitagaki, Jr.
Lee Manning
Suzanne Mapes

32 Sisse Brimberg
William Mercer McLeod
Rita Coury
Tammy Andrews
Sisse Brimberg
Kimberly Wassenberg
Timothy Ford

33 Sisse Brimberg
Rita Coury
Paul Kitagaki, Jr.
Sisse Brimberg
Timothy Ford
Nadia Borowski Scott, *The San Diego Union-Tribune*
William Mercer McLeod

34 Laura Kleinhenz
Carolyn Fox
Larry Angier
Nadia Borowski Scott, *The San Diego Union-Tribune*
Aicha Nystrom
Josh Haner
Kim Komenich

35 Ed Kashi
Kim Komenich
Nadia Borowski Scott, *The San Diego Union-Tribune*
Meri Simon
David Paul Morris
Sheila Masson
Mela Louise Norman

38 Brad Zweerink
Aicha Nystrom
Erad Zweerink
Jim Gensheimer, *The San Jose Mercury News*
Jim Merithew
Douglas Kirkland
Nadia Borowski Scott, *The San Diego Union-Tribune*

39 Jim Gensheimer, *The San Jose Mercury News*
Lea Garfield
Patrick Tehan
Jim Merithew
Kyo Suayan
Jim Merithew
Peggy Peattie, *The San Diego Union-Tribune*

40 Hector Mata
Helen Bae
Shlomit Levy Bard
Jim Gensheimer, *The San Jose Mercury News*
Helen Bae
Josh Haner
David Simoni

41 Aicha Nystrom
Shlomit Levy Bard
Jeffrey Aaronson, Network Aspen
Helen Bae
Maggie Hallahan, Network Images
Helen Bae
Shlomit Levy Bard

42 Mela Louise Norman
Stephen Carr
David Paul Morris
David Paul Morris
Kay Erickson
David Paul Morris
Laura Kleinhenz

43 David Paul Morris
Laura Kleinhenz
Stephen Carr
Suzanne Mapes
Marla Aufmuth
Stephen Carr
Stephen Carr

44 Carolyn Fox
Echo Lew
Sheila Masson
Kim Komenich
William Mercer McLeod
Laura Kleinhenz
Tony Nguyen-Campobello

45 Timothy Ford
Kim Komenich
Suzette Lee
Tony Nguyen-Campobello
Tony Nguyen-Campobello
Suzette Lee
Mela Louise Norman

56 Carolyn Fox
Dennis Dismachek
Anna Marie Dos Remedios, *The Pinnacle*
Anna Marie Dos Remedios, *The Pinnacle*

Peggy Peattie, *The San Diego Union-Tribune*
Tim J. Lee
Patrick Tehan

57 Michael Lambert
Anna Marie Dos Remedios, *The Pinnacle*
Peggy Peattie, *The San Diego Union-Tribune*
Sisse Brimberg
Peggy Peattie, *The San Diego Union-Tribune*
Peggy Peattie, *The San Diego Union-Tribune*
Ivan Kashinsky, San Jose State University

58 Kurt Hegre
Sandra Cannon, sfbayimages.com
Charles O'Rear
Kurt Hegre
Anna Marie Dos Remedios, *The Pinnacle*
Charles O'Rear
Josh Haner

59 Kurt Hegre
Charles O'Rear
Lori Bell
Charles O'Rear
Timothy Ford
Josh Haner
Sandra Cannon, sfbayimages.com

62 Kurt Hegre
Lexey Swall, *Naples Daily News*
Michael A. Pliskin
Robert Holmes
Robert Holmes
Lexey Swall, *Naples Daily News*
Tim J. Lee

63 Lexey Swall, *Naples Daily News*
Robert Holmes
Lexey Swall, *Naples Daily News*
Jim Merithew
Meri Simon
Lexey Swall, *Naples Daily News*
Robert Holmes

66 George Wedding, GEOPIX
H. Chris Stocker, Olympus Camedia Master
John B. Adrain
H. Chris Stocker, Olympus Camedia Master
John B. Adrain
PF Bentley, PFPIX.com
PF Bentley, PFPIX.com

67 PF Bentley, PFPIX.com
John B. Adrain
PF Bentley, PFPIX.com
John B. Adrain
PF Bentley, PFPIX.com
PF Bentley, PFPIX.com
PF Bentley, PFPIX.com

68 Alon Reininger, Contact Press Images
Brian Wytcherley, Brooks Institute Of Photography
Brian Wytcherley, Brooks Institute Of Photography
PF Bentley, PFPIX.com
Pip Bloomfield
Lori Bell
Josh Haner

69 Brian Wytcherley, Brooks Institute Of Photography
PF Bentley, PFPIX.com
Brian Wytcherley, Brooks Institute Of Photography
Josh Haner
PF Bentley, PFPIX.com
H. Chris Stocker, Olympus Camedia Master
Brian Wytcherley, Brooks Institute Of Photography

70 Paul Chu
Kurt Hegre
Shmuel Thaler, *Santa Cruz Sentinel*
Patrick Tehan
PF Bentley, PFPIX.com
PF Bentley, PFPIX.com
Paul Chu

71 Michael Lambert
PF Bentley, PFPIX.com
Carolyn Fox
Arthur Grace
Paul Chu
Patrick Tehan
Tammy Abbott

77 Michael Lambert
Roger Ressmeyer, Visions of Tomorrow
Patrick Tehan
Michael Lambert
Patrick Tehan
Michael Lambert
Patrick Tehan

78 Harvey W. Reed, Divertimenti.com
Nadia Borowski Scott, *The San Diego Union-Tribune*
Carolyn Fox
Courteney Coolidge
Harvey W. Reed, Divertimenti.com
Michael Grecco Photography, Icon International
Nadia Borowski Scott, *The San Diego Union-Tribune*

79 Ed Kashi
Kim Komenich
Jeffrey Aaronson, Network Aspen
Ed Kashi
Nadia Borowski Scott, *The San Diego Union-Tribune*
Jeffrey Aaronson, Network Aspen
Suzanne Mapes

82 Brian Wytcherley, Brooks Institute Of Photography
Greg Rahn
Naomi Brookner
Josh Haner
Jim Merithew

Naomi Brookner
Benjamin Le

83 Tim J. Lee
Maggie Hallahan, Network Images
Nadia Borowski Scott, *The San Diego Union-Tribune*
Peggy Peattie, *The San Diego Union-Tribune*
Tim J. Lee
Victor Fisher
Victor Fisher

86 Arthur Grace
Jeff Wong
Arthur Grace
Jeff Wong
Robert Holmes
Suzanne Mapes
Marla Aufmuth

87 Nadia Borowski Scott, *The San Diego Union-Tribune*
Michael Lambert
David Royal, San Jose State University
Rick Rickman
Robert Holmes
Shari Abercrombie, www.shariabercrombie.com
Robert Holmes

88 Victor Fisher
Josh Haner
Maggie Hallahan, Network Images
Shlomit Levy Bard
Suzanne Mapes
Rick Rickman
Victor Fisher

89 Suzanne Mapes
Maggie Hallahan, Network Images
Shlomit Levy Bard
Victor Fisher
Shlomit Levy Bard
Maggie Hallahan, Network Images
Victor Fisher

98 Jessica Brandi Lifland
Meri Simon
Jessica Brandi Lifland
Meri Simon
Meri Simon
Jessica Brandi Lifland
Meri Simon

99 Meri Simon
Jessica Brandi Lifland
Meri Simon
Meri Simon
Michael Lambert
Meri Simon
Meri Simon

100 Jenn Coyle
Gregory Stringfield
Jody Gianni
Ryan Krauter, Art Center College of Design
Jeffrey Aaronson, Network Aspen
Jennifer Wills
Paul Kitagaki, Jr.

101 Patrick Tehan
Aicha Nystrom
Sisse Brimberg
Dennis M. Brown
Ivan Kashinsky, San Jose State University
Maggie Hallahan, Network Images
Michael Lambert

102 Jean Jarvis
Michael Grecco Photography, Icon International
Michael Grecco Photography, Icon International
Michael Grecco Photography, Icon International
Sandra Cannon, sfbayimages.com
Kim Komenich
Jean Jarvis

103 Mela Louise Norman
Michael Grecco Photography, Icon International
Pip Bloomfield
Michael Grecco Photography, Icon International
Todd Thomas Hollenbeck
David Simoni
Jeffrey Aaronson, Network Aspen

104 Pip Bloomfield
David Royal, San Jose State University
Ian Randall Crockett
Michael Grecco Photography, Icon International
Francis Specker
Maggie Hallahan, Network Images
Francis Specker

105 Patrick Tehan
Thomas P. Mcconville
Rick Rickman
Rick Rickman
William Mercer McLeod
Rick Rickman
Rick Rickman

108 Ivan Kashinsky, San Jose State University
Sisse Brimberg
Kim Komenich
Maggie Hallahan, Network Images
Lou Dematteis
David Simoni
Jim Merithew

109 Shelly Castellano, SCPIX.com
Salim Madjd
Todd Thomas Hollenbeck
Nadia Borowski Scott, *The San Diego Union-Tribune*
Nadia Borowski Scott, *The San Diego Union-Tribune*

Nadia Borowski Scott, *The San Diego Union-Tribune*
William Mercer McLeod

110 Paul Kitagaki, Jr.
Josh Haner
Darcy Padilla
Darcy Padilla
Lou Dematteis
H. Chris Stocker, Olympus Camedia Master
Lou Dematteis

111 Deanne Fitzmaurice, *San Francisco Chronicle*
Yuri Dojc
Lou Dematteis
Deanne Fitzmaurice, *San Francisco Chronicle*
Lou Dematteis
Josh Haner
Darcy Padilla

114 Christopher Grisanti Photography
H. Chris Stocker, Olympus Camedia Master
David Sprague, *Daily News*, Los Angeles
H. Chris Stocker, Olympus Camedia Master
Jeff Gritchen, *Long Beach Press-Telegram*
Jeff Gritchen, *Long Beach Press-Telegram*
Peggy Peattie, *The San Diego Union-Tribune*

115 Jeff Gritchen, *Long Beach Press-Telegram*
Harvey W. Reed, Divertimenti.com
Jeff Gritchen, *Long Beach Press-Telegram*
Marla Aufmuth
Yuri Dojc
Peggy Peattie, *The San Diego Union-Tribune*
Christopher Grisanti Photography

117 Fernando Cepeda
Lise Dumont
George Wedding, GEOPIX
Timothy R. Kelly
George Wedding, GEOFIX
George Wedding, GEOFIX
Meri Simon

118 David Paul Morris
Deanne Fitzmaurice, *San Francisco Chronicle*
Timothy Ford
William Mercer McLeod
Raffi Hadidian, www.raffix.com
Arthur Grace
Darcy Padilla

119 Deanne Fitzmaurice, *San Francisco Chronicle*
Kurt Hegre
Jim Merithew
Michael Grecco Photography, Icon International
Jim Gensheimer, *The San Jose Mercury News*
Brad Zweerink
Kurt Hegre

122 Josh Haner
Sandra Cannon, sfbayimages.com
Laura Kleinhenz
Meri Simon
Marla Aufmuth
Maggie Hallahan, Network Images
Josh Haner

123 Josh Haner
Josh Haner
Suzette Lee
Roger Ressmeyer, Visions of Tomorrow
Jennifer Wills
Victor Fisher
Tammy Andrews

124 Michael Grecco Photography, Icon International
Dennis A. Maloney
Mela Louise Norman
Marla Aufmuth
Jim Gensheimer, *The San Jose Mercury News*
Fernando Cepeda
Mela Louise Norman

125 Meri Simon
Peggy Peattie, *The San Diego Union-Tribune*
Maggie Hallahan, Network Images
Mela Louise Norman
Maggie Hallahan, Network Images
Shari Abercrombie, www.shariabercrombie.com
Todd Thomas Hollenbeck

126 Arthur Grace
Patrick Tehan
Patrick Tehan
Patrick Tehan
Patrick Tehan
Patrick Tehan
Patrick Tehan

127 Patrick Tehan
George Wedding, GEOPIX
Patrick Tehan
Ryan Krauter, Art Center College of Design
Patrick Tehan
Patrick Tehan
Ryan Krauter, Art Center College of Design

132 Courteney Coolidge
Kim Komenich
Kim Komenich
Courteney Coolidge
Kim Komenich
Victor Fisher
Courteney Coolidge

133 William Mercer McLeod
Terry Chan
William Mercer McLeod
Deanne Fitzmaurice, *San Francisco Chronicle*

Victor Fisher
Tony Nguyen-Campobello
William Mercer McLeod

134 Benjamin Le
Carol Y. Liu, Stanford University
Larry Angier
Gregory Stringfield
Francis Specker
Timothy Ford
Jeff Wong

135 Lydia Ching Lam, Art Center College of Design
Larry Angier
Maggie Hallahan, Network Images
Ed Bystrom
George Wedding, GEOFIX
Keith Johnson
Nadia Borowski Scott, *The San Diego Union-Tribune*

136 Patrick Tehan
Hector Mata
Hector Mata
Keith Johnson
Kurt Hegre
Raffi Hadidian, www.raffix.com
Hector Mata

137 Kurt Hegre
Jim Merithew
Hector Mata
Patrick Tehan
Hector Mata
Hector Mata
Peggy Peattie, *The San Diego Union-Tribune*

140 Paul F. Gero
Paul F. Gero
David Paul Morris
Patrick Tehan
Shlomit Levy Bard
Sandra Cannon, sfbayimages.com
Deanne Fitzmaurice, *San Francisco Chronicle*

141 Deanne Fitzmaurice, *San Francisco Chronicle*
Nadia Borowski Scott, *The San Diego Union-Tribune*
Paul F. Gero
Jim Gensheimer, *The San Jose Mercury News*
Paul F. Gero
Nadia Borowski Scott, *The San Diego Union-Tribune*
Deanne Fitzmaurice, *San Francisco Chronicle*

142 Arthur Grace
Peggy Peattie, *The San Diego Union-Tribune*
Darcy Padilla
Deanne Fitzmaurice, *San Francisco Chronicle*
Peggy Peattie, *The San Diego Union-Tribune*
Deanne Fitzmaurice, *San Francisco Chronicle*
Darcy Padilla

143 David Paul Morris
Deanne Fitzmaurice, *San Francisco Chronicle*
Sisse Brimberg
Darcy Padilla
Deanne Fitzmaurice, *San Francisco Chronicle*
Sisse Brimberg
Deanne Fitzmaurice, *San Francisco Chronicle*

146 Michael A. Pliskin
Darin Fong, www.darinfong.com
Eric Wagner
Patrick Tehan
Josh Haner
Benjamin Le
Josh Haner

147 Darin Fong, www.darinfong.com
Michael A. Pliskin
Michael Grecco Photography, Icon International
Mela Louise Norman
Patrick Tehan
Thomas P. Mcconville
Fernando Aguila, FernandoAguila.com

153 Pip Bloomfield
Jeffrey Aaronson, Network Aspen
Matthew S. Kent, Contra Costa College
Keith Johnson
Paul Kitagaki, Jr
Scott Bourne
Michael Lambert

154 H. Chris Stocker, Olympus Camedia Master
Brian D. Schultz
Jim Gensheimer, *The San Jose Mercury News*
William Mercer McLeod
Josh Haner
Suzette Lee
Jody Gianni

155 William Mercer McLeod
Kim Komenich
Laura Kleinhenz
Timothy R. Kelly
Maggie Hallahan, Network Images
Kay Erickson
Yuri Dojc

156 David Sprague, *Daily News*, Los Angeles
Aicha Nystrom
Jeffrey Aaronson, Network Aspen
Arthur Grace
Carolyn Fox
Yuri Dojc
Jeffrey Aaronson, Network Aspen

157 Debra Myrent
Jorge Gallegos
Hector Mata
Dennis A. Maloney

Lisa Buoncristiani
William Mercer McLeod
Terry Chan

158 Julia Coburn
Julia Coburn
Julia Coburn
Arthur Grace
Julia Coburn
Julia Coburn
Julia Coburn

159 David J. Shuler
Marla Aufmuth
Julia Coburn
Thomas P. Mcconville
Julia Coburn
Julia Coburn
Will Adam Kosonen

161 Nadia Borowski Scott, *The San Diego Union-Tribune*
Nadia Borowski Scott, *The San Diego Union-Tribune*
Laura Kleinhenz
Victor Fisher
Nadia Borowski Scott, *The San Diego Union-Tribune*
Jenn Coyle
Yuri Dojc

164 David J. Shuler
Ed Kashi
Deanne Fitzmaurice, *San Francisco Chronicle*
Ed Kashi
Deanne Fitzmaurice, *San Francisco Chronicle*
Deanne Fitzmaurice, *San Francisco Chronicle*
Ed Kashi

166 Susana Millman
Charley Kohlhase
Jerry Perezchica
David Gregory
Susana Millman
David Gregory
David Gregory

167 Susana Millman
Tony Nguyen-Campobello
Arthur Grace
Deanne Fitzmaurice, *San Francisco Chronicle*
Susana Millman
William Mercer McLeod
Susana Millman

168 Frans Lanting, www.lanting.com
Brian D. Schultz
Anna Marie Dos Remedios, *The Pinnacle*
Ryan Tanaka
Brian D. Schultz
Brian D. Schultz
David Simoni

169 Hector Mata
Brian D. Schultz
Hector Mata
Ryan Tanaka
Brian D. Schultz
Brian D. Schultz
Kim Komenich

170 Brian D. Schultz
George Wedding, GEOPIX
Peggy Peattie, *The San Diego Union-Tribune*
George Wedding, GEOPIX
Erik Weber
Frans Lanting, www.lanting.com
Lori Bell

171 Brian D. Schultz
Kim Komenich
Brian D. Schultz
Kim Komenich
Peggy Peattie, *The San Diego Union-Tribune*
Raffi Hadidian, www.raffix.com
Brian D. Schultz

172 Kevin Eckert-Smith
Arthur Grace
Josh Haner
Brian D. Schultz
Dennis A. Maloney
Arthur Grace
Jeffrey Aaronson, Network Aspen

173 Carolyn Fox
Rina Ota
Kurt Hegre
Kim Komenich
Kurt Hegre
Walter Sharrow
Tony Nguyen-Campobello

180 Charles O'Rear
Jim Gensheimer, *The San Jose Mercury News*
Pip Bloomfield
Francis Specker
Don Taylor, aPictureStory.com
Jim Gensheimer, *The San Jose Mercury News*
Jay Garibay

181 Josh Haner
Jim Gensheimer, *The San Jose Mercury News*
Josh Haner
Josh Haner
Peggy Peattie, *The San Diego Union-Tribune*
Ed Bystrom
Kim Komenich

Staff

The *America 24/7* series was imagined years ago by our friend Oscar Dystel, a publishing legend whose vision and enthusiasm have been a source of great inspiration.

We also wish to express our gratitude to our truly visionary publisher, DK.

Rick Smolan, Project Director
David Elliot Cohen, Project Director

Administrative
Katya Able, Operations Director
Gina Privitere, Communications Director
Chuck Gathard, Technology Director
Kim Shannon, Photographer Relations Director
Erin O'Connor, Photographer Relations Intern
Leslie Hunter, Partnership Director
Annie Polk, Publicity Manager
John McAlester, Website Manager
Alex Notides, Office Manager
C. Thomas Hardin, State Photography Coordinator

Design
Brad Zucroff, Creative Director
Karen Mullarkey, Photography Director
Judy Zimola, Production Manager
David Simoni, Production Designer
Mary Dias, Production Designer
Heidi Madison, Associate Picture Editor
Don McCartney, Production Designer
Diane Dempsey Murray, Production Designer
Jan Rogers, Associate Picture Editor
Bill Shore, Production Designer and Image Artist
Larry Nighswander, Senior Picture Editor
Bill Marr, Sarah Leen, Senior Picture Editors
Peter Truskier, Workflow Consultant
Jim Birkenseer, Workflow Consultant

Editorial
Maggie Canon, Managing Editor
Curt Sanburn, Senior Editor
Teresa L. Trego, Production Editor
Lea Aschkenas, Writer
Olivia Boler, Writer
Korey Capozza, Writer
Beverly Hanly, Writer
Bridgett Novak, Writer
Alison Owings, Writer
Fred Raker, Writer
Joe Wolff, Writer
Elise O'Keefe, Copy Chief
Daisy Hernández, Copy Editor
Jennifer Wolfe, Copy Editor

Infographic Design
Nigel Holmes

Literary Agent
Carol Mann, The Carol Mann Agency

Legal Counsel
Barry Reder, Coblentz, Patch, Duffy & Bass, LLP
Phil Feldman, Coblentz, Patch, Duffy & Bass, LLP
Gabe Perle, Ohlandt, Greeley, Ruggiero & Perle, LLP
Jon Hart, Dow, Lohnes & Albertson, PLLC
Mike Hays, Dow, Lohnes & Albertson, PLLC
Stephen Pollen, Warshaw Burstein, Cohen, Schlesinger & Kuh, LLP
Rick Pappas

Accounting and Finance
Rita Dulebohn, Accountant
Robert Powers, Calegari, Morris & Co. Accountants
Eugene Blumberg, Blumberg & Associates
Arthur Langhaus, KLS Professional Advisors Group, Inc.

Picture Editors
J. David Ake, Associated Press
Caren Alpert, formerly *Health* magazine
Simon Barnett, *Newsweek*
Caroline Couig, *San Jose Mercury News*
Mike Davis, formerly *National Geographic*
Michel duCille, *Washington Post*
Deborah Dragon, *Rolling Stone*
Victor Fisher, formerly Associated Press
Frank Folwell, *USA Today*
MaryAnne Golon, *Time*
Liz Grady, formerly *National Geographic*
Randall Greenwell, *San Francisco Chronicle*
C. Thomas Hardin, formerly *Louisville Courier-Journal*
Kathleen Hennessy, *San Francisco Chronicle*
Scot Jahn, *U.S. News & World Report*
Steve Jessmore, *Flint Journal*
John Kaplan, University of Florida
Kim Komenich, *San Francisco Chronicle*
Eliane Laffont, *Hachette Filipacchi Media*
Jean-Pierre Laffont, *Hachette Filipacchi Media*
Andrew Locke, MSNBC
Jose Lopez, *The New York Times*
Maria Mann, formerly AFP
Bill Marr, formerly *National Geographic*
Michele McNally, *Fortune*
James Merithew, *San Francisco Chronicle*
Eric Meskauskas, *New York Daily News*
Maddy Miller, *People* magazine
Michelle Molloy, *Newsweek*
Dolores Morrison, *New York Daily News*
Karen Mullarkey, formerly *Newsweek, Rolling Stone, Sports Illustrated*
Larry Nighswander, Ohio University School of Visual Communication
Jim Preston, *Baltimore Sun*
Sarah Rozen, formerly *Entertainment Weekly*
Mike Smith, *The New York Times*
Neal Ulevich, formerly Associated Press

Website and Digital Systems
Jeff Burchell, Applications Engineer

Television Documentary
Sandy Smolan, Producer/Director
Rick King, Producer/Director
Bill Medsker, Producer

Video News Release
Mike Cerre, Producer/Director

Digital Pond
Peter Hogg
Kris Knight
Roger Graham
Philip Bond
Frank De Pace
Lisa Li

Senior Advisors
Jennifer Erwitt, Strategic Advisor
Tom Walker, Creative Advisor
Megan Smith, Technology Advisor
Jon Kamen, Media and Partnership Advisor
Mark Greenberg, Partnership Advisor
Patti Richards, Publicity Advisor
Cotton Coulson, Mission Control Advisor

Executive Advisors
Sonia Land
George Craig
Carole Bidnick

Advisors
Chris Anderson
Samir Arora
Russell Brown
Craig Cline
Gayle Cline
Harlan Felt
George Fisher
Phillip Moffitt
Clement Mok
Laureen Seeger
Richard Saul Wurman

DK Publishing
Bill Barry
Joanna Bull
Therese Burke
Sarah Coltman
Christopher Davis
Todd Fries
Dick Heffernan
Jay Henry
Stuart Jackman
Stephanie Jackson
Chuck Lang
Sharon Lucas
Cathy Melnicki
Nicola Munro
Eunice Paterson
Andrew Welham

Colourscan
Jimmy Tsao
Eddie Chia
Richard Law
Josephine Yam
Paul Koh
Chee Cheng Yeong
Dan Kang

Chief Morale Officer
Goose, the dog